JEWELER'S *enameling* WORKSHOP

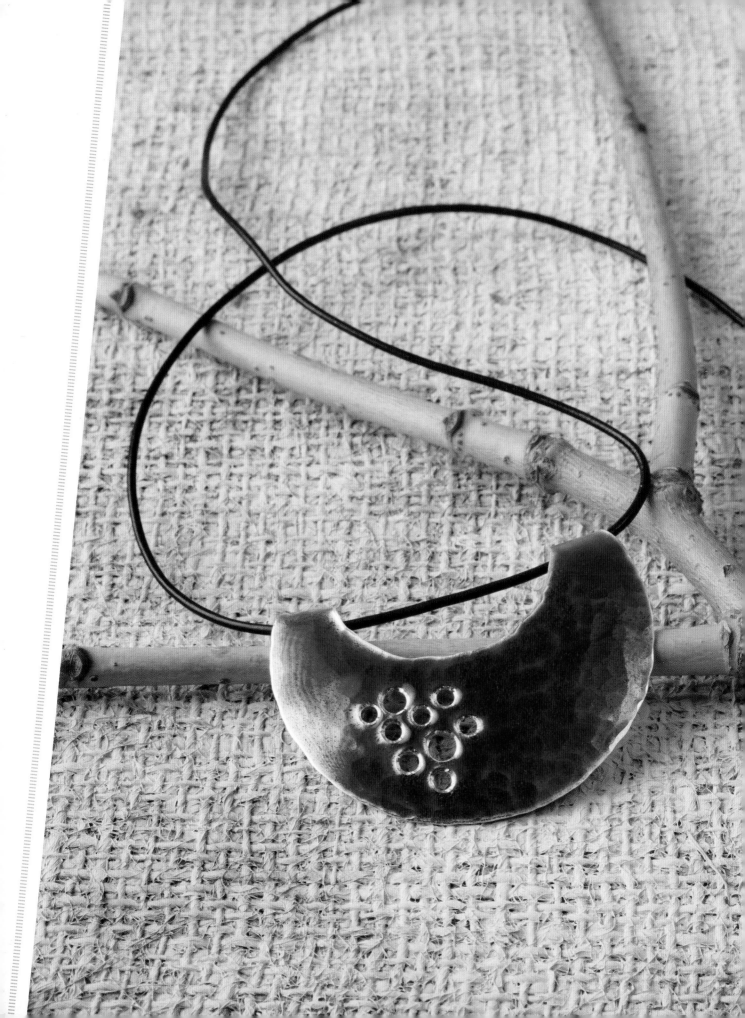

JEWELER'S *enameling* WORKSHOP

TECHNIQUES AND PROJECTS FOR MAKING ENAMELED JEWELRY

PAULINE WARG

INTERWEAVE.
interweave.com

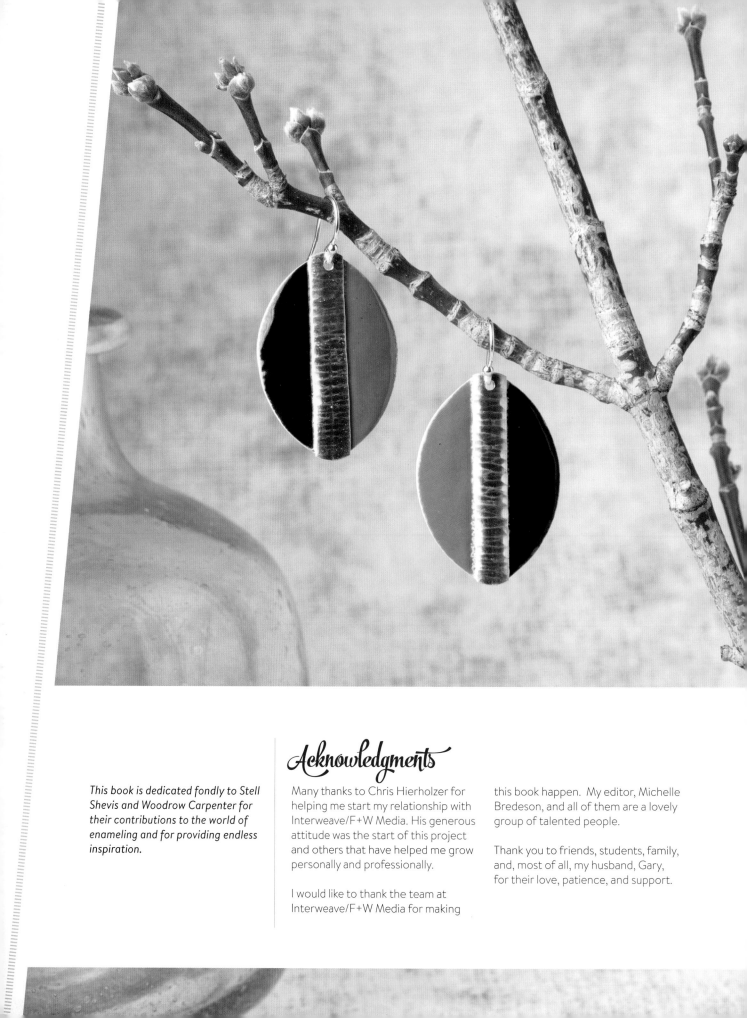

This book is dedicated fondly to Stell Shevis and Woodrow Carpenter for their contributions to the world of enameling and for providing endless inspiration.

Acknowledgments

Many thanks to Chris Hierholzer for helping me start my relationship with Interweave/F+W Media. His generous attitude was the start of this project and others that have helped me grow personally and professionally.

I would like to thank the team at Interweave/F+W Media for making this book happen. My editor, Michelle Bredeson, and all of them are a lovely group of talented people.

Thank you to friends, students, family, and, most of all, my husband, Gary, for their love, patience, and support.

Contents

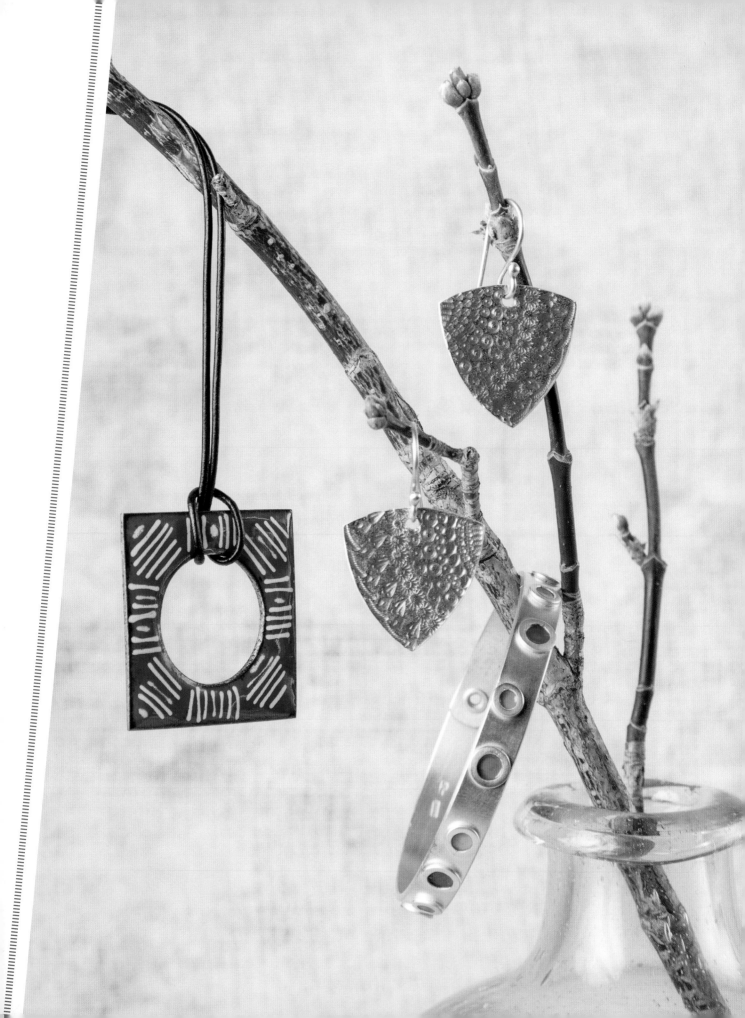

Introduction

At the tender age of seven, I was given a Trinket enameling kit by my favorite uncle. My parents let me set up a little studio in the basement of our home. I read and experimented with all the techniques described in the pamphlet that came with the kit. I was quite productive, making gifts of bowls, pins, pendants, and earrings for family members. That kiln gave me hours of enjoyment for many years, and I taught myself the basics of sifted enamels using it. After a few years I became distracted by other aspects of growing up, and the Trinket box became dusty.

Fast-forward to my college years. I became a classically trained jeweler and metalsmith in a unique and intensive European apprenticeship-style program. In addition, I later completed a BFA. While I was steeped in my metalsmithing training, I dreamed of learning more about enameling. I especially loved René Lalique's work and plique-à-jour. Someday . . .

My career as a metalsmith and jeweler gave me the opportunity to study the finer techniques of cloisonné, champlevé, and plique-à-jour with masters of these skills. I was able to add a whole range of enameling skills to my jewelry-making repertoire and was thrilled with the growth I was able to make through using these advanced enameling skills.

Enameling has been a journey of excitement and diversity. I love being able to add color to my work without necessarily using gemstones. There is a painterly quality to enameling that I enjoy very much. It is also a very meditative process. It is quiet, close, and thoughtful.

Enameling is an amazingly expansive technical area. It would be nearly impossible to cover every aspect thoroughly in one book. I hope to share a great deal of my knowledge of the techniques I have learned and with which I am more experienced. Many of the projects within are set up to engage and instruct beginners with no experience in enameling or metalsmithing. The projects move forward to include more advanced enameling and more involved metalsmithing skills.

Anyone interested in learning the art of enameling as a beginner and those with some experience who wish to expand their knowledge should gain from the content of this book.

Enjoy!

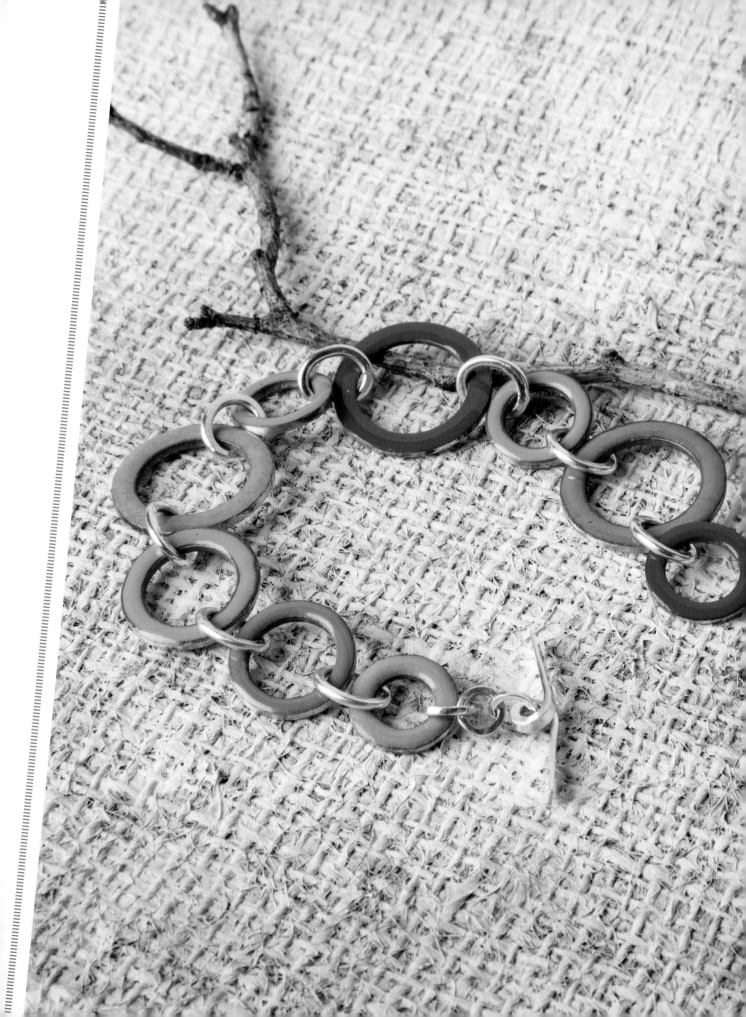

Enameling Basics

Enameling is a broad topic that covers a myriad of techniques in which powdered glass is applied to a metal surface and fused at high temperatures. The following section breaks these processes down step by step and covers all the tools and supplies you'll use to demystify enameling and ensure your projects are successful.

Enamels come in a wide range of colors, in both transparent and opaque forms.

Chemistry and Characteristics

The enamels I use in this book and those I teach with are called high-fired, or hard-fired, enamels, not to be confused with enamel as in oil-based paint. They consist of clear glass mixed with chemicals and/or metals to give the glass pigment, or color. These enamels melt at about 1,450°F (788°C). The enamels used mostly in jewelry making are called medium-temperature/medium-fusing enamels.

TYPES OF ENAMEL

There are several brands of glass enamels made for jewelry enameling. In this book, I will be using Thompson brand unleaded, or nonleaded, enamels, but other medium-temperature enamels can be used in the same way. Colors may vary from brand to brand.

Chemists have developed recipes to create different colors of powdered glass for enameling. The enamels start with pulverized clear glass. Different chemicals and/or metal powders are added to that clear glass to create a specific

color. For instance, there may be cobalt in some blue enamel and gold in red enamels. This mix is then remelted, cooled, and then re-pulverized to make the enamel powder. Most typically the glass is pulverized to what is called 80 mesh. *Mesh* is the term used to describe the grain size of the enamel, and 80 mesh looks similar to, but a bit finer than, granulated sugar.

Glass enamel powders do not mix to make additional colors. For example, blue enamel and yellow enamel grains mixed together do not make green enamel. If you fired them, the result would be speckles of blue and speckles of yellow. The grains of each color will maintain their individual integrity. Therefore, it's very important not to contaminate one dry enamel with another.

There are leaded and unleaded enamels, and both come in transparent colors and opaque colors. The primary difference between the two (leaded and non) for use in jewelry making is the accuracy of color in the warm range of transparent colors on silver. Some nonleaded transparent yellows, reds, and purples turn dark or brown when used on silver. This does not happen as much or as severely when leaded transparent warm-range colors are used on silver. This chemical reaction of nonleaded enamels on silver is a good reason to make a color sample board for reference.

FIRING ENAMEL

Most medium-temperature/medium-fusing unleaded enamels fire (melt) at about 1,450°F (788°C). The temperature may vary slightly from color to color. An enamel that melts at 100°F (38°C) more than 1,450°F is called a *harder* enamel. One that melts slightly below 1,450°F is

called a slightly *softer* enamel. The 1,450°F is an average at which these enamels *fire*.

When firing these enamels, whether with a torch or in a kiln, there are stages the enamel goes through until it becomes completely fired. *Sugar* is the first stage when the enamel is actually fused to the metal, yet maintains its granular visual effect. This is a stage that some artists use for a more textural finish. The next stage is called *orange peel*. This stage looks like its name. The enamel appears smoother with dimpling. This stage is usually not considered a professional finish. *Fire polish* is when the enamel becomes completely glossed over. This is the finish considered most desirable by a majority of artists.

PREPARING METAL FOR ENAMELING

Medium-temperature/medium-fusing glass enamels are compatible with pure gold, pure (fine) silver, and pure (99 percent) copper. The delicate chemistry of the enamels makes them reject most alloyed metals. If these enamels are used on brass, bronze, or nickel silver, which are not pure elements, the enamels may crack or actually slough off. These reactions can happen immediately after firing (melting) or develop over time. I have seen experimental projects that have seemingly worked successfully on an alloy. However, over a period of time the enamel work may appear damaged due to the incompatibility with the alloy used as a base.

There are ways to counteract the adverse reaction of the enamels to alloyed metals. The process of *depletion gilding* can be used on bronze, sterling silver, and karat gold. Depletion gilding

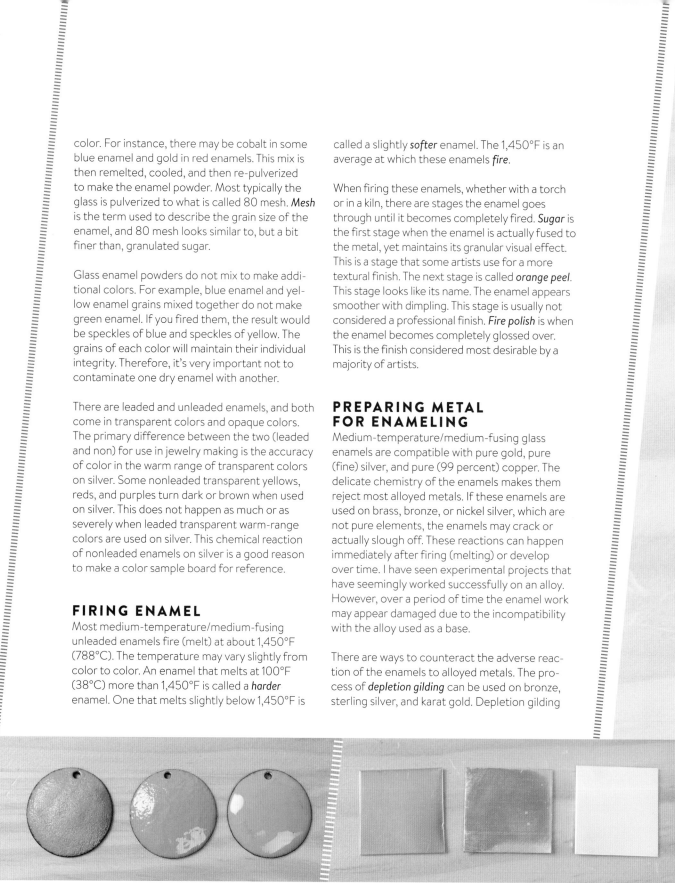

These samples show the firing stages of enamel. From left to right: sugar, orange peel, and fire polish.

Depletion gilding brings a layer of pure metal to the surface of alloyed metals, making it possible to successfully enamel them. Here, you can see how sterling silver becomes lighter and develops a frosty appearance (left to right), as it is depletion gilded.

is the process of heating an alloyed metal that contains pure gold, pure copper, or pure silver to bring up a surface layer of the pure metal and then enameling on that. Bronze contains pure copper, sterling silver contains pure (fine) silver, and karat gold contains pure gold. If any of these metals is heated to an *annealing* temperature, cooled, and then pickled, and then this process is repeated at least four times, a layer of the pure metal will create a skin that can then be enameled.

When I depletion gild, I repeat the process six or more times to ensure a healthy layer of pure metal. When using sterling silver, the process is complete when you see a white frosty surface. I usually don't depletion gild on any gold below 14 karat. The depletion gilding on karat gold shows a more yellow coloration and also has a somewhat frosty surface appearance. Bronze develops a copper-colored surface that is somewhat frosty looking.

Enamels like clean metal. If the metal you are planning on enameling has a lot of grease or dirt on it, you should clean the metal to remove it. Grease can be in polishing compounds, hand creams, and sometimes on workshop surfaces or tools.

To degrease, thoroughly wash the metal with soap, wipe it with acetone or ammonia, make a paste of baking soda and water and rub it on the surface, or place it in a mild acid (*pickle*) solution, and then rinse and dry with a clean paper towel or cloth. To remove dirt, such as sanding dust, wash thoroughly with detergent and hot water or place in an ultrasonic machine filled with a solution of water, ammonia (1 tablespoon [15 ml]), and detergent (1 teaspoon [5 ml]).

CAUTION!: Ammonia and acetone have harmful fumes. They must be used in a well-ventilated area. Always keep lids on them when not in use!

Most typically, 18-gauge metal is used as a base for jewelry enameling. This thickness gives stability to the work and helps prevent cracking in the enamel. Thinner metal may warp under the high temperature needed to melt the enamel. The metal and the enamel have different expansion and contraction characteristics during heating and cooling. This is why there is a tendency for enamel on thin or flat metal to craze or crack. Forming is another way to prevent stress and cracking of the enamel. If a piece of metal has

been formed or dapped so that it is no longer flat, it will have less tendency to flex or warp and crack the enamel. It's possible to use thinner metal (20- to 24-gauge, for example) as the base for enamel using a technique called *counter enamel* (see page 26).

Tools and Supplies

There are many tools and supplies used in making enameled jewelry. Although I have preferences for specific tools and ways to set up my enameling areas, I will try to offer some choices as I go over what is needed.

Tools and supplies may vary depending on whether you are torch firing or using a kiln. I will note which tools are used for which method or whether a tool may be used for both methods.

As I begin to describe the specifics of each technique in the firing processes section and in the projects, I will explain more about these tools and materials. Here are the main supplies you will need, in alphabetical order.

BINDERS

Binders are liquids that help keep dry sifted enamels (see page 25) in place when applying and drying the enamels before firing. Binders don't guarantee that dry enamels will stay in place, but they help. The most common binder is Klyr-Fire. This is a watery, slightly gelatinous plant-based liquid reminiscent of aloe vera juice. It is usually mixed 50/50 with distilled water before use and can be brushed on or sprayed.

Other binders include just water, mineral oil, and nonaerosol hair spray. Water, distilled or from the tap, will work, but it has the tendency to bead up rather than spread evenly on metal. Mineral oil works great to hold enamel in place. I used to use it as a child with my Trinket kiln. The problem with mineral oil is that as you are firing the enamel it burns off, causing a sooty and dirty environment in the air if torch firing, or deposits of soot in a kiln.

Nonaerosol hairspray also works well to hold dry enamel in place. This works best with opaque enamels. If you use the hair spray as a binder with transparent enamels, it will create unattractive cloudy spots.

Klyr-Fire, water, and hair spray are applied to the metal before applying enamel, and then the piece with the enamel needs to be dried. If you do not dry the pieces before firing, the binder will boil as you apply heat and pop off some, if not a great deal, of the enamel. Mineral oil does not have to be dried before firing.

BLU-STIC

This is a blue gluelike gel used to hold cloisonné-wire (see page 33) designs in place during the initial firing. Cloisonné wires are dipped ever so slightly into Blu-Stic and then set onto a thin prefired base coat of enamel. The Blu-Stic should be allowed to dry before firing onto the base coat. When fired, the Blu-Stic burns off cleanly, and the wires will adhere to the base coat of enamel.

DUST MASKS

When enameling, you are working with powdered glass. Although the glass powder is heavier than air, you still need to take precautions to avoid breathing in the dust or ingesting the glass. An inexpensive disposable particulate mask works fine. I prefer the reinforced type with a diaphragm in it, which helps keep moisture from building up inside the mask.

Masks should be worn whenever working with glass powders, such as when transferring glass powder from a bag or jar to another container and when dry sifting.

FIRING RACKS

These are screens that hold your work during the firing process. They are used in both torch firing and kiln firing. These racks should be made of a heavy-gauge (14-gauge) nichrome stainless steel, which holds up very well under high temperatures and does not give off a lot of contaminating *scale* or *oxides*.

When torch firing, the rack is placed on the top of a tripod over an opening. A jewelry-making soldering tripod may be used for this purpose. The rack allows the piece to be suspended over the tripod opening so the heat can flow through it to the piece being fired. If the gauge of the screen is not heavy enough, the screen may actually burn through and the piece could fall, causing a mishap and ruining the work.

If you're firing your enamels with a kiln, use racks to support the enameled piece when placing it in the kiln and removing it when firing is done. Racks need to have either the four corners or two opposite sides bent down at a right angle to create "legs" of ½ to ¾ inch (1.3–2 cm). This allows space beneath the rack for a kiln fork to slide under it easily and transfer the rack into and out of the kiln.

Most racks are sold flat. If you need to bend the "legs," it's easy to do in a vise. Mark the distance to be bent with a marker while the rack is flat. Place a corner of the rack in the jaws of the vise and tighten the jaws on it, then pull the rack down toward you to bend it. Repeat the process on the other three corners. If bending two sides opposite each other, put one side of the rack in the vise jaws, tighten, and bend. Flip to the other side and bend it.

GLASS BRUSHES

Glass brushes are exactly what they sound like. Extra-fine clear-rush fiberglass is encased in either a string wrap or plastic handle. As you wear down the fiberglass, the string or plastic can be peeled down to expose fresh glass. After you grind rough edges on enameled pieces, the grinding materials may leave particles in the enamel smaller than the eye can see. When refired, these particles (especially carborundum and diamond) may cause black spots in the enamel. Scrubbing the enameled surface with a glass brush under water after grinding will remove any remaining contaminants.

GRINDING TOOLS

When enameling, there are times when edges or surfaces may need to be ground to smooth a surface. Frequently, the sides of a piece may develop a small, sharp edge from adhering to a support. In processes like cloisonné, the entire surface may need to be ground smooth before the last firing. Since the material you are removing is glass, it's important to use the proper tools and process to be safe and keep your enameled piece from being damaged.

Glass should always be ground under water. This helps prevent glass dust from being released into the air for you to breath. If not done properly, grinding could also chip your piece.

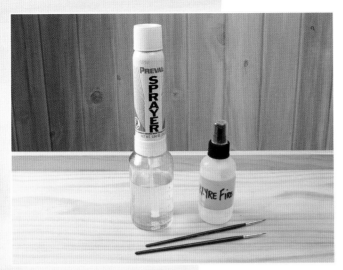

Binders and application tools.

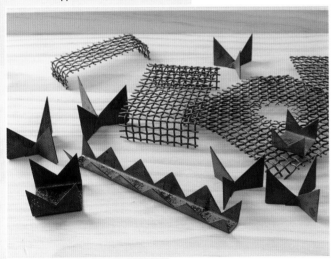

A variety of racks and trivets. (See Trivets on page 15.)

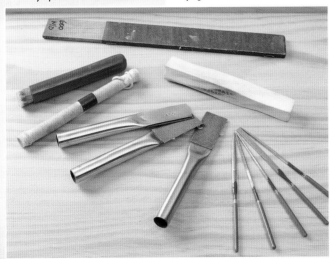

A selection of grinders and glass brushes.

Among the common tools used for grinding are alundum stones, diamond files, diamond cloth, and wet/dry sandpaper. There are some other grinding sticks similar to alundum stones. Some of these are made from carborundum, which can leave particles in the enamel surface. If refired, those particles can leave spots of contamination.

I tend to use alundum stones for initial or crude grinding. These are white "stones" that come in different grits ranging from 120 to 240. They are 1 inch (2.5 cm) square by 6 inches (15 cm) long. When using them, I turn my water faucet on just enough to dribble, hold the work under the water, and move the alundum stone back and forth over the area to be ground, keeping the alundum and the piece wet. The stone wears away as you use it. Eventually, it will turn into a very odd shape. However, it will conform to a surface to get more work done.

Diamond files and diamond cloth come in grits ranging from 200 to 800. These also need to be used under water. I tend to use diamond cloth, which comes in a strip 1 inch (2.5 cm) wide by either 4 or 8 inches (10 or 20.5 cm) long and has a self-adhesive backing. I like diamond cloth for two reasons: it's a little wider than diamond files, and I can make my own handle for it. I cut the strip of diamond cloth into 2-inch (5 cm) lengths. Then I take a ½-inch (1.3 cm) diameter by 5-inch (12.5 cm) long copper tube and flatten 2 inches (5 cm) on one end. I stamp the grit number of the cloth on one side of the flattened part. I peel off the backing on the cloth and apply the adhesive side to the side opposite the stamped number. I then have the diamond cloth on a waterproof comfortable handle. It will last for years.

KILNS

There are many more kilns that work for enameling than I could begin to cover here, but there are some common basics to enameling in them. Cabinet-type kilns are totally enclosed and have a hinged or sliding door. Kilns in this category should have a maximum temperature of at least 1,600°F (870°C). Always use a front-loading kiln rather than a deep top-loading ceramic kiln. It's extremely helpful if the kiln has a temperature gauge of some sort. Settings such as high/medium/low, a temperature indicator, or a programmable computer are important for consistency and predictability when firing.

Another type of enameling kiln is what I call a "kettle" kiln. It consists of a ceramic or metal base with legs and looks much like a hot plate on legs. Inside the base is a ceramic disc with electric elements coiled in the middle. The coils are covered with ceramic and are not bare and exposed. These kilns do not have a door but rather a lid that looks much like a small metal or ceramic cooking pot that nestles upside down over the base. They have a cutout on one side and a handle just like a pot would have. The cutout is to enable you to watch while the enamel is firing. My Trinket kiln was this type of kiln. See Kiln-Firing Setup (page 21) for more information on choosing a kiln.

KILN FORKS

Kiln forks are long and have two prongs that allow you to safely move firing racks into and out of the kiln, while supporting the enamel pieces safely. The forks tend to be a heavy-gauge steel or aluminum with a wood handle and a shield like a large disc between the fork and the handle. The shield protects the user from the heat of the kiln. The overall length may be from 18 inches (45.5 cm) to 2 feet (61 cm).

With a kettle-type kiln, a spatula is usually used to place and remove work from the heat coils. The handle of the spatula needs to be long enough to prevent you from getting too close to the hot elements. It also needs to be very stable and strong enough to hold more than the weight of your piece.

PAINTBRUSHES AND SPATULAS

When using enamels wet (see Wet Packing Enamels, page 30), they need to be applied with small brushes or tiny spatulas. I personally like to use small brushes more than spatulas. The brushes should be very small (00 or 000) and have natural bristles. The ones I use are sable. The small brushes allow you to place small amounts of the wet enamel exactly where you want it.

PENNY BRITE

This is a paste of primarily citric acid. It can be brushed onto copper to remove oxides. Penny Brite works with time, not heavy-duty scrubbing. It should be applied with a wet sponge and allowed to sit for several minutes and then gently scrubbed and rinsed off.

Because Penny Brite is an acid, it may burn if it gets into a cut. It will also mar a stainless-steel sink if left on it without rinsing.

SCALEX

Scalex is the brand name of ball clay, a superfine clay suspended in water. When painted onto a bare surface of metal (primarily copper), it will prevent oxides from being released during firing, thus eliminating contamination. It should be painted on thinly and completely dried before firing a piece. If one side of a piece has been fired with enamel on it and the other side has Scalex (ball clay) on it, when that piece cools the oxides will be absorbed into the Scalex and come off in pieces. It is also an anti-enamel, so it's important to keep areas to be enameled free of Scalex.

SIFTERS

Sifters are tools used to apply dry enamel over metal surfaces (see Dry Sifting Enamels, page 25). They are frequently plastic cups with a screen across the open bottom and a handle. I have seen them made out of metal tubing with a screen across the bottom and a soldered-on handle. Sifters come in different sizes, depending on the size of the piece you're applying the enamel to. For most wearable jewelry-size pieces, I tend to use a small sifter of about ½ inch (1.3 cm) in diameter. The mesh of the screen must allow the grains of enamel to pass through, without them pouring out quickly. A *line sifter* looks like a small pipe and enables you to sift enamels more precisely.

Sifters should never be washed. They need to be wiped clean with a dry paper towel to prevent color contamination.

TRIPODS AND OTHER TORCH-FIRING SETUPS

Tripods are used for torch firing enamels. They are metal hoops with long legs and a metal screen that bridges across the hoop. The screen supports the work while it is being torch fired. There are some tripods that are made commercially, just for torch firing. I find the best-made, most economical tripods are the ones made for jewelers to use for soldering, but they come with a rather lightweight screen. I replace that screen with a heavier gauge nichrome steel firing rack.

There are other ways to support work while torch firing. You can arrange soldering blocks in an annealing pan so that they create a tall

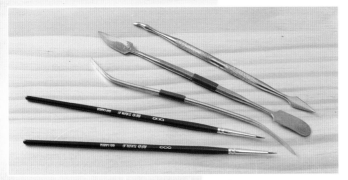

Paintbrushes and spatulas can be used to apply enamel.

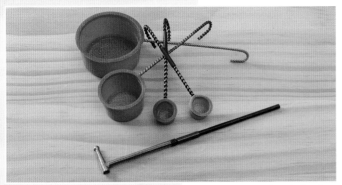

Sifters are used to apply even layers of dry enamels. Line sifters (front) allow for the most precise application.

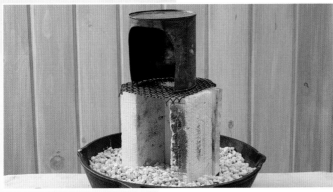

Instead of a tripod, you can use a firing rack on top of soldering blocks to support your pieces when torch firing. Some enamel artists use a coffee can to concentrate the heat.

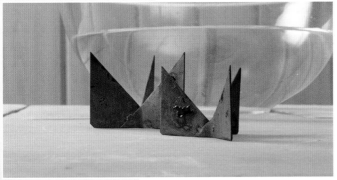

If enamel becomes fused to a trivet, you should grind it off under water.

"U"-shaped, vertical channel and then place a firing rack over them. Some older references use these setups and then place a metal coffee can (make sure there are no labels or paint on it) with an arch shape cut out on the front. This creates more of an ovenlike situation, which concentrates and conserves the heat. The problem I find with this is there tends to be more loose debris from the metal can that can contaminate the enamel. Since the torch firing is very rapid, it doesn't seem to need such a chamber to concentrate the heat. The tripod with no can cap on it is my preference.

TRIVETS

When a piece is enameled on both sides you cannot set it directly on a firing rack, or the glass will fire and attach to the rack. This causes a lot of problems for your work and the rack. Trivets (shown on page 13) are used to safely prop up work and avoid having melted glass fuse to the firing racks. Trivets can be three point, four point, or adjustable. The idea is that you support the work by balancing it evenly by its edges. That said, the edges of a piece can still have a tendency to fuse where they contact the edges of the trivet. When the piece cools, it has to be gently popped off the trivet. This leaves a very small sharp shard on the edge. Do not run your finger over the edge when this happens. The shards are like little razor blades! This is one case when you need to grind the edges under water until smooth.

TORCHES

There are many torches that have enough heat to fire enamels. Acetylene/oxygen (Little Torch), acetylene/air (Handi-Heat, Prestolyte), propane/oxygen (Hoke), propane/air (Cobra, Eazy Torch), natural gas/oxygen, and Mapp gas all burn hot enough to fire enamel. Depending on your studio situation and finances, some may be better options for you than others. Single-tank options are easier for many people to work because they have only one flame-adjusting knob. They are also more affordable. A two-gas system is more expensive and more complicated to operate. I most often use a Smith Handi-Heat acetylene/air system, and it is the torch system I use for teaching. I also have a Little Torch (acetylene/oxygen) and a Hoke (propane/oxygen). Do not use propane in larger quantities than 2 pounds (1 kg) inside a building. See Torch-Firing Setup (page 18) for more information of torches.

Work Area Setup

Before I begin to enamel, whether it be torch firing or using the kiln, I prepare an area and have certain tools and supplies close at hand. If I have all things within arm's reach, there is less chance of me having to hop up and down and possibly spill enamels or disturb work I'm preparing to enamel.

My favorite place to prepare pieces is on a ceramic tile–topped table. It's very easy to keep clean. I recommend having a clean space separated from any metalworking to do your enameling. If there is not enough room to be separate, clean an area when you're ready to enamel and do no metalwork until you're done enameling. Loose metal dust or dust from sandpaper may taint your enamel powders.

Health and Safety

When enameling, you're working with finely ground glass powders that contain chemicals and metals. It's very important to be careful and aware at all times. Breathing or ingesting powdered glass is hazardous to your health. If you have pets or small children, they should not be allowed near the enameling area.

Keep your work area clean. If enamels spill, it's easier to see them and clean them up if the area is clean and well lit. Keeping the work area clean will help maintain the integrity of your enamel colors. Use damp or wet sponges or towels to clean up to avoid creating airborne glass dust, which you could breathe in.

Food and drink should be kept away from the area where you're enameling. You don't want to ingest powdered glass no matter what. You may have some enamel on your hands, which will transfer to any food you pick up.

It's a good idea to wear safety glasses while enameling. They help in filtering heat and light from a torch or kiln. It's common to get some enamel dust on your hands. If your eye itches or hair falls in your eyes, and you touch your eye, the enamel may get in your eye. Safety glasses will remind you not to touch your eyes.

While you're enameling, your work, firing racks, trivets, tripods, forks, kiln, and torch tips may all be *very* hot. It's very easy to get burned. After pieces have been fired, it may take ten minutes or more for them to cool. After firing a piece, hold your hand 2 or 3 inches (5–7.5 cm) above it. If you feel *any* radiant heat rising from the piece, *do not* touch it.

Must-Have Enameling Tools and Supplies

- Plastic bottle caps for supporting work so I can pick up the piece by the edges only.
- Paper towels cut into quarters and/or a linen dishcloth for wiping tools and brushes.
- Disposable dust mask to wear with all dry processes, from removing powder from jars or bags to sifting.
- Natural bristle brushes of varying sizes for applying ball clay, binders, or decorative elements.
- Permanent markers and pencils for writing down enamel numbers I am using or drawing the design I intend.
- A lined wastebasket to dispose of paper towels that may have glass powder on them.
- Magnifying glasses to see what I'm doing!
- Very fine-tipped stainless-steel tweezers to pick up small items, to clean dry enamel out of drilled holes, and to pick up pieces with drilled holes without disturbing dry enamel.
- Work apron to keep enamel off of my clothes.
- A small scoop, spatula, or metal ruler to take small amounts of enamels out of jars or bags.
- Good lighting to make projects very clear and distinct while working.

When torch firing, you need to have a fire-safe area for the setup, torch, and cooling work. Torch firing can bring a piece up to nearly 2,000°F (1,100°C). This temperature will burn holes in tabletops, flooring, and, most critically, *you*. Tabletops need to be covered with ceramic tile, metal, Transite board, cement board, or thick stone such as granite. There should not be any flammable materials within a couple of feet. There should be no curtains close to the area. Pull back your hair while working with a torch. Loose clothing may also be a fire hazard. After firing, the torch tip will be hot. The hand piece with the tip needs to be set down on a fireproof surface or placed on a hook so it doesn't burn surfaces or allow you to bump into it. Place items that have been fired on the fireproof surface to cool.

A kiln needs to be set on a fireproof surface. Most kilns come with directions detailing how much space there needs to be around them. In most cases, 2 feet (61 cm) on any side (including above the kiln) should be adequate. It may also be a good idea to install fireproof material on any walls close to the kiln. Kiln walls may become very hot while the kiln is turned on. Be careful not to touch or bump into the exterior cabinet. Heat rises, so the top of the kiln will be the hottest part.

Make sure that the wiring on any kiln you use is UL listed to meet safety regulations. Many older kilns are not wired to current standards.

Do not allow the rack or fork to ever touch an exposed electrical element. The kiln fork will also be very hot after being in the kiln. Set it down safely on a fireproof surface, along with any work that needs to cool.

Firing Processes

Firing glass enamels onto metal requires high temperatures (over 1,350°F/730°C) for a short period of time. Enamels fuse best when heated very quickly (1 to 3 minutes). There are two different methods to do this: with a torch or with a kiln. For each of the projects in the book, I give instructions for either torch firing or kiln firing, although many of the projects can be fired either way. See "Enameling Techniques" at the beginning of each project for the recommended method(s).

TORCH-FIRED ENAMELS

Torch firing enamel is a method of fusing glass enamel powders onto metal using a torch rather than a kiln. There are advantages and disadvantages to each method of firing.

Using a torch can be more economical than purchasing a kiln, because you can fire with something as simple as a disposable propane torch. These are the torches you can purchase at a hardware store, frequently called a plumber's torch. They are very inexpensive and easy to use. Most torches a jeweler would use for silver soldering would also work for torch firing.

One of the major advantages I like about torch firing is that you can watch close up as the enamels go through their stages of sugar to orange peel to fire polish. It allows you to stop exactly when you need to. It is a very immediate process.

There is a process called *blanching* that is very easy to attain when working so directly with the piece as it is firing. When enameling copper, many transparent colors will become dark after firing. They lose the brilliance you might see on a silver or gold background. You can continue to heat a piece after it has become fire polished, until the oxides are actually absorbed by the enamel. This makes the copper appear bright and golden underneath the enamel. When the piece is cooled, it will look much more vibrant than a piece that is not blanched. This process is much easier to control when you are torch firing. Once you have blanched a piece under a transparent enamel, it will stay blanched through continued firings. Blanching has no effect on opaque enamels.

Some unique effects may be created during torch firing that do not happen when firing in a kiln. Sometimes when torch firing, if the gas from the flame glances directly over the fired enamel it will create a luster-like, iridescent finish. This is something you have to play around with and is not particularly easy to control. When it does occur, it is a really unique effect and worth experimenting with. There are some leaded opaque white enamels that are very conducive to this. It can happen on opaques and transparent enamels. If you do build this luster, you need to realize that repeated heating will eradicate it.

On the downside, torch firing can be a dirty process. Because you're firing in an open atmosphere, it's easy to have contaminants land on your piece and leave a variety of imperfections fused to the surface. Oftentimes it's difficult to see these contaminants until you're done firing. Black spots and other such unplanned design elements are common.

The problem is that no matter how careful you may be during the firing, this may still occur. If you have more organic work or are not bothered by this issue, no problem. It can be frustrating, though, if you have a very precise design, and it ends up being tainted by tiny pieces of debris.

Torch firing can be unpredictable in many ways. Because there is only a visual indication of temperature (by firing stages), a piece may look different from another that you thought was prepared and fired exactly the same way. This tends to happen more when using copper rather than silver or gold. If you're making a pair of earrings out of copper and enameling them with a torch, the pair may not match. However, you can get some very exciting, unpredictable effects if you are willing to go with the flow, so to speak.

Most typically when torch firing the torch is heating the piece from underneath. If there are repeated firings or if you are overfiring for the blanched effect, the underside, especially if counter enameled (see page 26), may become damaged or discolored. This, unfortunately, is an unavoidable side effect of torch firing.

Torch-Firing Setup

To torch fire enamels, you must have a sturdy and secure table or shelf with a fireproof surface. There are many different types of supports you can use for your work while firing. I have mentioned some of these previously in the "Tools and Supplies" section.

I work on a table covered with ceramic tile. It's the same table on which I do my jewelry soldering. In one of my pumice-filled annealing pans, I place a 9-inch-high (23 cm) tripod with a nichrome stainless-steel firing rack on top of it. The annealing pan is useful because it can be rotated during firing. The pumice in the pan is a safe area, should something fall during firing. It would land in the pumice and not roll around, causing burns on the floor, for example. It is rare that something falls, but it's good to be prepared.

Other options for ways to prop trivets during firing include fire bricks or soldering blocks set up in a "U" shape, with a screen over the top. However you arrange the supports for the firing rack, they need to be secure and allow enough space underneath to safely use the torch from below.

I always have tweezers with insulated grips within easy reach so if I need to move something when it is hot, I will be safe from burns. I also have a steel or brass soldering pick nearby in case I need to touch something on the piece during firing.

When using a torch, you must be very focused and alert. A large open flame can be very hazardous if you don't pay strict attention to it. If using a torch with a tank larger than a handheld disposable tank, the tank must be lashed to a secure

Torch-Firing Tools
These are the basic supplies you will need whenever you torch fire a piece.

- Trivet(s)
- Firing rack
- Soldering tripod
- Torch
- Insulated-grip tweezers
- Fire-safe surface
- Annealing pan filled with pumice
- Dust mask
- Safety glasses

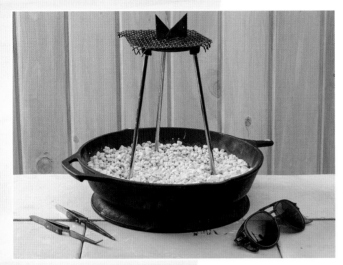

Tabletop setup for torch firing.

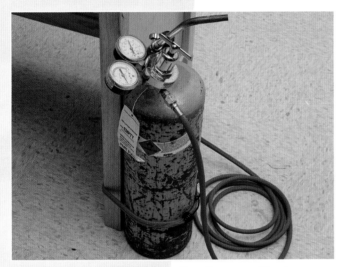

Make sure your tank is securely lashed to the wall or your workbench.

wall or a heavy table leg, or be in a holder that cannot tip over. I have my acetylene "B" tanks for my Handi-Heat torch lashed to a wall. I have made a loop of ¾-inch (2-cm) steel hardware chain around the tank. There is a heavy-gauge screw hook in the wall screwed to a stud. The chain hooks onto that hook so that if bumped, the tank cannot tip over. It is critical that the neck on the tank not get damaged. That could cause leakage or propulsion of the tank as the gas under pressure is released.

When setting up a torch system, once it is lashed to the wall, the hose line and gauge attachment need to be checked for leaks. Once the system is completely attached and set up, the tank should be opened enough to make the gauges register pressure and the hand-piece control should be shut. One joint at a time, brush on a thick, sudsy solution of several drops of detergent and a couple of drops of water. Watch for bubbles to appear. *If they don't,* wipe the joint dry with a paper towel and move on to the next joint and test it, and so on until all joints have been tested for leaks. If bubbles do appear, tighten that joint and test again. Do not move on to test the next joint until you have secured the leaking joint completely. Then continue on to test the rest of the joints.

If you're not familiar with how to set up a torch system, it's advisable to seek sound professional advice. A local welding supplier, reputable jeweler's supplier, or gas supplier may be able to help you. If in doubt, try to contact the company that made your torch and ask for instructions.

If your torch system has a pressure indicator gauge, you need to set the pressure appropriately to get work done safely and efficiently. Different torch systems have different recommendations for pressure settings. If you do not know what pressure to set your torch at, you need to seek professional advice from the manufacturer, dealer, or a welding-supply company. I set the pressure for my Smith Handi-Heat torch between 7 and 12 pounds (3–5.5 kg). This seems to work just fine.

If you do not have a system with a pressure gauge, you can usually have a visual and audio reading of the correct flame size. It is helpful to have a clearly defined dense blue cone immediately coming

out of the tip. Beyond that, there should be a thinner light blue to pale yellowish blue surrounding the flame. At any time you should be able to adjust the flame down to a soft and inaudible blue cone (*reducing flame)* and up to a larger, louder, and somewhat hissing blue cone (*oxidixing flame)* without changing the pressure. In other words, at the correct pressure you will have a full range of reducing flame to an oxidizing flame. For enameling, you will use an oxidizing flame.

Any torch may have pressure fluctuations, depending on the temperature of the room it is in. A torch left outdoors in the winter will have somewhat reduced pressure. A torch in a hot room or left outdoors in the sun will have increased pressure. If the torch tank is below 50°F (10°C) or over 90°F (32°C), it should be allowed to come to a more moderate temperature before use.

Torch-Firing Step by Step

Here is the basic process for torch firing enamels.

1. Set an annealing pan on a fire-safe table or shelf.

2. Place a 9-inch (23 cm) soldering tripod in an annealing pan filled with pumice or carborundum chips.

3. Over the opening on top of the tripod, set a heavy-gauge nichrome steel firing rack.

4. Place the piece to be fired level in a three-point trivet.

5. Place the trivet centered on the firing rack on the tripod.

6. If using a Smith Handi-Heat (silversmithing) torch, a #2 or #3 tip should be used.

7. Light the torch and adjust to an oxidizing flame, which means it will have a hissing noise (appropriate flame and tip size depend somewhat on the size of the piece).

8. Point the flame up and slowly come in under the screen to make sure the enamel is dried.

9. If enamel pops off, the piece is not dry. In this case, hold the flame underneath, but 4 to 5 inches (10–12.5 cm) away from the screen to dry the enamel. This usually takes less than 30 seconds.

10. The tip of the dense blue cone of flame should be ½ to 1 inch (1.3–2.5 cm) away from the bottom of the trivet.

11. Hold the flame there steadily and watch for the three stages of firing: sugar, orange peel, and fire polish.

12. As soon as the piece is glazed over and fire polished, remove the flame and turn off the torch.

13. Rest the hand piece on a fire-safe surface, as the tip will be very hot.

14. Using insulated-grip tweezers and grasping it at the base, *carefully* pick up the trivet and set it down on the fire-safe surface.

15. The fired piece on the trivet must be allowed to air cool.

16. If you place your hand a couple of inches over the fired piece and feel any radiant heat, do not touch it. The piece and the trivet will be very hot.

17. When the piece is cooled, remove it from the trivet.

18. Visually check the edges (*do not* run your fingers along the edge at this point) for any small shards that may have been created by slight fusion of glass to the trivet.

19. If there are any little sharp edges, grind them off under a trickle of water or in a bowl of water with an abrasive stone or a diamond file.

KILN-FIRED ENAMELS

The primary difference between torch firing and kiln firing is control and cleanliness. More sophisticated kilns with thermocouples, pyrometers, and computer readouts can give you fairly exacting temperatures, controlled times, and a clean, uncontaminated environment in which to fire. If you are making very time-consuming, complicated work, it may be worth your while to invest in a more expensive, totally enclosed kiln with advanced features. Another advantage to an enclosed kiln is that the heat is more even throughout the firing chamber. If firing

haze around
blue cone

thinner
blue/yellow
bushy flame

blue cone

maximum
heat zone

torch tip

A silent reducing flame will have a softer edge on the blue cone; a hissing oxidizing flame will have a crisp edge on the blue cone.

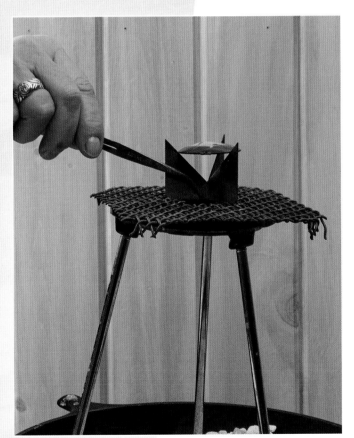

To move a piece that has been fired, pick up the trivet at the base, using a pair of insulated-grip tweezers.

dimensional pieces, such as bowls, vases, or hollow forms, there will be greatly reduced chances of uneven firing due to hot and cold spots.

Kiln-Firing Setup

There are many, many types of kilns. The smaller "kettle"-type kilns, such as a Trinket kiln, will be a different experience than using a totally enclosed cabinet kiln with a pyrometer, thermocouple, and computer. Then there are kilns somewhere in between.

Trinket-type kilns are small and more affordable than a totally enclosed kiln with a fire-brick or cast ceramic-fiber interior. These kettle-type kilns are not efficient at firing large, thick, or dimensional pieces. There is very limited space in them. They also tend to lose a lot of heat during the process, as they have an opening for you to view the work while it is firing. These kilns do not have any temperature control, so you fire until you see that the work is fire polished. Visual indication is all you have. Most of these kilns have a maximum temperature of about 1,600°F (870°C). This is hot enough to fire medium-temperature/medium-fusing enamels as long as you are careful not to leave the lid off for more than a few seconds while placing pieces in and out of the kiln. For firing small jewelry-sized pieces economically, a Trinket kiln is easy to use and affordable.

Trinket kilns run on regular household current (120V). They need to be set up on a fireproof surface and have surroundings much like you would have for a torch-firing setup. The lid of the kiln becomes extremely hot. You need to take precautions for picking up and setting down the lid safely.

Firing in a Trinket-type kiln may take longer in general than firing in an enclosed-chamber kiln. The kettle kilns have hot and cold spots due to the fact that they are not totally enclosed. This can be problematic if the piece is slightly too large for the firing surface. Frequently, if firing is quite slow, especially on copper, the metal develops oxides that reject the enamel before the enamel has a chance to fuse to the metal surface. For instance, if your firing surface (the ceramic base with heating coils) is 3 inches (7.5 cm) in diameter, you would not want to fire a piece more than 2 inches (5 cm) in diameter. There also always needs to be space between the interior of the lid and the piece being fired.

This is the best way to get the heat circulating as completely and evenly as possible.

There are two main differences in the construction of enclosed-chamber kilns. There are kilns with a fire-brick interior and ones with a ceramic fiber interior. Each has its advantages and disadvantages.

The fire brick interiors are heavier overall. This impacts shipping costs and venues for shipping. Because of the density of the fire brick, these kilns take longer to heat up. However, once up to temperature, they hold heat extremely well. They also take longer for the chamber to cool after it is turned off. The heating elements in fire- brick kilns are set into channels that are routed out of the bricks. Depending on the style of the kiln, the elements may be on three sides or in the top of the kiln. These elements are flush with the fire brick, yet are exposed to the inner chamber. You must be careful not to let a firing fork make contact with an element, as this may be a dangerous risk of electrocution. It is very easy to avoid this hazard.

A kiln lined with fire brick requires maintenance. To avoid damaging the bricks by spilling enamel or other materials that may fuse to it, you need to coat the brick with a material called kiln wash. This powder is mixed with water and painted onto the bottom interior bricks as a protective coating. After the bricks become dirty the kiln wash may be scraped off and then repainted with fresh kiln wash. How often the kiln wash needs to be refreshed depends on how much the kiln is used and whether or not there have been any significant spills. This is all done when the kiln is *off* and

cool. The interior sides of the kiln do not need kiln wash, just the bottom.

The fire-brick kilns, as well as most other enclosed-chamber kilns, have different types of controls. Some have merely on/off. Others have high/medium/low, a meter-type gauge with a needle readout, or a more complex computer with one or more programs. As long as the kiln has a maximum temperature of at least 1,600°F (870°C), you can enamel on copper, silver, or gold. If the kiln has high/medium/low settings, it's best to do a test run at the three different settings to find a baseline guide. The setting is suitable when a 1-inch (2.5 cm) piece of 18-gauge prepared with a layer of enamel is fire polished after 2 minutes.

The kiln I use most frequently is a Paragon SC3 with a form-fitted, ceramic-fiber interior and a programmable digital computer. This is a very popular, lightweight, low-maintenance kiln. It ships easily due to its weight and is easy to transport if needed. I often travel with the kiln to teach at a studio other than my own. Ceramic-fiber muffle kilns also warm nearly twice as fast as fire-brick kilns. Likewise, they cool off faster. The heating elements are in the fiber "muffle" and not exposed to the interior of the kiln. This prevents the user from touching the firing fork or any firing racks to a live element. The downside is that if an element breaks or the fiber becomes damaged, the entire internal muffle must be replaced. In most fire-brick kilns, the elements may be replaced individually and relatively easily.

The programmable computer with digital readout is very convenient. This feature is not exclusive to ceramic-fiber kilns. Several companies make fire-brick kilns with similar computers. The computers

Kiln-Firing Tools
You'll need to have these items on hand when kiln firing.

- Kiln
- Trivet(s)
- Firing rack
- Fork
- Insulated-grip tweezers
- Timer
- Dust mask
- Safety glasses

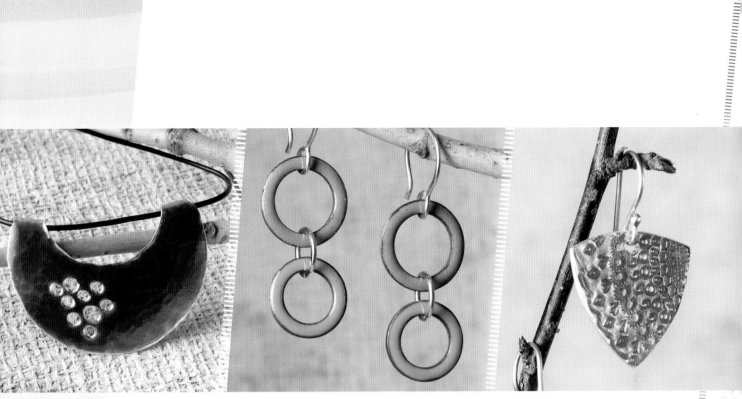

All of these projects can be fired in a kiln or with a torch.

are in the base of the kiln, under the firing chamber or in a unit attached to the side of the kiln on the exterior. These kilns are very well insulated to protect the computers and the surfaces surrounding them.

It's always a good idea to leave plenty of air space around the body of the kiln. This is a safety precaution to prevent fire hazards. All combustible materials should be a good distance from the kiln, at all times. Paper towels, fabric, plastics, or any flammables should be kept out of the immediate area of the kiln. The surface the kiln sits on should be fireproof.

I have placed a kiln blanket and a Marinite board on the inside bottom of my ceramic-fiber muffle kiln. This prolongs the life of the bottom of the muffle by preventing any glass dust or other materials from fusing or sinking into the muffle. Unlike the fire brick covered with kiln wash, which may be scraped clean periodically, glass will sink into the ceramic fiber at high temperatures. This *cannot* be scraped off, as that will ruin the muffle.

There are a few more tools you will need to use with an enclosed-chamber kiln. A kiln fork is necessary to place pieces into the kiln and remove fired pieces safely. The firing racks you use in the kiln need to have two sides or the corners bent in order to raise the rack enough for the fork to fit comfortably underneath it, without jarring it. You'll need a timer with minutes and seconds

to alert you when a piece is fired so as to avoid overfiring and ruining pieces.

Temperatures may vary from kiln to kiln by about 100°F (38°C). This is normal and does not mean the kiln is defective. Each and every kiln needs to be tested for the temperature and duration of time to reach the fire-polish stage. For example, set your kiln to 1,450°F (788°C), put a piece with enamel on it ready to fire in the kiln, and set a timer for 2 minutes. If the piece comes out fire polished, that's the setting and time you need. If it is orange peel, try to raise the temperature to 1,500°F (815°C) for 2 minutes. If that doesn't fire polish the piece, try to either raise the temperature or lengthen the time by 15 seconds. If a piece comes out overfired, try reducing the time, 15 seconds at a time, and/or lower the temperature.

When testing a kiln for proper firing temperature, it is easier to adjust the time by 15-second intervals than to raise and lower the temperature. Once a kiln has warmed up it will take longer for it to lower in temperature. Reducing the time is much faster. All pieces for a test should be similar in size to provide an accurate baseline.

Opening and closing kiln doors in an efficient manner takes some practice. First, as mentioned earlier, all kilns for enameling should be front- *not top-* loading kilns. Items going into the kiln should be balanced and level on a kiln fork for loading

and unloading. Have the loaded kiln fork as close to the door of the kiln as possible for loading. Make a smooth motion of opening the door, sliding the rack in, and gently releasing it onto the floor of the kiln. As you remove the fork, start closing the door. It is possible to lose hundreds of degrees by holding the door open too long. Be careful, but be as smooth and quick as you can.

As with any hard-fired enameling process, once the piece is fired it must be set on a fireproof surface and allowed to cool naturally. If you place your hand a few inches above the piece and feel *any* radiant heat, **do not** touch it.

If the piece does not lift off of the trivet easily once cooled, you may need to flex the legs of the trivet slightly to pop the piece off. If it has adhered at all to the trivet, do not run your fingers around the edges as there may be small shards of glass where it bonded to the trivet. These are very sharp, like little razors. Take the piece to a bowl of water or a sink with a trickle of water running and grind the edges with an alundum stone or a diamond file in the water.

Kiln-Firing Step by Step

Follow these basic steps when kiln firing enamels.

1. Set the kiln to the appropriate setting and let it warm up.

Trinket = element is bright orange red

Enclosed chamber = set to tested setting for fire polish (about 2 minutes)

Enclosed with meter gauge = turn dial to desired temperature, watch gauge register

Computerized programmable = set at 1,450°F (788°C), watch readout

2. Prepare the piece to be fired and allow it to dry on a trivet on a firing rack on top of the kiln.

3. Preset the timer to 2 minutes.

4. Carefully place the kiln fork under the firing rack and lift the rack with the trivet and dry piece. Keep the fork and rack *level* so as not to drop anything.

5. Place one hand on the kiln door handle, while the loaded fork is in place by the opening of the door.

6. Bring the fork into the kiln and center it carefully on the floor of the kiln as you pull the fork out from underneath.

7. Slide the fork out of the kiln and close the door.

8. Press "start" on the timer.

9. When the timer goes off, bring the fork to the door opening.

10. Slide the fork in under the rack and with a balanced, level movement, pick up the rack and remove it from the kiln; close the kiln door (turn off timer).

11. Set the hot rack down on a fire-safe surface.

12. Allow the piece on the trivet on the rack to cool naturally.

13. After a few minutes, hold your hand 2 to 3 inches (5–7.5 cm) above the cooling piece. If there is any radiant heat, **do not** touch.

14. When the piece is cool, remove it from the trivet and *visually* check for sharp edges.

15. If there are sharp edges, grind it in a bowl of water or under a dripping faucet with an alundum stone or a diamond file.

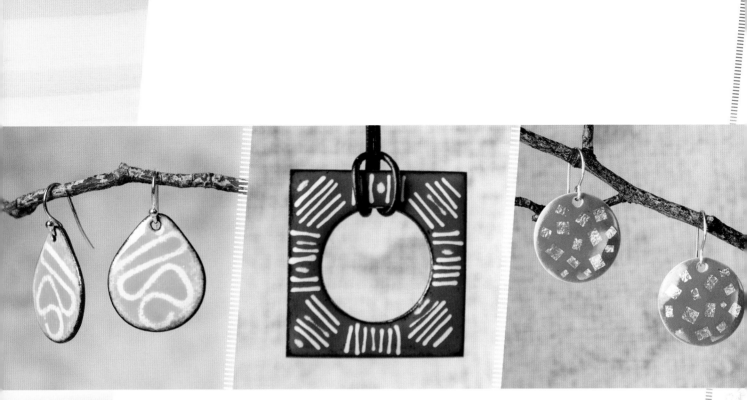

There are many techniques you can use when dry sifting enamels.
From left to right: stenciling, glass threads, and foil.

Enameling Techniques

There are myriad enameling techniques. I will be covering some of the most commonly used and all the basics for how to do them. The projects that are created in the book utilize these techniques in a variety of ways and designs.

The projects themselves reiterate the processes explained in this part, plus the specifics needed for each individual piece. Refer back to this section while working on the projects to help clarify any instructions that aren't clear or for confirmation.

DRY SIFTING ENAMELS

Dry sifting is the technique of applying glass enamel powders in their dry form to the surface of metal (copper, silver, gold). Here is the basic process:

1. Start with clean metal. Scrub with Scotch-Brite, sandpaper, or a baking-soda slurry. Try to remove all dirt, grease, and dust from the surface.

2. If using copper and firing in a kiln, the side not getting enameled in the first firing should be painted with Scalex (ball clay) and allowed to dry.

3. Set the piece onto a bottle cap to lift it up and make it easier to move later.

4. Paint or spray binder (Klyr-Fire) onto the bare metal side. This should be a thin, even layer or a fine, even mist.

Enamel-Sifting Tools

Have these supplies on hand when dry sifting enamels.

- Paper plate or layered magazine pages over a manilla folder
- Sifters
- Bottle caps
- Apron
- Dust mask
- Paper towels or linen dishcloth
- Safety glasses

5. Fill a sifter halfway with enamel powder. Do not overfill the sifter, or it will spill out over the top edge and create clumps.

6. Tap the handle of the sifter gently to sift the enamel onto the wet binder in slightly overlapping rows. Coverage should be such that you cannot see the metal reflecting back through the powder.

7. Move the piece from the bottle cap to a trivet. If it is difficult to move without disturbing the enamel, place a small metal ruler next to the bottle cap and slide the piece over onto the ruler using the tips of fine tweezers or your fingers against the edge of the piece **(figures 1 and 2)**.

8. Allow the binder and enamel to dry.

9. Fire the piece to fire polish.

10. Air cool the piece.

Counter Enamel

To balance the expansion and contraction of glass enamel fired onto metal, it is recommended in most cases to have enamel on both sides of a piece of metal. This is called **counter enamel.** Counter enamel creates balance between the metal and the enamel, which helps prevent cracking. (Two other options to help prevent cracking from expansion and contraction are to use very thick metal (16-gauge or thicker) or to give the piece of metal a form, such as deep dapping. This forming still needs to be done with relatively thick metal, as thin metal (22-gauge or less), formed or not, may flex too much.)

Most typically, the metal to be enameled should be about 18-gauge. This thickness provides a great deal of strength and integrity to enameled work. Small metal pieces (less than ¾ inch [2 cm] diameter) can be enameled successfully on a thinner gauge, such as 20- or 22-gauge, if counter enamel is fired onto the back, followed by the decorative enamel on the facing or front side. Even if a piece is going to be bezel set, it still needs to be counter enameled.

Counter enamel may be one color straight out of the jar or the collected droppings saved and contained after sifting dry enamel. This will give a multicolored layer for the counter. I use both types depending on whether the back will show and how I want it to look.

Counter enamel is applied in the same manner as any dry-sifted layer of enamel and is usually applied and fired before the decorative side is fired. Both sides of any piece may have decoration. Typically, the counter side is plain and the reverse has decoration, as most pieces will only show one side at a time.

If torch firing, the counter enamel may become damaged by direct contact with the intense flame.

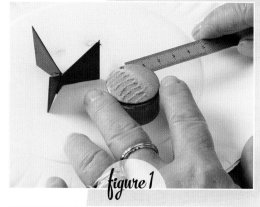

figure 1

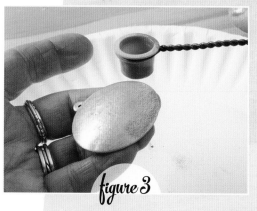

figure 2

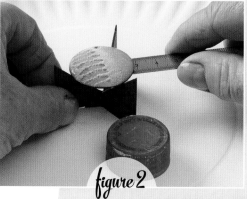

figure 3

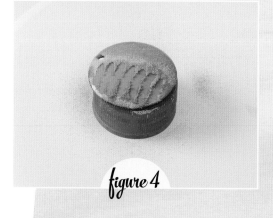

figure 4

When applying counter enamel it helps to have an idea of how many layers of enamel will be used on the decorative side and approximate that thickness on the counter side. This is even more helpful in preventing cracking from expansion, contraction, and flexing during cooling. Flat pieces will always have more of a tendency to flex than dapped pieces, especially on larger pieces (larger than 1 inch [2.5 cm]).

Base Coats

A base coat is a solid layer of one or more colors that provides a foundation for some decorative techniques. Techniques such as blocking or stenciling and foil all need a fired base coat before the decorative layer of enamel is applied.

To apply a base coat, follow the directions for applying a dry-sifted layer of enamel and fire that layer to fire polish. Make sure there is enough enamel to cover the front side thoroughly.

NOTE: When applying a sifted layer over the binder on a curved surface, you may need to hold the piece of metal on your fingertips and rotate it slightly as you sift in order to get coverage on the edges. The sifter should always be at a 90-degree angle to the surface you are sifting onto *(figure 3)*.

Stenciling

Stenciling, or blocking out, is one of my favorite dry-sifting techniques, because it provides endless color and design possibilities. It involves using a piece of paper, metal, leaf, or other object to create a design on top of a base coat of enamel. There are many different options for materials that can be used to either block out or stencil, including manila folders, Mylar, leaves, wire, paper, and metal. The technique varies slightly depending on which materials you use. (See the Stenciled Earrings project on page 42 for instructions on using wire as a stencil.) It's also possible to do complex multiple blocking out and stenciling on one piece.

RIGID PAPER OR SHEET METAL

Manila folder can be cut with an X-Acto blade, punched with paper punches, or cut with decorative scissors to create a stencil pattern. Sheet metal with symmetrical stamped-out designs is available at hardware stores. Any copper, brass, or other jewelry-making metal can be pierced with a jeweler's saw to make designs.

For the piece on the left, I used a coiled piece of wire to block out a spiral design. The piece on the right was done with plastic and pierced-metal stencils.

Manila folder or sheet metal shapes will not conform easily to a curved surface. You can use them with a slightly curved surface if you hold the stencil above the surface while sifting, but the edges will be blurred.

1. Prepare the piece of metal you're stenciling or blocking out with counter enamel on the back and a layer of fired base-coat enamel on the front.

2. Apply a light spray of binder to the rigid stencil to keep the sifted enamel from falling off and ruining the definition of the pattern you have created.

3. Spray the piece to be enameled with binder.

4. Load the sifter with the desired color. It's best to have a color that will show distinctly against the base coat. Subtle color changes don't always register clearly when stenciling.

5. Hold the stencil close to the piece of metal. Try to keep the hand holding the stencil very still. Gently sift the dry enamel onto the base coat over the patterned material. Apply a thorough layer of enamel sifted over the pattern *(figure 4)*, but don't build too thick of a layer. If the stenciled layer is too thick, it may blur the definition of the design when fired.

6. After the binder has dried, fire the piece as usual.

THIN PAPER, MYLAR, OR ORGANIC MATERIAL

Regular copier-weight paper cut into shapes can also be used for stenciling. Mylar is a thin plastic film that also makes excellent stencils. It can be cut with scissors or sharp knife blades. Since it is plastic it may be washed and used over and over. It is pliable, so it will conform to curved surfaces, unlike manila or sheet-metal stencils. Delicate organic material such as fern leaves work well as stencils. Dried leaves need to be slightly rehydrated. I usually dip them into water before using. Rehydration makes the leaf pliable, so it will conform to the surface of the piece. You can also use a fresh leaf, which won't need to be rehydrated. Here is how to use a leaf as a stencil.

1. Prepare the piece to be stenciled with counter enamel on the back and a base coat on the front.

2. Spray a thin layer of binder onto the base coat of the piece. Place the damp, not dripping wet, leaf onto the base coat. If there is too much moisture on the surface, the stencil will blur.

3. Load a small sifter halfway with the desired enamel color. Sift lightly over the leaf and edges. Don't be too heavy-handed with the enamel, or it may cause blurring of the desired edge pattern.

4. Carefully pick the leaf up off the piece with a pair of very fine-tipped tweezers. It is easy to do this if you have left a small tip or stem of the leaf overhanging the piece. If it is a large piece and a large leaf, you may want to pick it up on each end and lift or peel it off.

5. After the binder has dried, fire the piece as usual.

Leaves may be rinsed in a glass of water, then placed between two paper towels with a weight over them to dry flat and use again (**figure 5**).

If using a design of thin-weight paper or Mylar, use this same procedure, but do not presoak the paper.

Beads, Sticks, and Lumps

Beads, sticks, and lumps are three forms of glass that can be used to create designs and decorations on enameled pieces.

BEADS

Traditional glass seed or bugle beads can be used with enameling. They **must** be glass. Many seed beads are actually plastic and they will not work. Be careful not to use glass beads with foil centers. The centers turn into black spots when fired. It does not matter whether you place the beads with the hole up or on its side.

It's a good idea to do a test of the beads you plan on using before you fire them onto a piece. Glass beads fire at different rates. I have found that black beads are especially slow to melt.

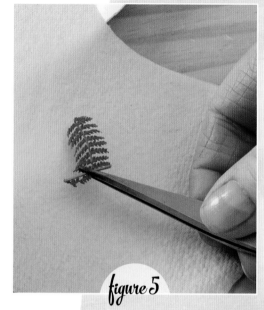

figure 5

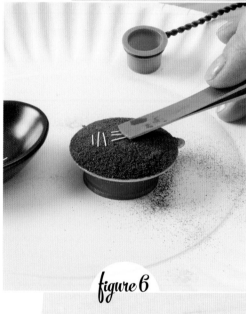

figure 6

Be careful if firing large glass beads with tiny seed beads, as the seed beads may melt into puddles before the larger beads slump.

STICKS

Sticks, or threads, of glass can also be used as a decorative element in enameling. They are glass that is melted and then pulled into long threads and broken up into pieces about ½ inch (1.3 cm) long. Sticks come in a variety of opaque and transparent colors. Most mixes of sticks are primarily opaques.

LUMPS

Lumps are pieces of glass that are melted and crushed into large, crudely shaped shards (⅛ to ½ inch [3–13 mm]). These come in transparent and opaque. When melted, the surface tension makes them conform to a mostly round shape. Sometimes they will fire so round that they look like a cabochon stone.

APPLYING BEADS, STICKS, OR LUMPS

When using any of these items, you must have a healthy layer of counter enamel fired on the back. The front should be clean and ready for sifting. If firing small beads or threads with larger lumps, the smaller pieces will melt and "bleed" onto the surface before the larger lumps melt.

1. Spray binder onto the front side of the metal piece.

2. Fill the sifter with the desired color of enamel. Sift a thorough layer of enamel onto the piece. This layer of enamel is what keeps the sticks, beads, or lumps in place while moving them to a trivet or in and out of a kiln.

3. Pick up the sticks, beads, and lumps with fine-tipped tweezers and place them gently onto the dry enamel on the piece. Then use the flat end of the tweezers to gently tap the beads, sticks, or lumps securely into the enamel *(figure 6)*.

Foil

Foils are actual precious metals (pure gold, silver, or copper) formed into a thin sheet about 0.03 mm thick. This foil is so thin that it is difficult to pick up with your hands. It should be handled only with fine-tipped tweezers, to keep it clean and neat.

Foils are used to brighten or "pop" colors or specific areas on an enameled surface. They only work when used beneath transparent colors. Opaque colors will obliterate them and make them disappear. They can also be used to cover an undesirable color in order to rework a piece. The fired foil will be a fine silver surface that can be enameled as usual.

Because foils are so very thin and delicate, it is best to cut them with very sharp scissors while they are in between thin tissue paper. This makes them easier to control.

Foils are always fired by themselves over a fired base coat. After the foils are fired and cooled, a transparent enamel may be sifted or wet packed and fired over them to protect and preserve them. Foil fired and left alone as a top surface will not be durable.

Over the years, I have learned three different ways to apply foil. I will cover the method I use most often.

1. Cut the foil into the desired shapes for your design. Place in a dry shallow container. This will make it easier to pick up the foil when ready to place it on the enamel.

2. Place the foil one piece at a time on a piece in the arrangement you would like.

3. Use an eyedropper to gently place a small drop of water next to one edge of the foil. As the water is pulled under the foil it will suck the foil down onto the enamel base coat. Proceed in this manner until all of the foil pieces are where they should be on the piece. Allow the water to dry. You may also use a 50/50 mix of binder and water with the eyedropper.

4. Once dry, fire as you would any layer of enamel. The melted enamel bonds to the foil. When the foil is fired it will look extremely smooth. Allow to cool completely.

5. If desired, apply a layer of transparent enamel over the foil and fire this layer as usual. After the foil has been enameled over and fired, it will no longer be as smooth as it was when fired by itself. This is normal. The grains of enamel pull and push the foil as they melt over it.

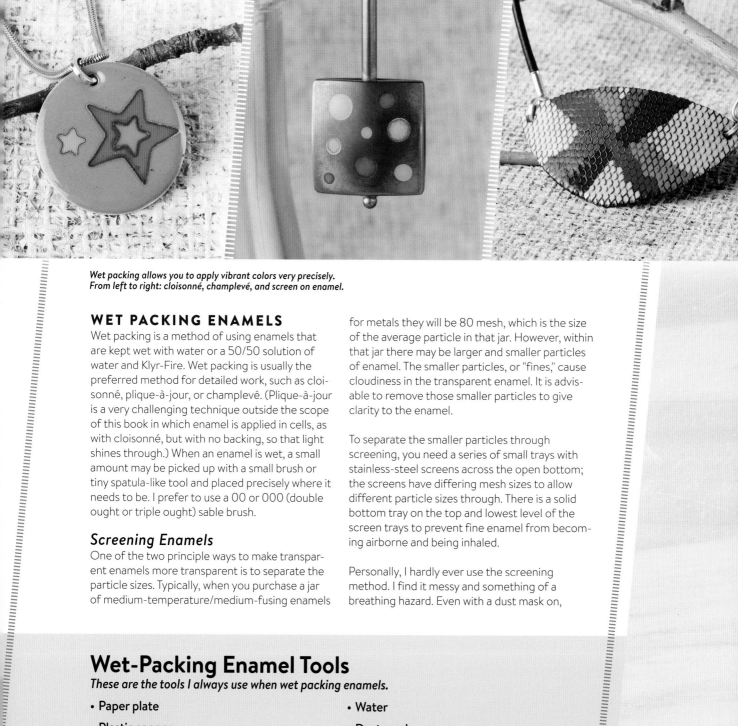

Wet packing allows you to apply vibrant colors very precisely. From left to right: cloisonné, champlevé, and screen on enamel.

WET PACKING ENAMELS

Wet packing is a method of using enamels that are kept wet with water or a 50/50 solution of water and Klyr-Fire. Wet packing is usually the preferred method for detailed work, such as cloisonné, plique-à-jour, or champlevé. (Plique-à-jour is a very challenging technique outside the scope of this book in which enamel is applied in cells, as with cloisonné, but with no backing, so that light shines through.) When an enamel is wet, a small amount may be picked up with a small brush or tiny spatula-like tool and placed precisely where it needs to be. I prefer to use a 00 or 000 (double ought or triple ought) sable brush.

Screening Enamels

One of the two principle ways to make transparent enamels more transparent is to separate the particle sizes. Typically, when you purchase a jar of medium-temperature/medium-fusing enamels for metals they will be 80 mesh, which is the size of the average particle in that jar. However, within that jar there may be larger and smaller particles of enamel. The smaller particles, or "fines," cause cloudiness in the transparent enamel. It is advisable to remove those smaller particles to give clarity to the enamel.

To separate the smaller particles through screening, you need a series of small trays with stainless-steel screens across the open bottom; the screens have differing mesh sizes to allow different particle sizes through. There is a solid bottom tray on the top and lowest level of the screen trays to prevent fine enamel from becoming airborne and being inhaled.

Personally, I hardly ever use the screening method. I find it messy and something of a breathing hazard. Even with a dust mask on,

Wet-Packing Enamel Tools

These are the tools I always use when wet packing enamels.

- Paper plate
- Plastic spoons
- Small spatula
- 00 or 000 sable paintbrush
- Water
- Dust mask
- Paper towels or linen dishcloth

I don't feel it is the healthy way to go. Still, I will go over the process briefly if you would like to try it.

1. Have on hand three or four different mesh size screening trays. I suggest 80, 150, and 325. Also have two solid trays, one for the topmost and one for the last (bottom) tray. Place the 80 on the top, then slip the edge of the 150 over the bottom of the 80, then the 325 below the 150. Each tray should be snug on the bottom of the previous tray to prevent leakage. Secure one of the solid trays under the 325 tray.

2. Wearing a dust mask, deposit the contents of a jar of enamel onto the 80-mesh tray. Place the other solid tray on top of that tray.

3. Gently shake the stack of trays back and forth sideways *(figure 7)*. As you do this, the larger particles will stay in the top tray. Medium particles will stay in the middle tray. The finest particles will stay in the last tray. Particles like dust will remain in the solid tray.

4. The particles for wet packing are in the top tray. Place them in a jar with a good seal and a lid that won't rust and label for size.

5. Add enough distilled water to the jar to saturate the enamel and leave a covering of about ⅛ inch (3 mm) of water over the enamel. At this point, the enamel is ready to be used for wet packing.

6. The finer particles can either be placed in a jar to be used as counter enamel or the very finest can be saved and used for painting.

7. Be sure to clean the screen trays thoroughly with a dry cloth or pressurized air before screening the next enamel.

Washing Enamels

Washing is my preferred way of removing the fines from transparent enamels as it's less messy than the screening method. You will need small jars (½ to 1 ounce [15–30 ml]) with tight, nonrusting lids and a good seal. Plastic or glass work well. Wet enamels may go "bad" if exposed to air or heat. If you keep only a small amount of wet at a time, you have less risk of ruining a large batch.

1. Start by writing the number of the enamel to be washed on the lid and side of the jar. This will help prevent cross-contaminating colors.

2. Fill the jar halfway full with the desired dry transparent enamel *(figure 8)*.

3. Place a coffee filter over the drain of a sink or glass container.

4. Have a drizzle of water running. Fill the jar almost full with tap water. Distilled water may also be used, especially if you have very hard water.

figure 7

figure 8

5. Cap the jar and shake it gently *(figure 9)*. The water will become cloudy. This is because the fines of enamel have become suspended in the water. Remove the cap and pour the cloudy water into the coffee filter *(figure 10)*. This process will reduce the amount of enamel in the jar by nearly half. The enamel in the coffee filter can be dried and saved to add to your counter enamel.

6. Continue adding water, shaking and pouring off until the water after shaking becomes clear. The larger heavier grains sink and stay in the bottom of the jar.

7. Top off the washed enamel with about ⅛ inch (3 mm) of distilled water. Close the lid on the jar tightly until ready to use.

8. Place the coffee filter over a cup or glass, and it should be dry in 12 to 24 hours. Add the dry enamel to your counter-enamel jar.

Washed enamels have a shelf life of a couple of weeks to months or more. The more you open the jar, the faster they will deteriorate. They have gone bad when white spots appear on the top surface. This means they are oxidizing and the enamels are breaking down.

There is no need to wash opaque enamels. The fines make enamels more opaque, so they do not affect their quality and do not need to be removed.

If using opaques for wet packing, simply place some of the enamel in a jar and add distilled water until saturated and just barely covering the enamel.

Wet-Packing Techniques

There are many enameling techniques that require wet packing rather than sifting. These techniques are usually more delicate and somewhat more tedious than the dry-sifting techniques, but they lend very rich and detailed effects and tend to have a more painterly quality to them.

Although there are many techniques and styles that might use wet packing, I will only be covering those that relate to the projects in this book. Those are screen on enamel, cloisonné, and pierced sweat-soldered champlevé.

SCREEN ON ENAMEL

Fine silver screen or copper screen may be used with enamels to help lay down a grid for designing. Many different effects can be derived from this technique. If using fine silver screen, the process is much cleaner, as the fine silver does not create oxides during the process. Copper screen is much more readily available, but needs to have the oxides removed and cleaned off after every firing.

1. Start with clean metal for the base. There should be fired counter enamel on the back.

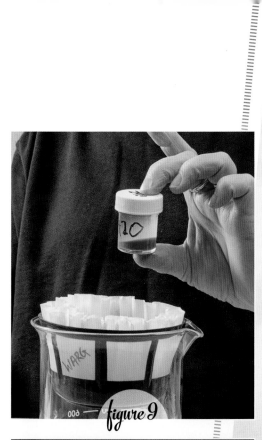

figure 9

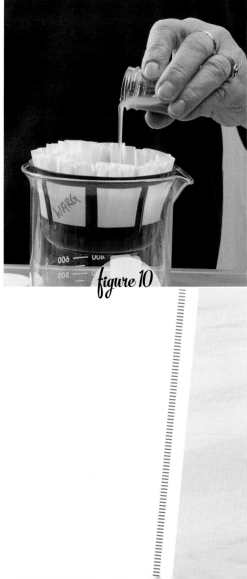

figure 10

This is my setup for shaping wire for cloisonné.

insulated handle. Tap the screen onto the enamel as the base coat remelts. Allow to cool.

8. Wet pack enamel into the grid of the screen, creating whatever design you desire.

9. Fire the piece again. Repeat the wet packing and firing until the screen and enamel are level.

10. Trim off any excess screen with shears, then grind the edges smooth with an alundum stone under water.

11. Under a trickle of water, or in a bowl of water, grind the surface of the piece with an alundum stone until it is smooth and even. Continue to grind with either a fine-grit (800) diamond file or wet/dry sandpaper.

12. Refire the piece until the enamel gets a fire polish.

CLOISONNÉ

Cloisonné is a method of creating cells from thin strips of fine silver, copper, or fine gold, applying them to the surface of metal, then wet packing enamel into them and firing. The process can develop detailed and beautiful or simple and dramatic designs. It's helpful for anyone attempting cloisonné to have experience using jeweler's pliers. The wire is very delicate and can be frustrating to form if you're not familiar with using pliers.

I recommend practicing making shapes with thin flat wire before sitting down to make a jewelry piece. A good way to do this is to draw the desired design on a sturdy piece of paper, such as a manila folder. The flat wire most typically used for cloisonné is 30-gauge by 1 mm. Anneal and pickle some of this wire. Hold the wire over the drawing and begin bending it, following the lines of the drawing. The wire is so fine and soft that it will conform easily if guided by the tips of the pliers. If you make a mistake, carefully straighten out the wire and start again.

The process of cloisonné may be tedious at times. There are usually a series of many firings to get pieces to the point of completion. When the piece is done, there may be considerable grinding to get the surface smooth and even before the final fire polish.

2. Sift a thin layer of base coat onto the top surface of the piece. Fire that base coat.

3. Anneal the screen to be used. This makes it more pliable, so it will conform the surface of the piece better. If using copper screen, it will need to be pickled before applying to the enamel.

4. Lay the screen down on the base coat of enamel. Sometimes it works better if the screen is larger than the piece, so it can be bent around the edges to hold it in place during the first firing.

5. Fire the piece again with the screen over the base coat. Kiln firing may be preferable. However, it may be torch fired also.

6. As soon as the piece comes out of the kiln, tap the screen down onto the tacky hot enamel with a long-handled spatula. Be very careful not to get burned. Gloves may be a good precaution. Allow to cool.

7. If torch firing, you will definitely want to wear gloves. Make sure the spatula tool used has a long

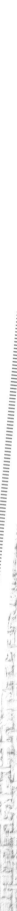

In the projects in this book, I will only be using fine silver cloisonné wire. If using copper cloisonné wire, it will need to be cleaned of oxides with Penny Brite in between each firing.

When I first learned how to do cloisonné, I was taught to solder all of the cloisonnés down with IT (extra hard) solder. This was a grueling process, as it required high heat with extremely delicate wire. Since then someone developed a much easier and practical way to attach the cloisonné wire to a piece.

1. Draw the desired design onto a manila folder or a large paper plate. That paper plate can then become your clean surface to work on.

2. Anneal a length of cloisonné wire. Pickle, rinse, and dry the wire.

3. Use fine-tipped jeweler's pliers to bend the wire a little at a time to echo the shapes of the lines in the drawing.

4. Sift counter enamel onto the back of the piece and fire it. Allow to cool.

5. Sift a thin layer of a base coat onto the front of the piece. I usually use Thompson #2020 clear for silver.

6. Hold the cloisonné wires one at a time with fine-tipped tweezers and dip very lightly into Blu-Stic. Too much Blu-Stic will take a very long time to dry.

7. Place the wire or wires one at a time onto the base coat of the piece where they need to be. Allow the Blu-Stic to dry.

8. Place the piece on a trivet on a firing rack and fire in a kiln. (I prefer to do cloisonné in a kiln because it is a more controlled and clean environment.) Allow to cool.

9. Choose your color palette. If using transparent colors, they will need to be washed and stored in well-marked and sealed jars.

10. Take a plastic spoon for each of the colors to be used and write the number of the color to be used on that spoon handle.

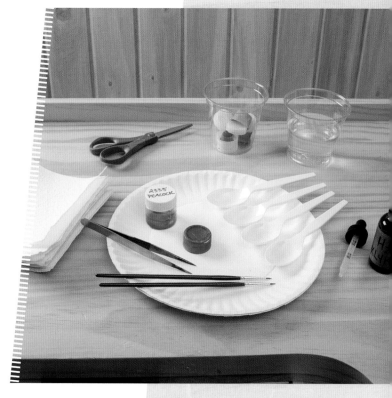

Cloisonné-enameling supplies organized and ready to use.

11. Place the spoons in a radial formation on the paper plate.

12. Use a small spatula or even a metal ruler or knife blade to scoop a little of the enamel out of its jar and place it in the proper spoon. Use an eyedropper to put a drop of water and one drop of Klyr-Fire over each color to keep them hydrated.

NOTE: If using opaque enamels, simply place a small amount of an enamel in a spoon with that enamel's number on it and add the water and Klyr-Fire to hydrate.

13. Near the paper-plate setup, place a pile of paper towels cut into quarters (about 4 by 4 inches [10 by 10 cm]), a cup or glass of clean water, a very fine (000 or 00) natural bristle paintbrush, and the eyedropper.

14. Set the piece to be enameled on top of a bottle cap, on the paper plate. This allows you to pick the piece up by its edges when it needs to be moved onto a trivet.

15. Use the brush with a slight rolling motion to pick up a small amount of one of the enamels out of the spoon. Carefully place the enamel into the proper cell or cloisonné. Water is what gives the granules of enamel mobility. If you want to keep the enamel exactly where you put it, use the edge of one of the paper towels and carefully touch the enamel and siphon the water out.

16. You can add a little enamel to each cell and then fire the piece. Or you can work on one area, fire, and then work on another. Just make sure not to put too much enamel into any cell at any one time. The enamels like to be built up slowly, not packed in thickly at once.

17. Continue to pack and fire until all the cells are nearly if not completely flush with the tops of the cloisonné wires.

18. Use an alundum stone under water to grind the top surface of the piece. After grinding, the surface will be matted from the stone. Any places appearing shiny are the low spots that need more enamel and firings. If the entire piece is matte, then continue grinding with a finer wet/dry sandpaper or diamond file. This leaves the tops of the wires closer to being polished.

19. Scrub the whole piece with a glass brush under water. This will remove any particles of alundum or diamond that might have remained in the enamel and will cause tiny black spots if fired into the piece.

20. Place the piece on a trivet on a rack and fire for 10 to 15 seconds less than previous firings. This will be the last firing and will give the piece a fire polish. And done!

Champlevé

This is one of my favorite enameling techniques. Being a jeweler and metalsmith, I like it because it involves more work with the metal. For those who do not have metalsmithing skills, it may not be a good choice for a first project.

Champlevé is French for "raised field." In this technique, there is one layer of sheet metal that will have a design pierced out of it with a jeweler's saw. That layer is then silver soldered onto a solid sheet metal back plate. The openings of the pierced design are then gradually filled with enamel. The lines of metal around the pierced openings are wider and more pronounced than the delicate lines created by cloisonné wires.

You can also simply use different-sized drill bits to drill holes, creating a dot pattern that can then be enameled.

This technique is best done with sterling silver, but it can be done with copper or gold. The sterling silver gives the piece more strength than fine silver does. This means that it's not necessary to counter enamel the piece.

Sterling silver is an alloy, and enamels don't tend to bond as well to alloyed metals. To prevent problems and still use the sterling silver, you must first depletion gild the piece before enameling. This is a process where the piece is brought to annealing temperature with a torch or in a kiln (1,000°F [540°C]), pickled, rinsed, and dried, repeatedly, for no fewer than four times. When done, the sterling will look very white. The depletion gilding creates a layer of fine silver on top of the sterling, which allows the enamels to adhere better and have less discoloration.

1. Draw a design on paper. Cut out the design along its perimeter. Use a glue stick to adhere it to a piece of 22-gauge sterling silver sheet. Allow to dry.

2. Saw out the perimeter shape of the design with a jeweler's saw (3/0 or 4/0 blade).

3. Center punch and drill a small hole in each of the negative spaces of the design.

4. One by one, feed a jeweler's saw blade into a jeweler's saw frame through the hole, retighten the saw blade in the frame, and on a jeweler's bench pin, saw out the negative spaces.

5. Use a needle file to smooth the edges on the inside of each of the cutouts.

6. Tap the piece of pierced sterling flat with a mallet over a steel block or hard flat surface.

7. Make sure the underside of the pierced sheet is clean of any bumps or burrs that may have occurred as a result of sawing. This can be done with sandpaper or an abrasive such as Scotch-Brite.

8. Take a piece of 18-gauge sterling silver sheet just slightly larger than the pierced 22-gauge sheet and flatten and clean it the same way.

9. At a jeweler's soldering bench, set the pierced piece of 22-gauge upside down on a soldering block.

10. Cut several dozen paillons of hard silver solder 1 × 1 mm.

11. Warm the pierced piece with a torch and brush on liquid flux. I prefer Prip's flux.

12. Place a drop of the flux on a nonabsorbent surface on the soldering bench. I have tile on my bench, and that works just fine.

13. Use very fine-tipped solder tweezers to pick up one of the pieces of solder, touch it to the drop of flux, and then place it on the pierced piece.

14. Continue to do this until the entire back of the pierced piece is covered with paillons each about ¹⁄₁₆ inch (2 mm) apart from each other. This is the preparation for sweat soldering the 22-gauge sheet to the 18-gauge sheet.

15. Place the 18-gauge sterling sheet on a soldering block. Warm and flux it.

16. Warm the pierced piece until the flux is no longer white and foamy.

17. With tweezers, turn the pierced piece over onto the 18-gauge sheet.

18. Using insulated-grip tweezers, carefully pick up the piece by one corner. Heat the underside of the 18-gauge sheet with a torch flame (the size will depend on the size of the piece), moving in a circular motion, until you start to see the solder flow *(figure 12)*. Then, without taking the flame off, set the piece down on a soldering block and heat from the top. If there are any gaps, press them down with a soldering pick while still heating in a circular motion.

19. Cool the piece, then pickle it. When clean, remove from the pickle and rinse and dry it.

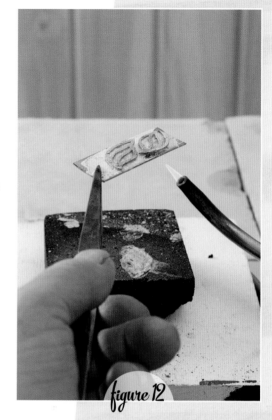

figure 12

20. Saw the 18-gauge back plate, now soldered to the 22-gauge sheet, along the edge of the 22-gauge sheet to match the perimeter of the 22-gauge shape.

21. File the perimeter of the piece until the two edges look like one.

22. If the piece is to be formed or dapped, now is the time to do that.

23. Depletion gild the piece at a soldering bench (see page 10). When depletion gilded, it is time to set up for enameling the voids that were sawed out.

24. Choose your palette of enamel colors. If using transparent enamels, you will need to wash them and keep them in well-marked and sealed jars.

25. I use plastic spoons to hold my enamels while I am working on a piece. Take as many plastic spoons as you have colors in your palette and write one of the color numbers on the handle of each spoon.

26. Place the spoons in a radial formation on the paper plate.

27. Use a small spatula or even a metal ruler or knife blade to scoop a little of the enamel out of its jar and place it in the proper spoon. Use an eyedropper to put a drop of water and one drop of Klyr-Fire over each color to keep them hydrated.

NOTE: If using opaque enamels, simply place a small amount of an enamel in a spoon with that enamel's number on it and add the water and Klyr-Fire to hydrate.

28. Near the paper-plate setup, place a pile of paper towels cut into quarters (about 4 by 4 inches), a cup or glass of clean water, a very fine (000 or 00) natural bristle paintbrush, and the eyedropper.

29. Set the piece to be enameled on top of a bottle cap on the paper plate. This allows you to pick the piece up by its edges when it needs to be moved onto a trivet.

30. Use the brush with a slight rolling motion to pick up a small amount of one of the enamels out of the spoon. Carefully place the enamel into the proper pierced void. Water is what gives the granules of enamel mobility. If you want to keep the enamel exactly where you put it, use the edge of one of the paper towels and carefully touch the enamel and siphon the water out.

31. You can add a little enamel to each void or recess and then fire the piece, or you can work on one area, fire, and then work on another. Just make sure not to put too much enamel into any void or recess at any one time. The enamels like to be built up slowly, not packed in thickly at once.

32. Continue to pack and fire until all the negative spaces are nearly if not completely flush with the tops of the pierced 22-gauge top.

33. Use an alundum stone under water to grind the top surface of the piece. After grinding, the surface will be matted from the stone. Any places appearing shiny are the low spots that need more enamel and firings. If the entire piece is matte, then continue grinding with a finer wet/dry sandpaper or diamond file. This leaves the tops of the piece closer to being polished.

34. Scrub the whole piece with a glass brush under water. This will remove any particles of alundum or diamond that might have remained in the enamel and will cause tiny black spots if fired into the piece.

35. Place the piece on a trivet on a rack and fire for 10 to 15 seconds less than previous firings. This will be the last firing and will give the piece a fire polish.

36. The top of the piece can now be buffed either on a polishing lathe or with a flexible-shaft machine. The buff itself should be soft muslin. The compound used should be Tripoli or white diamond. When the surface looks smooth and shiny, wash the piece with hot water and soap.

37. Then with another soft buff and rouge compound, polish the piece again. Wash the piece again and dry with a soft cloth towel.

Troubleshooting

There are a variety of problems that may occur when enameling. Here are some of the most common ones and their possible causes and solutions.

CRACKING

Cracking usually occurs right after a piece has cooled, but sometimes it will develop later. It can be very frustrating if it does not develop for a long time after a piece seems finished.

REASON: Too thin a gauge or too long and narrow a piece of metal. Warping may occur during cooling and therefore stress and crack the enamel.

SOLUTION: Use heavier gauges and avoid extra-long, thin shapes.

REASON: Not enough counter enamel to balance with a heavy top layer of enamel.

SOLUTION: Add more counter and refire. The cracks may heal.

REASON: Cooling too quickly, such as force cooling by quenching in cold water.

SOLUTION: Always air cool naturally.

REASON: Counter enamel has an incompatible coefficient to the reverse side color.

SOLUTION: Use mixed-color counter enamel or the same color as the base coat on the other side.

ENAMEL PULLS AWAY FROM EDGES

There are times when the enamel seems to peel away from the edges of a piece. It may look clumpy and very unattractive.

REASON: Enamel was applied much too thickly at one time.

SOLUTION: Grind some of the enamel off, sift a thin layer of enamel onto the piece, and refire.

REASON: Piece was severely overfired.

SOLUTION: Be careful of timing when kiln firing. During some torch-firing techniques, such as using beads and lumps, it may be difficult to avoid having the underside pull away some, due to how long it may take to get beads and lumps to melt.

REASON: The metal was not cleaned properly. Grease and/or heavy oxides can interfere with bonding of glass to metal.

SOLUTION: Always clean and degrease metal surfaces before enameling. Avoid handling metal with your hands, as they may have natural oils or creams on them.

BLACK SPOTS

Black spots in enamels after firing is a common problem. They can happen whether using a kin or torch firing, but are more common when using a torch. Prevention is the only real way of dealing with them.

REASON: The enamel being used has been contaminated with another color or dirt from the environment.

SOLUTION: Always clean any tool that is put into an enamel *very* well. Use paper towels or compressed air to clean sifters in between using different colors of enamel.

REASON: Trivets and/or firing racks have a buildup of oxides that release while firing.

SOLUTION: Scrub firing racks routinely to remove oxide buildup. A metal brush will do a good job. Grind and scrub trivets on a regular basis to remove glass buildup and oxides.

REASON: Pieces have not been cleaned well after grinding with diamond abrasives or alundum stones.

SOLUTION: After using diamond or alundum to grind a piece, scrub the piece under water with a glass brush to remove any particles of the abrasives from the glass.

DISCOLORATION

Firing a color of enamel and then finding it to be a very different color than you expected is frustrating and confusing. There is a lot of chemistry involved in enameling that can change color results.

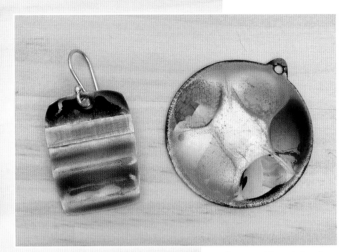

In the piece on the left, stress cracks formed from using very thin metal and an unstable form. Using much thicker enamel on the top surface than for the counter enamel caused cracking in the piece on the right.

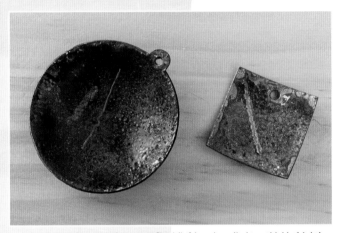

In these pieces, the enamel was overfired (left) and applied too thickly (right), causing it to pull away from the edges.

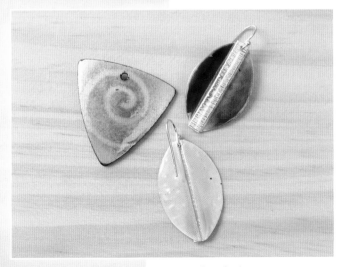

Even tiny black spots can ruin an otherwise well-made piece.

REASON: A warm color, such as a transparent red or yellow, turns dark or brown on silver.

SOLUTION: Warm transparent colors are very sensitive to silver. Try laying down a thin layer of a clear and firing that to create a barrier between the silver and the color. Then lay down the color and fire it over the clear.

REASON: On a piece of pierced and soldered champlevé the enamels turn brownish around the edges of the recesses.

SOLUTION: The enamel is being tainted by excess solder from soldering. Be very neat and yet complete with the solder. Grind away any excess before beginning to enamel.

REASON: After repeated firings opaque pinks and purples fade or turn brown.

SOLUTION: Opaque pinks and purples are very sensitive to overheating. Try to use them as the last firing or fire them at a slightly lower temperature (1,350°F to 1,400°F [730–760°C]) or for 10 to 15 seconds less time.

DRILLED HOLES FILL WITH ENAMEL

This is a common problem, but it is easy to prevent and remedy.

REASON: Holes are too small.

SOLUTION: Always drill holes at least 1.5 mm in diameter. It is nearly impossible to keep smaller holes clear of enamel.

REASON: Enamel got in a hole while sifting or wet packing.

SOLUTION: Use a toothpick or small wire to ream it out before firing. If a hole is filled with enamel *after* firing, use a diamond-coated drill bit under a small amount of water and redrill the hole. Go very slowly and use moderate to light pressure. (This is done under water to keep the drill bit cool, and therefore sharp, and to keep glass dust out of the air you're breathing.)

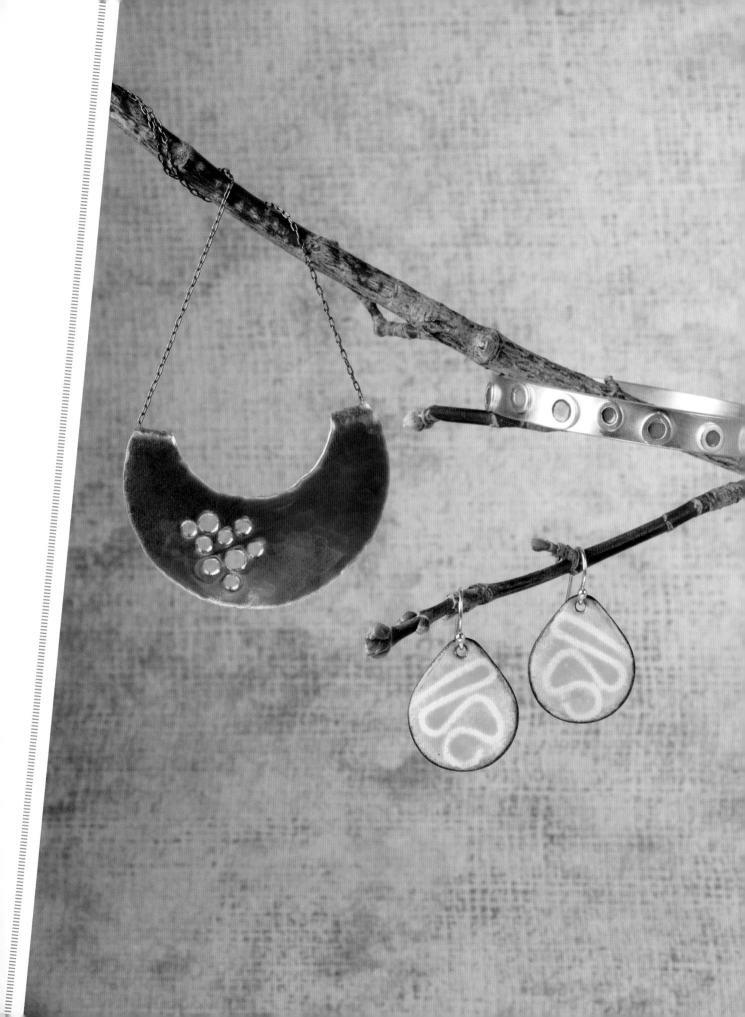

THE
Projects

I designed the projects in this book to explore a wide range of jewelry-making and enameling techniques and jewelry styles. My hope is that everyone from the absolute beginner jewelry maker to the more advanced metalsmith will add to their jewelry-making repertoire and find plenty of inspiration to enhance their designs.

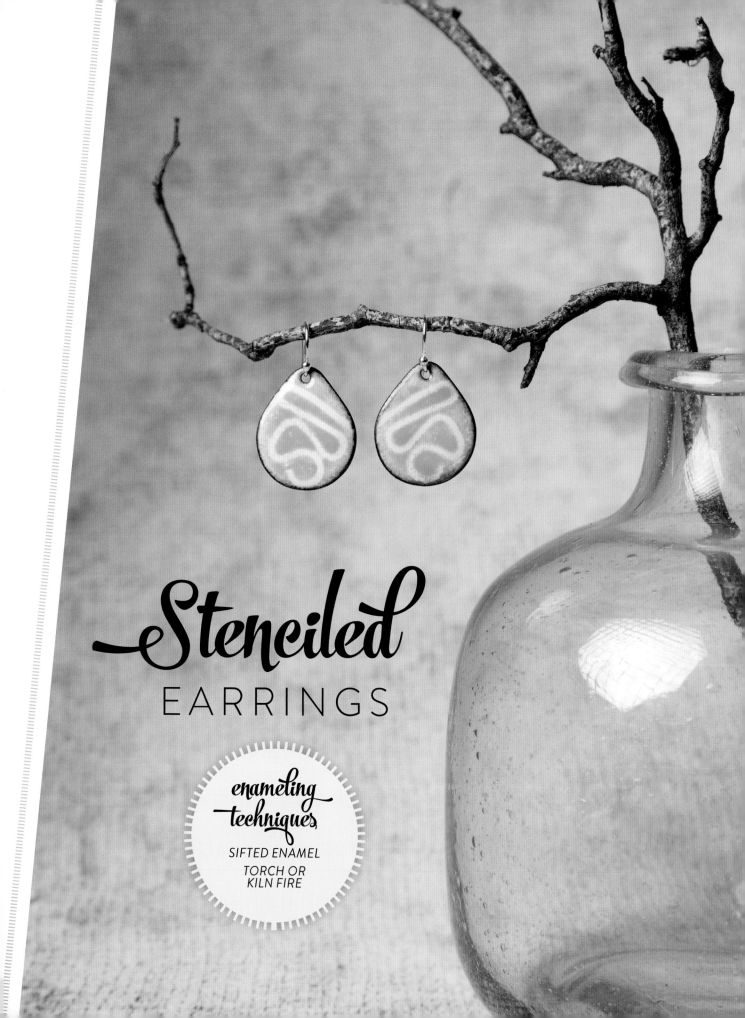

Stenciled
EARRINGS

For these simple earrings, I used shaped wire to create a stenciled design. Wire is readily available in a variety of gauges and is easy to bend into different shapes. Wire shapes also make mirror images for earrings simple as they can just be flipped over. (See Stenciling on page 27 for more ideas and tips for using stencils in your work.)

TIP

When applying a transparent enamel over an opaque base coat, the transparent must be darker than the opaque in order to show up.

JEWELRY-MAKING SKILLS
Using pliers

MATERIALS
Two 18-gauge copper shapes (any shape under 1" [2.5 cm] overall with a drilled hole for hanging will work; I used Thompson's V-45, ⅞" × 1" [2.2 × 2.5 cm] teardrop with hole)

Binder (Klyr-Fire/distilled water)

Thompson Opaque Enamel: #1225 (Lemon Yellow)

Thompson Transparent Enamel: #2840 (Mandarin Orange)

Pair of sterling silver ear wires

TOOLS
Penny Brite or abrasive cleaner

Enamel-sifting tools (page 25)

Torch-firing tools (page 18); this project can also be kiln fired

Fine-tipped tweezers

Round-nose pliers

Steel or wooden bench block

16-gauge copper or brass wire

Rawhide or plastic mallet

Glass of water

2 pairs chain-nose pliers

Scotch-Brite pad or wheel, or 80-grit 3M radial bristle disc

FINISHED SIZE
⅞" × 1⅜" (2.2 × 3.5 cm) with ear wire

1. Clean the copper shapes with Penny Brite or an abrasive cleaner. Make sure any dust or residue is wiped or rinsed off. (**NOTE:** This project will be torch fired, so there is no need to use Scalex [ball clay] to prevent the buildup of copper oxides. If kiln firing, coat the front of the pieces with Scalex and let dry before sifting counter enamel onto the backs.)

2. Place the two pieces front side down onto two bottle caps. Spray binder onto each of the pieces.

3. Wearing a dust mask, fill a small sifter halfway with #1225 enamel. Sift a layer of this enamel onto each piece as counter enamel. Allow to dry.

4. Place each piece onto a small trivet. If it's difficult to pick up the pieces without disturbing the dry enamel, use fine-tipped tweezers to pick them up; place one tip in the drilled hole and one tip on the outer edge to get a grip.

5. Put one of the trivets onto a firing rack on a soldering tripod.

6. Light the torch and adjust the flame to a slightly hissing oxidizing flame. Heat the piece from underneath with the torch. The dense blue cone of the flame should be about ½" (1.3 cm) from the base of the trivet. Hold the flame there until the enamel reaches the fire-polish stage.

7. Remove the flame and turn off the torch.

8. Carefully pick up the trivet from the firing rack with insulated-grip tweezers. Place the trivet and piece on a fire-safe surface and let the piece cool naturally.

9. Repeat Steps 4 through 8 with the second piece.

10. Clean the front of the two copper shapes with Penny Brite, Scotch-Brite, or an 80-grit 3M radial bristle disc.

11. Set each earring piece onto a bottle cap. Spray with binder and sift a thorough layer of #1225 enamel onto each piece. Let dry.

12. Place each piece onto a trivet and fire one at a time, as in Steps 4 through 6.

13. When the pieces are cool, place each one, front side up, on a bottle cap.

14. Using round-nose pliers, bend an abstract shape out of 16-gauge round copper or brass wire (*figures 1–3*). The design shape should be about 1" (2.5 cm) in diameter.

figure 1

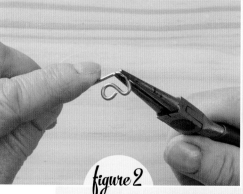

figure 2

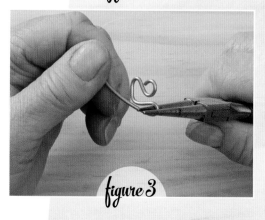

figure 3

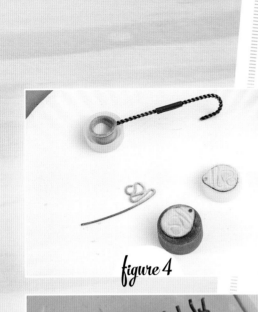

figure 4

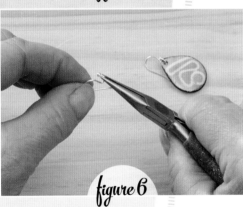

figure 5

15. Tap the bent shape flat on a steel or wooden bench block with a rawhide or plastic mallet.

16. Set the wire "stencil" on top of one of the earring shapes. Spray with binder.

17. Fill a clean sifter halfway full with #2840 enamel. Sift a layer of enamel onto the piece and over the wire stencil of one of the earrings.

18. Carefully lift the wire off the earring piece without spilling the enamel that may have stuck to it *(figure 4)*. Use tweezers if necessary. Rinse the stencil in water and dry it off.

19. Turn the stencil over and place it on the second earring. This will give a mirror image for the matching earring. Spray with binder.

20. Repeat Steps 17 and 18.

21. Place each piece on a trivet *(figure 5)*. Fire each earring as in Steps 4 through 6, being very careful not to overfire. Watch as the enamel melts on the base coat. As soon as it reaches the fire-polish stage, remove the flame. Overfiring will cause the stenciled design to spread and lose definition.

22. When the earrings are cool, attach the ear wires using the chain-nose pliers *(figures 6 and 7)*.

TIP
If you'd like to make your own ear wires, see page 149.

figure 6

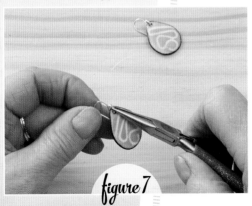

figure 7

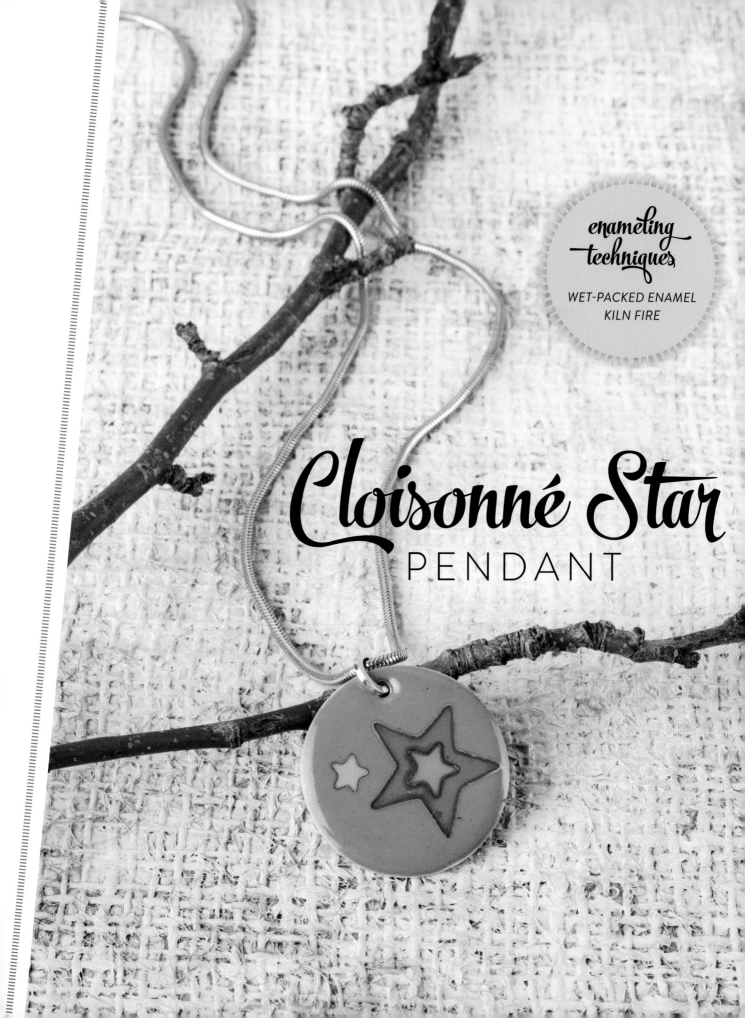

Cloisonné Star
PENDANT

This eye-catching pendant features a striking star motif and high-contrast colors. If stars don't appeal to you, try another shape. Simple geometric shapes, such as triangles, circles, and squares, would work well. If you don't have a lot of experience forming with pliers, I recommend using only shapes that bezel mandrels or miniature mandrels come in.

JEWELRY-MAKING SKILLS
Sawing
Filing
Sanding
Basic forming
Using pliers
Drilling

MATERIALS
One 18-gauge fine silver disc, 1¼" (3.2 cm) diameter, or 18-gauge sheet fine silver sheet, 1¼" × 1¼" (3.2 × 3.2 cm)

30-gauge × 1mm fine silver cloisonné wire, 4" (10 cm)

Binder (Klyr-Fire/distilled water)

Thompson Transparent Enamel: #2020 (Clear for Silver)

Thompson Opaque Enamels: #1425 (Sapphire), #1860 (Flame Orange), #1840 (Sunset Orange), and #1820 (Goldenrod Yellow)

Blu-Stic

18-gauge square wire jump ring, 6mm

Sterling silver chain or leather cord, 18" (45.5 cm)

TOOLS
Kiln-firing tools (page 22)

Plastic circle template (optional)

Fine-point permanent marker or scribe (optional)

Jeweler's saw frame and 2/0 saw blades or a disc cutter and brass mallet (optional)

#2 flat file (optional)

#400 silicon carbide sandpaper (optional)

Ruler

Center punch and hammer

Hand drill, Dremel, or flexible-shaft machine

#60 and #40 drill bits

Star-shaped mandrel

Wire snips

Small chain-nose pliers or flat-nose pliers

Enamel-sifting tools (page 25)

Fine-tipped tweezers

Wet-packing enamel tools (page 30)

Alundum stone

Glass brush

FINISHED SIZE
Pendant: 1¼" × 1¼" (3.2 × 3.2 cm)

Chain and clasp: 19¼" (49 cm) long

1. Set the kiln temperature at 1,450°F (788°C), turn it on, and let it warm up.

2. If not using a purchased disc, trace a circle from a plastic template onto the silver sheet and saw out or disc cut a 1 ⅛" (2.8 cm) circle. File and sand the edges smooth.

3. Use a ruler to measure a mark about ⅛" (3 mm) from the edge of the circle. Center punch the mark.

4. Drill the mark first with a #60 drill bit, then redrill with a #40 bit to enlarge the hole.

5. Using a star-shaped mandrel, mark the mandrel where it would make a ¼" (6 mm) star and again where it would make a ¾" (2 cm) star.

6. With wire snips, clip the end of the cloisonné wire so it is even and straight.

7. Hold the end of the wire against the side of the star shape over the mark on the smaller end of the mandrel and carefully push it against the next side, creating one of the points. Move on and bend corner by corner, always securing the previous bend with your other hand (*figure 1*). As you complete the star, carefully slide it off of the mandrel.

8. Clip the other end of the star, where it should meet the first end. Manipulate the star so that the ends come as close to meeting as possible.

9. Set the star down on a hard flat surface and gently push it down with your fingers to make it as flat as possible.

10. If any of the corners are not crisp, go in with a small pair of chain-nose or flat-pliers and gently squeeze to straighten out. If the ends have come apart, gently move them into place.

11. Repeat Steps 7 through 10 over the mark on the larger end of the star mandrel.

12. Place the circle on a bottle cap. Wearing a dust mask, spray with binder, then sift a thorough layer of #1425 on that side of the circle. This will be the counter enamel. Allow to dry.

13. Place the circle on a firing rack, enamel side up. Fire in the kiln for 2 minutes until fire-polished.

14. Remove from the kiln with a kiln fork and allow the piece to cool completely.

15. Set the piece on a bottle cap bare side facing up. Spray with binder.

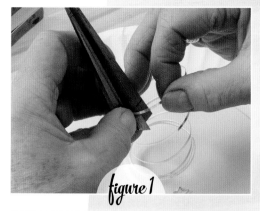

figure 1

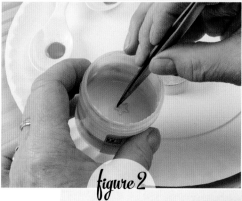

figure 2

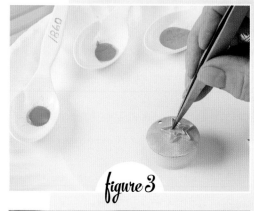

figure 3

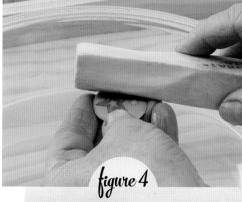

figure 4

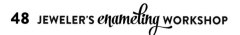

16. Put dust mask back on. Clean the sifter. Fill the sifter halfway with #2020 clear. Sift a very thin layer of the enamel onto the face of the piece. Allow to dry.

17. Set the circle in a trivet on a firing rack. Fire as usual to get a fire polish on the clear enamel. Remove from the kiln and cool.

18. Using fine-tipped tweezers, gently pick up one of the stars. Carefully dip the star into the Blu-Stic just enough to cover the bottom edge. Place the star on the face of the piece, on top of the fired clear enamel, and position it as desired using the tweezers (*figures 2 and 3*).

19. Repeat Step 18 with the second star. Allow the Blu-Stic to dry. As it is drying, gently press the stars down to make good contact with the clear enamel.

20. Place the circle on a trivet on a firing rack and fire the piece again. Any parts of the stars touching the enamel will become attached to the clear base coat during firing. Remove from the kiln and let it cool.

21. Take a small amount of each enamel to be used (½ teaspoon [2.5 ml]) and put it in its own plastic spoon. Write the number of the enamel on the handle of the spoon. Place the spoons on a paper plate as you do this. Place a bottle cap on the plate. Have some small pieces of paper towel close by to clean your brush.

22. Add a couple of drops of water to each spoon to hydrate the enamels.

23. With the circle on the bottle cap, use the small paintbrush to carefully pick up a small amount of one enamel and place it on the pendant where it belongs. If the enamel is appropriately wet, it will come off the brush easily onto the segment of the design where you want it to be. If it does not come off the brush in a fluid manner, it is too dry. If it runs all over the surface,

it may have too much water; touch the enamel lightly with the edge of a paper towel and to siphon off the excess water.

24. Do not attempt to fill the cloisonnés (cells) too much at any one time. Fill a little at a time, let it dry, and then put it on a trivet on a firing rack and fire and cool as usual. There may be as many as six or seven applications and firings.

25. When the enamel has been added and fired repeatedly until it comes to the top of the cloisonné wires, it is time to begin finishing and perfecting the piece.

26. Hold the piece under a trickle of water or partially submerged in a bowl of water and grind with an alundum stone. You can also dip the alundum stone in water and grind the piece over a bowl of water. Grind until the surface feels more even and smooth. Scrub with a glass brush under water, then dry the piece (*figure 4*).

27. Look for shiny spots. These are the places where the enamel is low. Return to the working area and add small amounts of enamel to the low spots. Allow to dry and fire again.

28. Grind the piece with the alundum stone until all areas are level with the cloisonnés.

29. If there are no shiny spots left after grinding, do a fire polish to finish the piece. Scrub with a glass brush under water and dry the piece.

30. Fire the piece one more time for 10 seconds less than the previous firings. When removed from the kiln the piece should be totally glossed over.

31. When cool, use pliers to open the 18-gauge jump ring. Slip it into the drilled hole of the pendant. Close the jump ring with the pliers.

32. Slip the finished silver chain through the jump ring or attach a leather cord.

Copper Washers
EARRINGS

enameling techniques

SIFTED ENAMEL

TORCH OR KILN FIRE

Copper washers are great for enameling. They often come in a package with six sizes, from 14-gauge to 18-gauge, making them heavy enough that they do not need counter enamel. The line sifter is a more accurate and economical way to sift onto these narrow surfaces. A regular small sifter will also work, but it will waste more enamel.

JEWELRY-MAKING SKILLS

Sawing

Sanding

Forming wire

Using pliers

MATERIALS

14- to 18-gauge copper washers, two 11/16" (1.75 cm) and two 5/8" (1.5 cm) (Harbor Freight item #67526)

Binder (Klyr-Fire/distilled water)

Thompson Opaque Enamels: #1319 (Bitter) and #1530 (Twilight Blue)

16-gauge sterling silver round wire, 2" (5 cm)

18-gauge sterling silver round wire, 4" (10 cm)

TOOLS

400-grit silicon carbide sanding stick or fine Scotch-Brite pad

Enamel-sifting tools (page 25), including line sifter with 1/32" (1 mm) hole

Cotton swab or paper towel (optional)

Torch-firing tools (page 18; this project can also be kiln fired)

Fine-tipped tweezers

7/7.5 mm rod or 5/16" (7.5 mm) drill-bit shank

Jeweler's saw frame and 2/0 saw blades

2 pairs chain-nose pliers

Wire clippers or snips

Round-nose pliers

1/2" (1.3 cm) dowel, 3" (7.5 cm) or longer

FINISHED SIZE

1 3/8" (3.5 cm) long with ear wire

1. Clean the washers by using the sanding stick or Scotch-Brite pad. This will also put some "tooth," or texture, on the surface of the metal, which helps the enamel adhere.

2. Set the washers on bottle caps and spray with binder.

3. Dip the clean line sifter into the #1319 enamel and fill about three-quarters full. Sift the enamel onto the two ¹¹⁄₁₆" (1.75 cm) diameter washers **(figure 1)**.

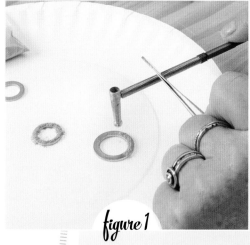

figure 1

4. Clean the line sifter by gently tapping the top of it over a paper towel or tabletop, then lightly blowing into the top of the sifter away from you, over a trash can. You can also use a cotton swab or a corner of paper towel twisted into a long, narrow point to wipe out the sifter.

5. Repeat Step 3 with #1530 enamel and the two ⅝" (1.5 cm) washers. Allow the enamel on all the washers to dry.

6. Pick up the four washers with tweezers and set them on a firing rack on a soldering tripod.

7. Light the torch and adjust the flame to a slightly hissing oxidizing flame. Heat the pieces one at a time until each reaches the fire-polish stage. Remove the heat and allow the pieces to cool.

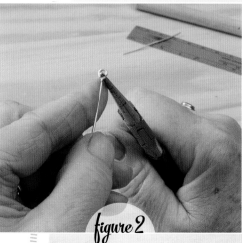

figure 2

8. When cool, sand the edges and backs of the enameled copper washers. This will reveal clean copper for the finished pieces.

9. Wrap the 16-gauge sterling silver wire around the rod or drill-bit shank to create a coil. Saw through the coil to make several jump rings. (See Making Jump Rings, page 150.)

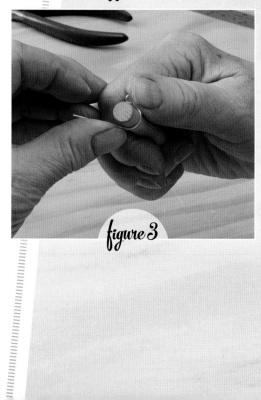

figure 3

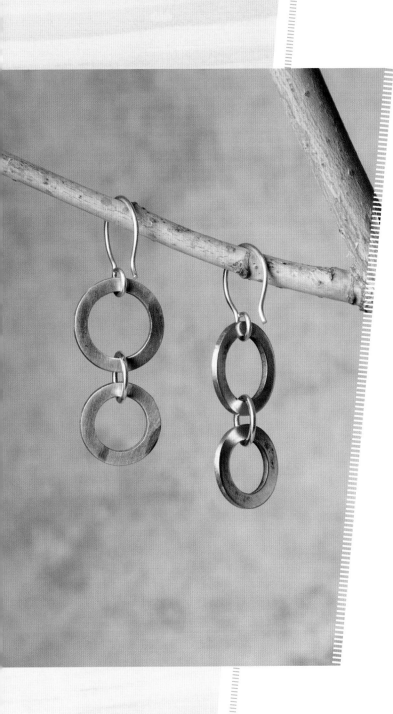

10. Open a jump ring. (See Opening and Closing Jump Rings, page 151.) Slip one #1319 washer and one #1530 washer onto a jump ring. Close the ring sideways with pliers. (**NOTE:** If using a Smith torch or Little torch, the ring can be soldered shut without damaging the enamel. *Do not* attempt this with a butane or copperhead torch. It will damage the enamel before the solder will flow. Note that 16-gauge wire is strong enough that it is not necessary to solder the rings shut.)

11. Use clippers or snips to cut the 18-gauge sterling wire in half to create two 2" (5 cm) long pieces. Sand the ends flat and smooth.

12. Bend a ⁵⁄₃₂" (4 mm) loop on one end of each 2" wire with the round-nose pliers. Place the pliers with one jaw inside the ring and one outside the ring where the end of the loop touches the remaining wire. Give a little bend to center the loop on the rest of the wire *(figure 2)*.

13. Form the remaining length of wire around a ½" (1.3 cm) dowel. Bend the very end of the wire in a reverse curve to create an ear wire *(figure 3)*. Trim the wire and file the end to smooth.

14. With the chain-nose pliers, open the ring of the ear wire sideways and slip onto one of the #1530 enameled washers. Close the ring. Repeat with the other #1530 washer and ear wire.

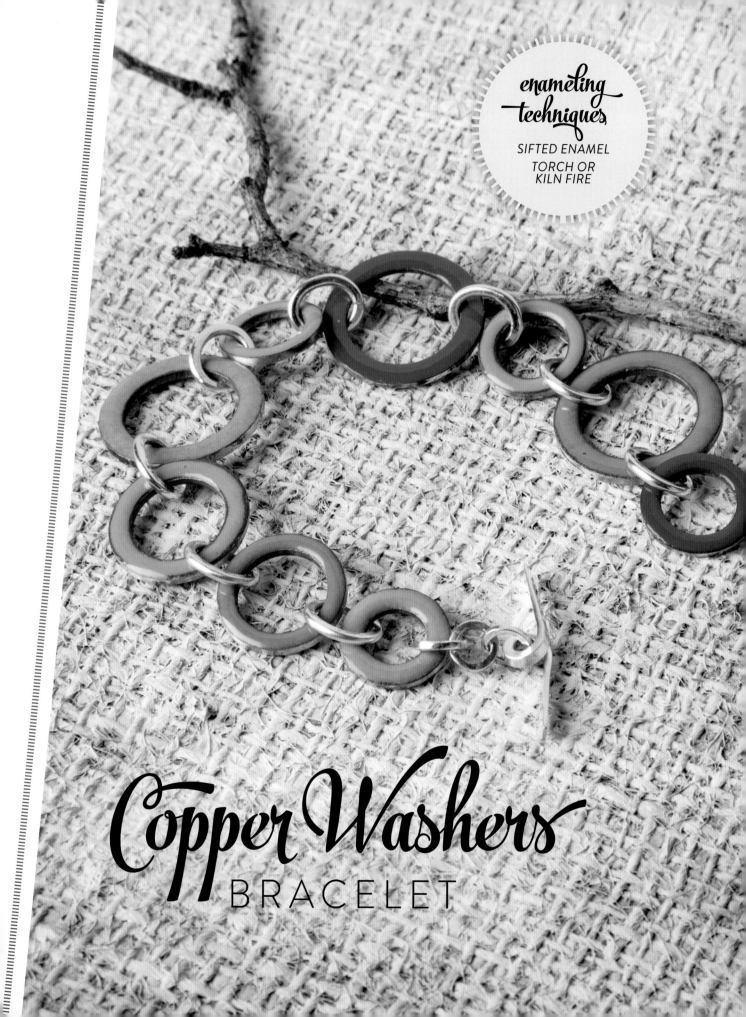

Copper Washers
BRACELET

Fun and colorful, this is an excellent project for torch firing. The palette includes blues, blue-greens, and greens, creating a "cool" range of colors. The bracelet can easily be made in a warm range of colors or a mix of complementary colors. All of these varying palettes are striking and create different effects. Since copper is the base, transparent colors may look dark and muddy after firing. Experiment to determine successful transparent palettes.

JEWELRY-MAKING SKILLS

Sawing

Using pliers

Forming wire

MATERIALS

14- to 18-gauge copper washers: three ⅝" (1.5 cm), three ¹⁵⁄₁₆" (2.4 cm), one ¾" (2 cm), one ¹¹⁄₁₆" (1.75 cm), and one ⁹⁄₁₆" (1.4 cm) (Harbor Freight stock number #67526)

Binder (Klyr-Fire/distilled water)

Thompson Opaque Enamels: #1660 (Ultramarine Blue), #1430 (Spruce), #1319 (Bitter Green), #1425 (Sapphire), #1422 (Aqua Marine Green), and #1530 (Twilight Blue)

16-gauge sterling silver round wire, 12" (30.5 cm)

18-gauge sterling silver round wire, 3" (7.5 cm)

14-gauge sterling square wire, 1½" (3.8 cm)

TOOLS

400-grit silicon carbide sanding stick or Scotch-Brite pad (fine or medium grade)

Enamel-sifting tools (page 25) including line sifter with ¹⁄₃₂" (1 mm) hole or small sifter

Cotton swab or paper towel (optional)

Torch-firing tools (page 18; this project can also be kiln-fired)

Tweezers

Pickle

Hand drill

5 mm and 7.5 mm (³⁄₁₆" and ⁵⁄₁₆") rods or drill-bit shanks

Jeweler's saw frame and 2/0 saw blades

2 pairs chain-nose pliers

Planishing hammer or small polished ball-peen hammer

Steel bench block

#2 flat hand file

Ruler

Permanent marker

Round/flat-nose pliers

FINISHED SIZE

7½" (19 cm) long

⅝"
#1660 ¹⁵⁄₁₆"
#1430 ⅝"
#1319 ¹⁵⁄₁₆"
#1660 ⅝"
#1425 ¹⁵⁄₁₆"
#1530 ¾"
#1319 ¹¹⁄₁₆"
#1430 ⁹⁄₁₆"
#1422

figure 1

1. Clean all of the washers with the sanding stick or Scotch-Brite. The slight matte finish created by these abrasives will be visible on the exposed copper of the completed bracelet.

2. Set each of the washers on a separate bottle cap. Place the washers to be enameled the same color near each other so that they can be sifted at the same time. (Refer to *figure 1* for the placement of different-size washers and enamel colors I used for the finished bracelet.)

3. Spray binder onto the washers as you prepare to sift one color at a time. (If all the washers are sprayed at the same time, some will be dry before they get the enamel sifted on them.)

4. Start with one color. Dip the clean sifter into enamel and fill three-quarters full. Make sure to hold the hole on the line sifter close to the surface of the washer when sifting, so as not to waste a lot of enamel. Clean the sifter between colors by gently tapping the top of it over a paper towel or tabletop, then lightly blowing into the top of the sifter away from you, over a trash can. You can also use a cotton swab or a corner of paper towel twisted into a long, narrow point to wipe out the sifter. Continue spraying the washers with binder and sifting until all nine washers are covered with the proper enamel *(figure 2)*.

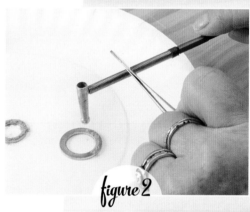

figure 2

5. Move the washers to a firing rack on a soldering tripod. The opening of the tripod under the firing rack will allow half the washers to be fired at a time. Place washers 1 through 5 on the rack using tweezers to pick them up *(figure 3)*.

6. Light the torch and adjust the flame to a hissing, oxidizing flame. Heat the washers from underneath until they reach the fire-polish stage. Remove the heat and turn off the torch.

7. Pick up the washers one by one with tweezers and set them on a fire-safe surface to cool.

8. Repeat Steps 5 through 7 with washers 6 through 9.

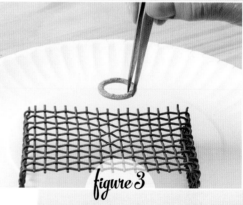

figure 3

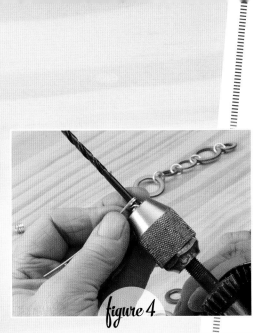

figure 4

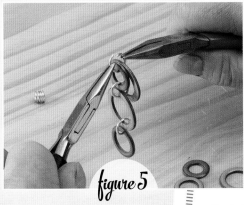

figure 5

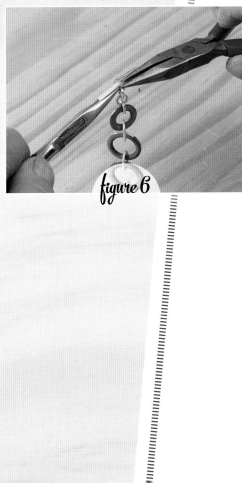

figure 6

9. Sand the outer edges and backs of the washers with a 400-grit silicon carbide sanding stick. This will clean off any dark copper oxides and leave the pieces with a brushed finish.

10. Anneal the 16-gauge sterling silver round wire. Pickle, rinse, and dry the wire.

11. Wrap the 16-gauge wire around a 7.5 mm (⁵⁄₁₆") rod or drill bit shank to create to create a coil *(figure 4)*. Saw through the coil to make several jump rings. (See Making Jump Rings, page 150.)

12. Open each jump ring. (See Opening and Closing Jump Rings, page 151).

13. One by one connect the enameled washers with a silver jump ring until they are all connected, closing them one by one after they are put on to the washers *(figures 5 and 6)*.

14. Wrap the 18-gauge 3" (7.5 cm) sterling silver round wire around a 5 mm rod or drill-bit shank to make a coil.

15. Repeat Step 12 with this coil.

16. Open three rings with chain-nose pliers. Attach and close the rings one by one onto the #9 washer, creating a three-link chain off the last washer.

17. Using a planishing hammer or polished ball-peen hammer and bench block, hammer each end of the 14-gauge square wire until it becomes flared and wider.

18. File and/or sand the ends of the hammered 14-gauge square wire until they are smooth and even. If the sides are bumpy from the hammering, sand them smooth.

19. Anneal, pickle, rinse, and dry the 14-gauge square wire.

20. Measure to find the center of the 14-gauge square wire. Mark the center with a permanent marker.

21. Hold the middle of the 14-gauge square wire with round/flat-nose pliers in one hand. With the other hand, bend the wire around the round tip of the pliers. The two ends of the wire will cross past each other, creating a loop in the middle with two long ends that jut out past the loop. This is the toggle for the clasp.

22. Open the toggle loop with two pairs of chain-nose pliers with the same sideways method used to open and close the jump rings. Open, attach, and close the toggle to the last of the smaller jump rings on washer #9. The washer at the opposite end of the bracelet is the loop the toggle will slip into to close the bracelet.

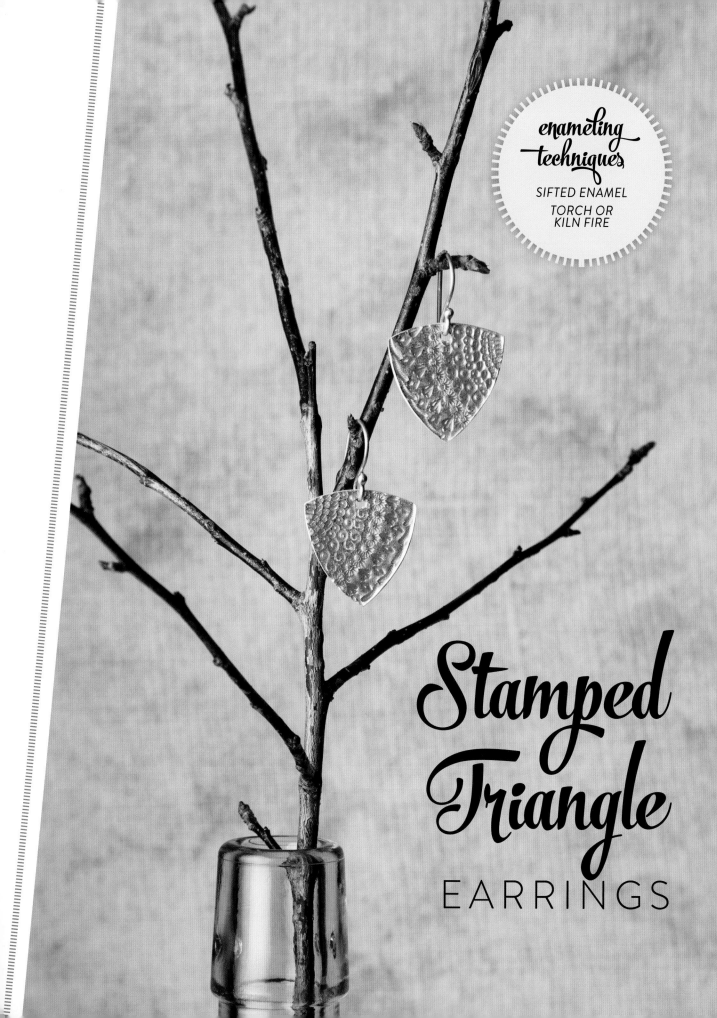

Stamped Triangle

EARRINGS

These earrings are simple and quick to make. The design on them can vary greatly, depending on the stamps used and their placement. Stamps are readily available from many sources. I have a large collection of old and new stamps, some of which I have made myself. Remember, for the stamped design to show through, transparent enamel must be used.

JEWELRY-MAKING SKILLS

Sawing

Filing

Sanding

Stamping

Using pliers

Drilling

MATERIALS

18-gauge fine silver sheet, 2" × 1¼" (5 × 3.2 cm)

Water and detergent

Binder (Klyr-Fire/distilled water)

Thompson Transparent Enamels: #2530 (Water) and #2510 (Cascade Blue)

Pair of sterling silver ear wires

TOOLS

Kiln-firing tools (page 22; this project can also be torch-fired)

Triangle template (page 154)

Scribe

Steel bench block

Duct tape

Decorative metal stamps

Chasing hammer or brass mallet

Jeweler's saw frame and 2/0 saw blades

#2 flat hand file

#400 silicon carbide sandpaper

Rawhide mallet

Brass brush

Ruler

Fine-point permanent marker

Center punch and hammer

Hand drill, Dremel tool, or flexible-shaft machine

#55 drill bit

Enamel-sifting tools including ½" (1.3 cm) sifter

Toothpick

2 pairs chain-nose pliers

FINISHED SIZE

1" × 1½" (2.5 × 3.8 cm) with ear wire

1. Set the kiln temperature at 1,450°F (788°C), turn it on, and let it warm up.

2. With the triangle template and scribe, trace two 1" (2.5 cm) triangles on the fine silver sheet *(figure 1)*.

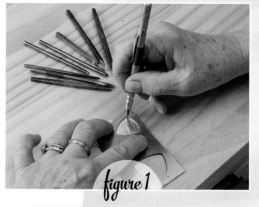

figure 1

3. Secure the sheet to the steel bench block with duct tape.

4. Use the decorative stamps and a chasing hammer or brass mallet to stamp the design onto the sheet metal.

5. Saw out the two triangles with the jeweler's saw and saw blade.

6. File and then sand the edges of the triangles to make them smooth *(figure 2)*.

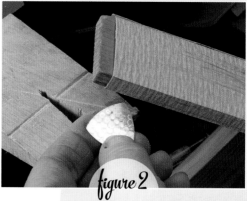

figure 2

7. If the two triangles are warped from the stamping, tap them gently with a rawhide mallet on the bench block. (**NOTE:** Stamping may leave marks on the back of the sheet metal. This is normal. To remove the marks, sand the back of the pieces with a #400 silicon carbide sanding stick. Then use a brass brush with a drop of detergent and water to scrub and give sheen to the metal *[figure 3]*).

8. With a ruler, measure across the top of each piece and mark the middle with a fine-point marker. Make another mark ⅛" (3 mm) from the top of the triangle where the mid-mark is, crossing the mid-mark *(figure 4)*.

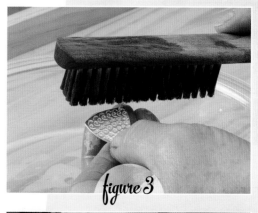

figure 3

9. Center punch and then drill a #55 hole at this point on each earring.

10. Spray binder on the back of each triangle.

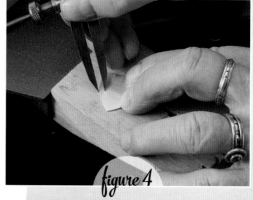

figure 4

11. Fill a small sifter halfway with #2530 enamel. Sift a layer of enamel on the back of each triangle for counter enamel. Set each one on a trivet on a firing rack and allow to dry. After sifting, use a toothpick to clear out the hole before firing.

12. Fire the triangles for 2 minutes at 1,450°F. Remove them from the kiln and allow to cool.

13. Spray the fronts of the two triangles with binder.

14. Fill the small sifter halfway with #2510 enamel. Sift an even yet thorough layer of enamel onto each triangle.

15. Place the triangles on trivets on a firing rack and allow to dry.

16. Fire the two triangles for 2 minutes at 1,450°F. Remove them from the kiln and let cool.

17. When cool, attach sterling ear wires to the triangles with chain-nose pliers.

TIP
If you're planning to make multiples of a project, you can cut out a metal template to reuse. See page 152 for instructions.

TIP
If you'd like to make your own ear wires, see page 149.

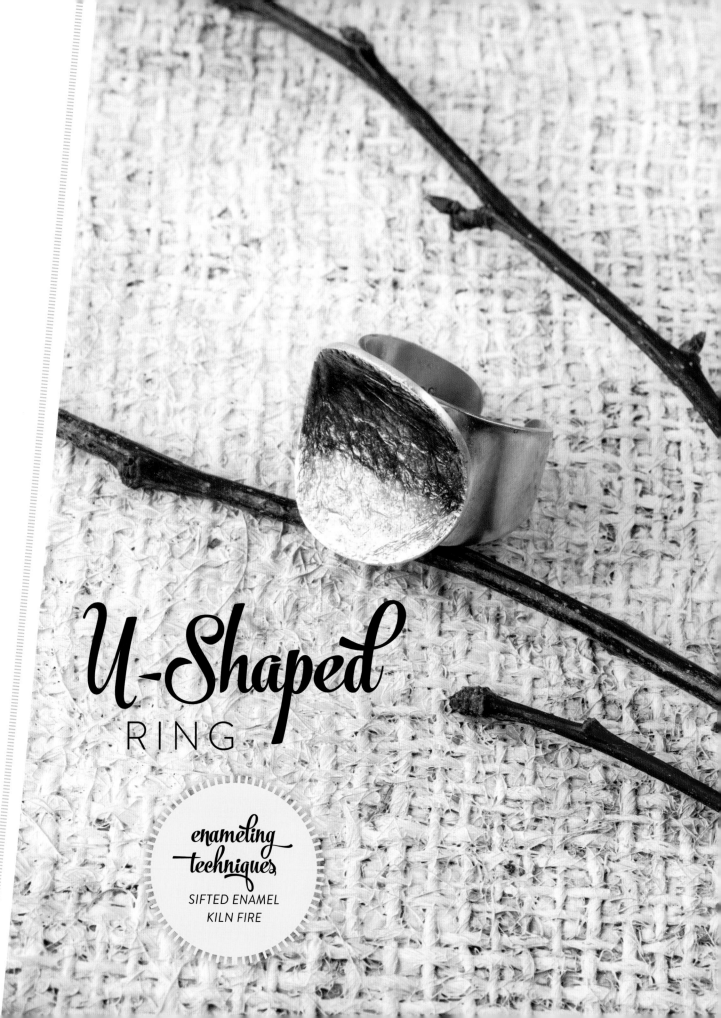

U-Shaped
RING

This chunky ring has a simple, yet elegant, design. The heavier gauge of fine silver has several purposes. Because the shank is fine silver, it needs to be heavier in order not to be too soft. The heavier gauge also allows the disc, which is shaped into a "U," to be enameled on one side without warping or cracking. Making the entire piece out of fine silver rather than sterling avoids the issue of firescale on the shank and the back of the disc.

JEWELRY-MAKING SKILLS

Annealing

Sawing

Filing

Sanding

Drilling

Forming

Soldering

Finishing

MATERIALS

16-gauge fine silver sheet, 2¼" × ⅝" (5.5 × 1.5 cm) and 1" × 1" (2.5 × 2.5 cm)

Binder (Klyr-Fire/distilled water)

Thompson Transparent Enamel: #2915 (Oil Gray)

Fine silver foil, 1" × 1" (2.5 × 2.5 cm)

TOOLS

Kiln-firing tools (page 22)

Shank template (page 152)

Fine-point permanent marker or scribe

Scissors (optional)

Glue stick (optional)

Jeweler's saw frame and 2/0 saw blades

#2 half-round hand file

#400 sanding stick

Center punch and hammer

Drill

#60 and #44 drill bits

Torch for annealing

Pickle

Ring mandrel

Rawhide or plastic mallet

Sandbag or ring-bending block

Slim cone reamer, 5 mm or larger

Beeswax

Bud bur or cone bur, 8 mm

Circle template

Soldering tools (page 153)

Hard silver solder

Dust mask

Enamel-sifting tools

Small paintbrush or an eyedropper

Burnisher

Fine Scotch-Brite pad or sandpaper

FINISHED SIZE

⅞" (2.2 cm) across × 1" (2.5 cm) deep

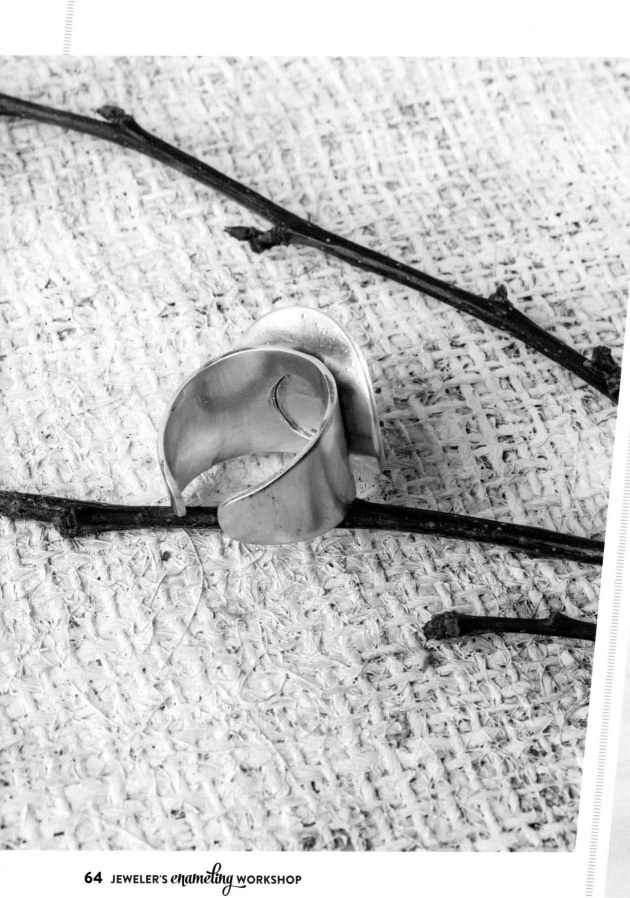

figure 1

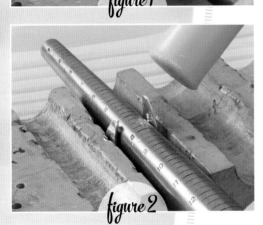

figure 2

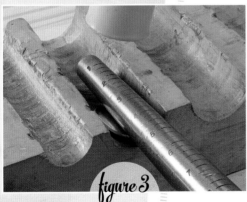

figure 3

1. Set the kiln temperature at 1,450°F (788°C), turn it on, and let it warm up.

2. Trace the shank template onto the 2 ¼" × ⅝" (5.5 × 1.5 cm) strip of 16-gauge fine silver sheet using a fine-point marker or scribe or cut the design out and glue it on with a glue stick.

3. Saw out the ring shank shape with a jeweler's saw and 2/0 saw blade. File and sand the edges smooth.

4. Mark the midpoint on the shank with a marker or scribe. Center punch the center of the shank. Drill a small hole (#60) at the center mark.

5. Anneal the shank strip of fine silver. Pickle, rinse, and dry.

6. Use a ring mandrel and a mallet to shape the shank into a ring. For support while doing this, place the strip over a ring-bending block or sandbag. Place ring mandrel over the metal and tap until the ring shank forms a "U." Then strike the ends over the mandrel to complete the shank shape. Leave about ⅛" (3 mm) space between the ends *(figures 1 and 2)*.

7. Drill the hole in the ring shank again with a larger (#44) drill bit.

8. Use a cone reamer to expand the hole. A cone reamer works much more smoothly than a very large drill bit. It shaves the hole more gradually and does not jerk as it moves. Beeswax on the reamer will help it move even more smoothly and will help keep it sharp.

9. Use an 8 mm cone bur or bud bur to enlarge the hole once more.

10. Trace a 1" (2.5 cm) circle onto the 1" square of 16-gauge fine silver using the template.

11. Saw the circle out with a jeweler's saw and 2/0 blade. File and sand the edges of the circle.

12. Anneal the circle of fine silver. Pickle, rinse, and dry.

13. Use the ring mandrel to shape the disc into a uniform "U" shape *(figure 3)*.

14. Place the rounded side of the half-round hand file over the hole in the shank and file across the hole in the long direction of the shank *(figure 4)*. This will create a "U" groove for the "U" circle to sit in.

15. At the soldering station, set the "U" circle concave side down on a soldering block. It may be necessary to use a prop of a small piece of pumice or a soft block to keep the piece level.

16. Flux the bottom of the "U" facing up. Set the ring shank on top of the circle and make sure it's balanced evenly.

17. Cut four pieces of hard silver solder ¹⁄₁₆" (2 mm) square. Set them on the inside of the cutout in the shank, on the back of the circle "U" *(figure 5)*.

18. Heat the pieces with a large but soft reducing flame, in a steady rotational motion, until the solder flows and attaches the shank to the "U" circle. Cool, pickle, rinse, and dry.

19. Spray the concave part of the circle on top of the ring with binder.

20. Put on your dust mask. At the enameling setup, fill a small sifter with #2915 enamel. Because of the shape of the top, it's necessary to hold the ring and rotate it sideways to get enamel on the entire surface. Sift a thin but thorough layer of the enamel onto the top of the ring. This ring will sit level and securely on a 2" (5 cm) trivet. Before placing on the trivet, wipe off any residual enamel that may be on the shank with your fingers or a paper towel. Allow to dry *(figure 6)*.

21. Fire the ring in the kiln until fire polished, 2 minutes. Remove from the kiln and allow to cool *(figure 7)*.

22. Place the silver foil across and into the recess of the ring top, on top of the fired layer of enamel. With a brush or an eyedropper, carefully lay a drop of water down on any edge where the enamel meets the foil. The water will pull the foil down onto the enamel. Carefully pat the foil down in an effort to reduce any air space.

23. Place the ring back on the trivet. Allow the foil to dry down onto the enamel.

24. Fire the ring as if firing a layer of enamel. When the ring comes out of the kiln, use a burnisher to pat the foil down while the piece is still hot. Be very careful not to burn yourself!

25. When the piece is cool, spray with binder and sift another layer of the #2915 over the foil. Allow to dry.

26. Fire the piece one more time until the enamel is fire-polished. Remove from the kiln and allow to cool.

27. Use a fine Scotch-Brite pad or fine sandpaper to clean the inside and outside of the ring and to leave a satin finish.

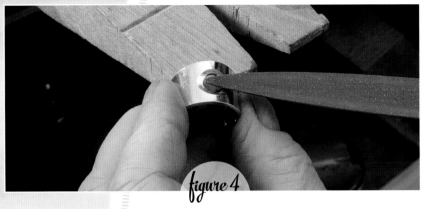

figure 4

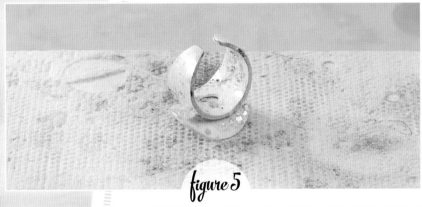

figure 5

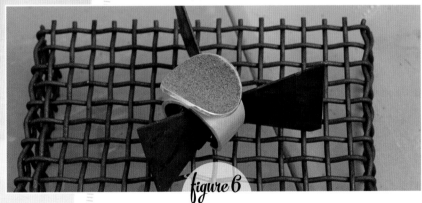

figure 6

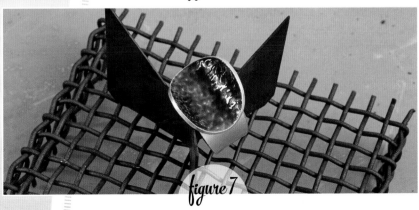

figure 7

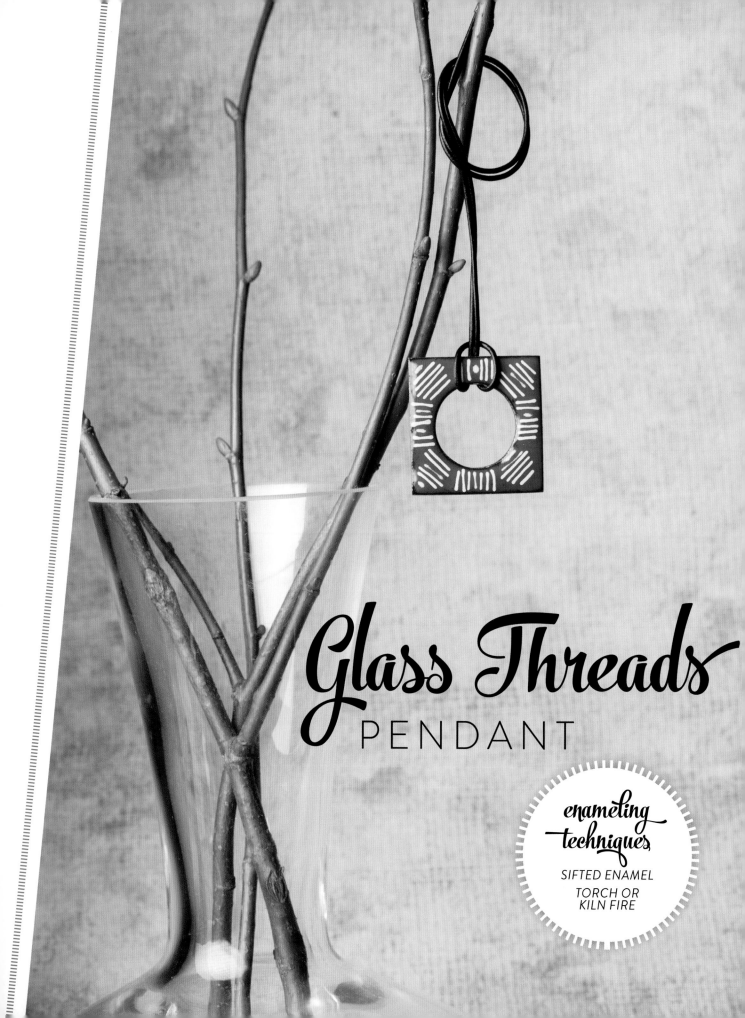

Glass Threads
PENDANT

enameling
techniques

SIFTED ENAMEL
TORCH OR
KILN FIRE

Glass threads are available from enamel suppliers and can be used in a variety of ways to decorate pieces either simply or with great intricacy. The design in this project falls somewhere in between. It takes a bit of patience to work with the threads, but the rewards are well worth it. (See page 28 for more tips on incorporating threads, as well as glass beads and lumps, into your designs.)

JEWELRY-MAKING SKILLS

Sawing

Filing

Sanding

Drilling

MATERIALS

16- or 18-gauge copper sheet, 1½" × 1½" (3.8 × 3.8 cm)

Scalex (ball clay)

Binder (Klyr-Fire/distilled water)

Counter enamel (optional; #1880 or other color)

Thompson Opaque Enamel: #1880 (Flame Red)

50 to 60 opaque white glass threads

Leather cord with closure

TOOLS

Kiln-firing tools (page 22; this project can also be torch-fired)

Pendant template (page 154)

Fine-point marker or scribe

Ruler

Jeweler's saw frame and 2/0 saw blades

#2 half-round hand file

400-grit silicon carbide sandpaper

Center punch and hammer

Drill (hand or electric), Dremel tool, or flexible-shaft machine

#60 drill bit

Jeweler's bench pin

½" (1.3 cm) dowel, 3" to 6" (7.5–15 cm) long

Enamel-sifting tools (page 25)

Penny Brite, Scotch-Brite, or a coarse (80-grit) 3M radial bristle disc

Fine-tipped stainless tweezers

Thin cloth or latex-coated gloves

Alundum stone or diamond file (optional)

FINISHED SIZE

Pendant: 1½" × 1½" (3.8 × 3.8 cm)

Cord and clasp: 16" (40.5 cm) long

1. Set the kiln temperature at 1,450°F (788°C), turn it on, and let it warm up.

2. Using the template and a scribe or fine-point marker, trace the shape on the copper sheet.

3. With a jeweler's saw frame and 2/0 saw blade, saw out the square from the copper sheet. File and sand the edges smooth.

4. Center punch inside the traced circle inside the square. Drill a #60 hole.

5. Using a jeweler's saw frame and 2/0 saw blade, thread the blade through the hole and tighten the blade in the saw frame. Supporting the piece on a jeweler's bench pin, pierce out the circle.

6. Use the rounded side of the #2 hand file to smooth the interior edges of the pierced circle.

7. Wrap some 400-grit silicon carbide sandpaper around a ½" (1.3 cm) diameter dowel and sand the interior edges of the pierced circle.

8. Paint Scalex (ball clay) on the front of the pierced copper square. Let it dry completely.

9. If you're using 18-gauge, it's a good idea to counter enamel the back. (With 16-gauge, it's optional.) Place the piece Scalex side down on a bottle cap. Spray or paint binder onto the side facing up. Wearing a dust mask, fill a small sifter halfway with counter enamel or #1880 (Flame Red). Sift over the binder and let dry.

10. Place the piece on a trivet, then place the trivet on a firing rack.

11. Using a firing fork, lift the firing rack up and place in the kiln. Set a timer for about 2 minutes. Time may vary according to each individual kiln and type of kiln.

12. When the timer goes off, remove the rack with the trivet and piece on it and set it down on a fire-safe surface. Allow the piece to cool naturally.

13. Clean the front of the piece where the Scalex was painted on with Penny Brite, Scotch-Brite, or a coarse (80-grit) 3M radial bristle disc. Wipe off any residual dust with a soft cloth or paper towel (*figure 1*).

Follow this diagram to place the glass threads. The actual-size template for making the pendant is on page 154.

14. Place the piece back onto a bottle cap bare side up. This will be the front. Spray or paint binder on the piece. Fill the small sifter halfway with #1880 (Flame Red) enamel. Let dry.

15. Fire the piece as in Steps 10 through 12.

16. When completely cooled, place the piece front side up and repeat Step 14.

17. Carefully break the white glass threads into four different lengths: ³⁄₁₆" (5 mm), ¼" (6 mm), ⁵⁄₁₆" (7.5 mm), and ½" (13 mm). This needs to be done with a pair of fine-tipped stainless tweezers and a gloved hand. The threads can be very sharp on the ends. Group threads of similar lengths.

18. Use fine-tipped tweezers to place the threads onto the dry enamel (*figure 2;* see photo of finished piece and thread placement diagram for placement). Be careful not to bump the piece while doing this. The dry enamel will *help* keep the threads in place, but they can still move easily.

19. Place the piece on a trivet and then onto a firing rack. Fire as in Steps 11 and 12.

20. The edges of the piece may be ground clean or left alone. If there are any spots that stuck to the trivet, grind the edges smooth with an alundum stone or a diamond file under running water.

21. Attach a leather cord with a clasp onto the square as shown in the photo (*figure 3*).

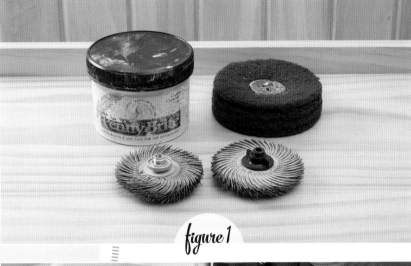

figure 1

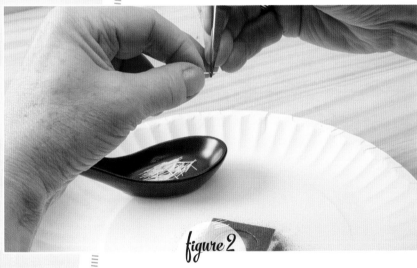

figure 2

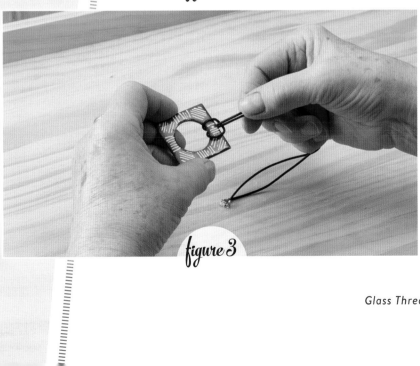

figure 3

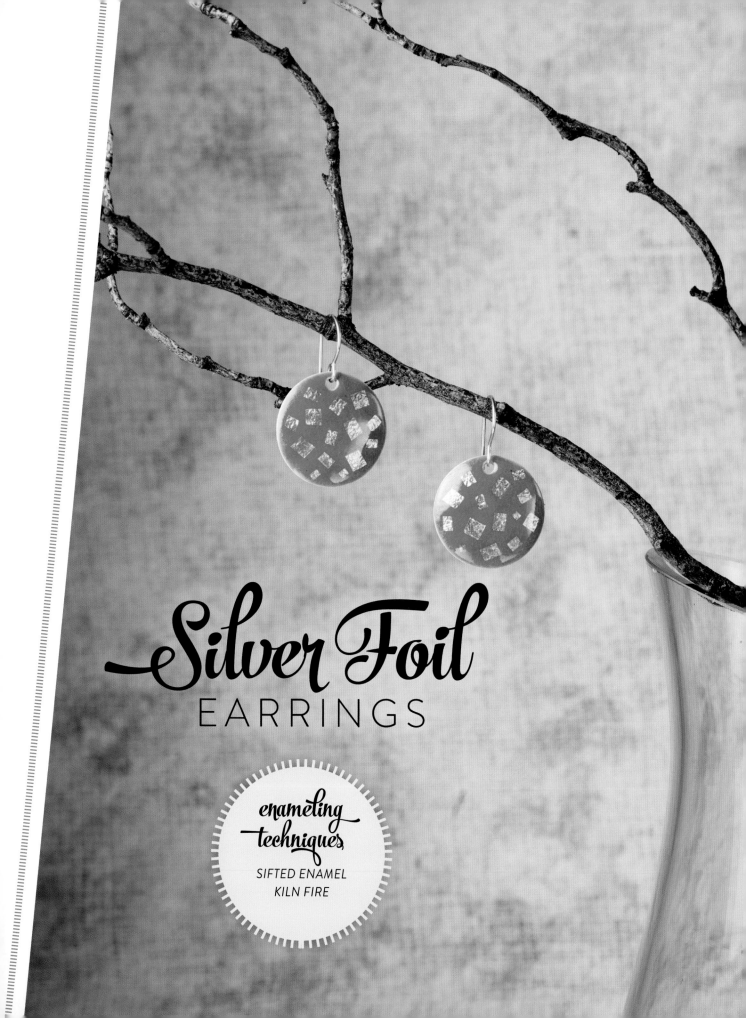

Silver Foil
EARRINGS

enameling techniques
SIFTED ENAMEL
KILN FIRE

These are fun and fast earrings to make, and using foil is a way to make the colors of enamel "pop." The foil design can be nearly anything you would like as long as you can cut it out of the foil with scissors. I have chosen a simple design of random squares.

JEWELRY-MAKING SKILLS

Sawing or disc cutting

Filing

Sanding

Dapping

Drilling holes

MATERIALS

20-gauge fine silver sheet, 1" × 2" (2.5 × 5 cm), or two 20-gauge fine silver discs, 1" each

Binder (Klyr-Fire/distilled water)

Thompson Opaque Enamel: #1420 (Mint Green)

Thompson Transparent Enamel: #2420 (Sea Green)

Fine silver enameling foil, 1" × 1" (2.5 × 2.5 cm)

20-gauge sterling silver round wire, 4½" (11.5 cm), or pair of sterling silver ear wires

TOOLS

Kiln-firing tools (page 22)

Plastic circle template (optional)

Fine-point permanent marker

Jeweler's saw frame and 3/0 saw blades or disc cutter (optional)

#2 flat file (optional)

#400 silicon carbide sandpaper (optional)

Center punch and hammer

Dremel, hand drill, or flexible-shaft machine

#55 drill bit

Dapping block and punch

Rawhide or plastic mallet

Enamel-sifting tools including small sifter (page 25)

Scissors

Fine-tipped tweezers

Fine-tipped natural bristle paintbrush

Wire cutters

Round-nose pliers

Rod, dowel, or BIC pen

Chain-nose or flat-nose pliers

FINISHED SIZE

1" × 1½" (2.5 × 3.8 cm) with ear wire

1. Set the kiln temperature to 1,450°F (788°C), turn it on, and let it warm up.

2. If you are not working with premade circles, use the circle template to draw two 1" (2.5 cm) diameter circles on the 20-gauge fine silver sheet. Use a jeweler's saw to saw out the circles. A disc cutter may also be used to punch out two circles.

3. If you have sawed out the circles, file and then sand the edges smooth.

4. Center punch on each earring about ⅛" (3 mm) from the edge. Drill that mark on each earring with a #55 drill bit.

5. Place the discs one at a time in a shallow recess of a wood dapping block. Tap each disc with the punch using a rawhide mallet to strike it. Move the punch around the disc to get good form.

6. Set the discs on two bottle caps concave side up. Spray with binder.

7. Wearing a dust mask, fill a small sifter halfway full with #1420 enamel. Sift the enamel over the back facing you until you have a thorough and even layer of enamel. You should not see uneven piles of enamel, nor should you be able to see the silver shining back at you through the enamel. Let the pieces dry. This is the counter enamel.

8. Place the domes enamel side up on a firing rack. Fire for about 2 minutes at 1,450°F. Remove from the kiln and cool.

9. If there are any dimples in the enamel, spray binder, sift on a very light layer, let dry, and refire.

10. Place the earrings on two bottle caps, convex side up. Put the dust mask on again. Spray with binder and sift on a thorough layer of #1420 enamel (*figure 1*). Allow to dry.

11. Place each disc convex side up into a three-point trivet and place on a firing rack. Fire as in Step 8. Remove from the kiln and allow to cool.

12. Prepare the silver foil for applying to the pieces. Place on a nonabsorbent surface such as plastic, metal, or tile. The foil will cut easily with sharp scissors. It's best to hold the foil with tweezers while cutting to keep finger grease from getting on it.

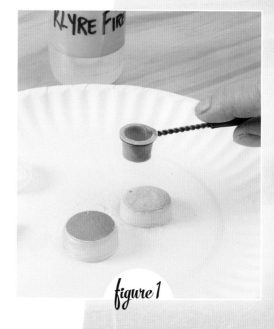

figure 1

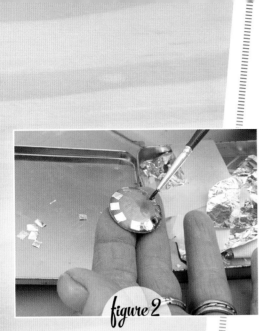

figure 2

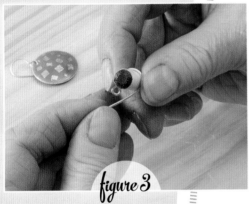

figure 3

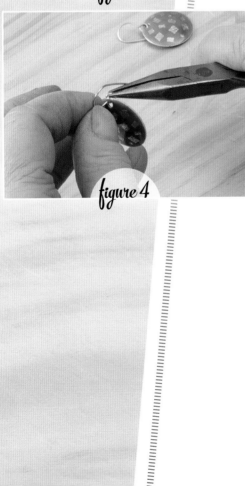

figure 4

13. Dip a small paintbrush in water to wet it (not dripping wet) and touch it to one of the pieces of foil. The wet brush should pick up the foil and moisten it. Lay the foil down onto the base coat of one of the earrings. If there is moisture on the foil, it will stay put. If you need to move it around, moisten the brush more and transfer some of the water to the foil.

14. Continue until you have all the foil down for your design *(figure 2)*.

15. Fire the earrings foil side up on a trivet on a firing rack. The foil fires for the same time and temperature as any layer of enamel would. The enamel below the foil needs to remelt to have the foil bond. Remove from the kiln and allow to cool. The foil will look very smooth.

16. Place the earrings on the bottle caps. Spray them with binder.

17. While wearing a dust mask, fill a small, clean sifter halfway with #2420 enamel. Sift a thorough layer over the entire top of the earring, covering the foil and the base coat that is showing. Allow to dry.

18. Place the earrings on trivets on a firing rack and fire them again. Remove them from the kiln and allow to cool. The foil will look crinkled under the transparent enamel. This is normal.

19. Make 20-gauge sterling ear wires for the earrings: Cut the 4½" (11.5 cm) of round wire in half. Sand the ends smooth on the two pieces of wire. Lightly grip one end of one wire with the round-nose pliers. Roll the pliers with your fingers supporting the wire as it forms a small (⅛" [3 mm]) circle. Place the pliers where the end of the loop meets the longer extension of the wire and give it a small bend forward to center the loop on the wire.

20. Use a rod, dowel, or ballpoint pen to form the larger loop that goes in the ear. Bend the very tip of the wire away from the earring with the pliers *(figure 3)*. Repeat with the other wire.

21. Use chain-nose or flat-nose pliers to open the small loop of the ear wires sideways. Slip the earring onto the loop. Shut the loop sideways. If using commercial ear wires, open the loop, slide the earring on, then close the loop *(figure 4)*.

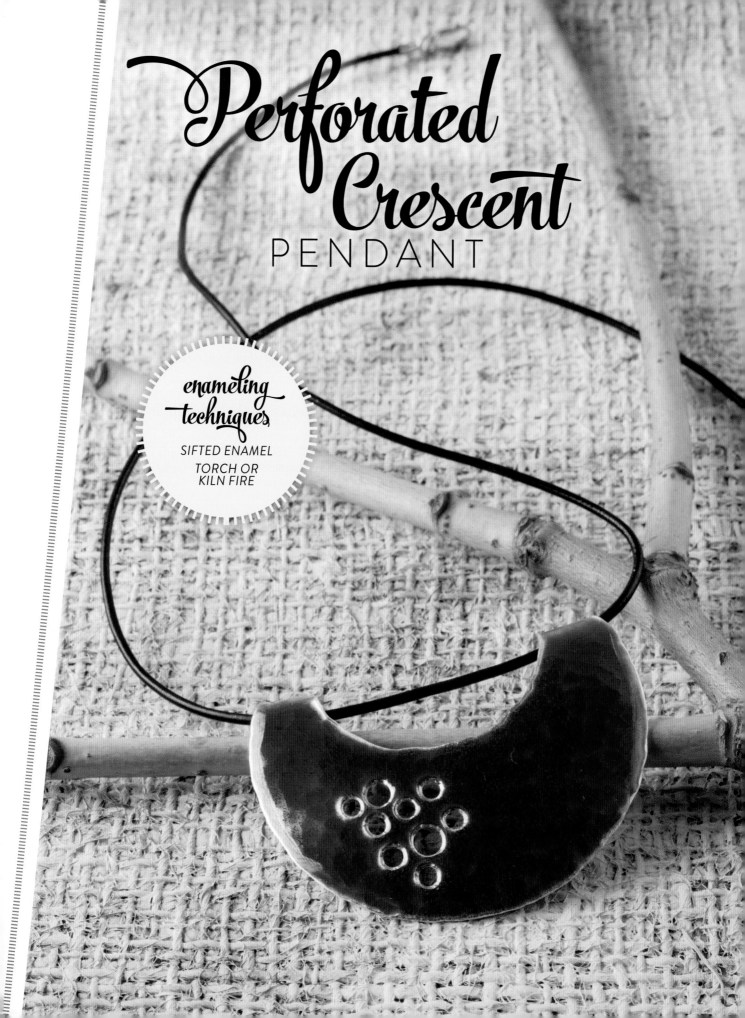

Perforated Crescent
PENDANT

enameling techniques

SIFTED ENAMEL
TORCH OR
KILN FIRE

This is a simple yet very dramatic pendant, made from a single piece of sheet metal. The corners are bent to create bails from which it can be hung. The perforations add interest and a focal point to the pendant. Hammering not only gives the crescent dimension but also lends the piece a more reflective surface.

TIP

If using copper, pale blue or green transparent colors work best. Any opaque will work with copper or silver, but it might be a waste of more expensive material, as the metal will only show on the edges.

JEWELRY-MAKING SKILLS

Sawing

Filing

Sanding

Plier shaping

Hammer texturing

Drilling

MATERIALS

24-gauge copper or fine silver sheet, 2¼" × 2" (5.5 × 5 cm)

Binder (Klyr-Fire/distilled water)

Thompson Transparent Enamels: #2680 (Prussian Blue) or #2350 (Grass Green)

Chain or leather cord

TOOLS

Kiln-firing tools (page 22; this project can also be torch-fired)

Crescent template (page 154)

Fine-point permanent marker or scribe

Jeweler's saw and 4/0 blades

#2 half-round or flat hand file

Ball punch, spoon stake, or rounded anvil horn

Ball-peen or planishing hammer

Center punch and hammer

Hand drill, Dremel, or flexible-shaft machine

³⁄₃₂", ⅛", and ⁵⁄₃₂" drill bits

Large (¼" [6 mm]) drill bit

Round-nose pliers

Enamel-sifting tools (page 25), including ½" (1.3 cm) sifter

FINISHED SIZE

Pendant: 2¼" × 1½" (5.5 × 3.8 cm)

Cord and clasp: 18½" (47 cm) long

1. Set the kiln temperature at 1,450°F (788°C), turn it on, and let it warm up.

2. Trace the crescent shape onto the metal sheet with permanent marker or a scribe.

3. Saw out the crescent shape with a jeweler's saw.

4. File the edges of the crescent smooth with a #2 half-round or flat file.

5. Hammer the crescent shape over a ball punch or rounded stake in rows that slightly overlap each other (*figures 1 and 2*). This will give the crescent some curvature and a faceted finish.

6. Just off center, on the *back* of the pendant, draw a random pattern of five to eight dots in a group.

7. Center punch each dot, then drill the holes in three different sizes, creating a "Swiss cheese" effect.

8. Remove any sharp or rough edges around the holes with the ¼" (6 mm) drill bit (*figure 3*). (See Cleaning Drilled Holes, page 149.)

9. Using round-nose pliers, roll the points of the crescent toward the body of the crescent (*figure 4*). This will create the bails.

10. Set the crescent front side down on a bottle cap.

11. Spray a fine mist of binder on the back of the piece.

12. Put on a dust mask. Fill a small (½" [1.3 cm]) sifter halfway with the enamel color of your choice.

13. Sift the dry enamel onto the crescent in even rows that slightly overlap each other. There should be enough enamel covering that you do not see silver shining directly through the enamel. Do not put so much on that you see lumps and piles that are uneven.

14. Transfer the piece to a trivet and carefully place the trivet onto a firing rack. Let dry.

15. Lift the rack up with a firing fork and place the setup into the kiln. Set a timer for 2 minutes.

16. When the timer goes off, carefully remove the piece with the firing fork and set the rack down on a fire-proof surface. Allow to cool completely.

17. When cool, remove the piece from the trivet.

18. Wearing a dust mask, place the crescent on a bottle cap, front side facing you. Spray with binder and sift an even layer of the same enamel onto the front of the piece. Place on a trivet on a firing rack.

19. Repeat Steps 15 and 16.

20. When the crescent is completely cooled, string a chain or leather cord through the bent corner bails.

TIPS

If holes get clogged with enamel while sifting, gently ream them with a toothpick before firing.

It's not necessary to cover the bails with enamel.

If there are thin or thick spots in the fired enamel, spray again with binder and sift on another thin layer of enamel, then fire again as in Steps 15 and 16.

TIP

If you're planning to make more than one pendant, it's helpful to make a thin metal template that can be traced repeatedly (see page 152).

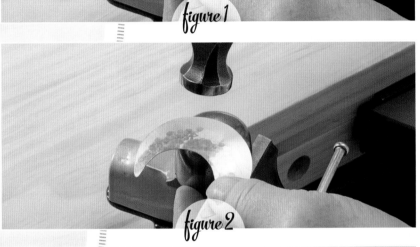

figure 1

figure 2

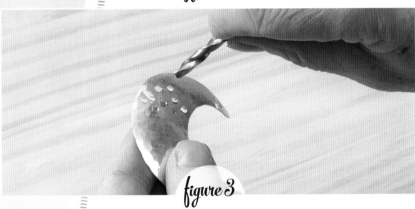

figure 3

figure 4

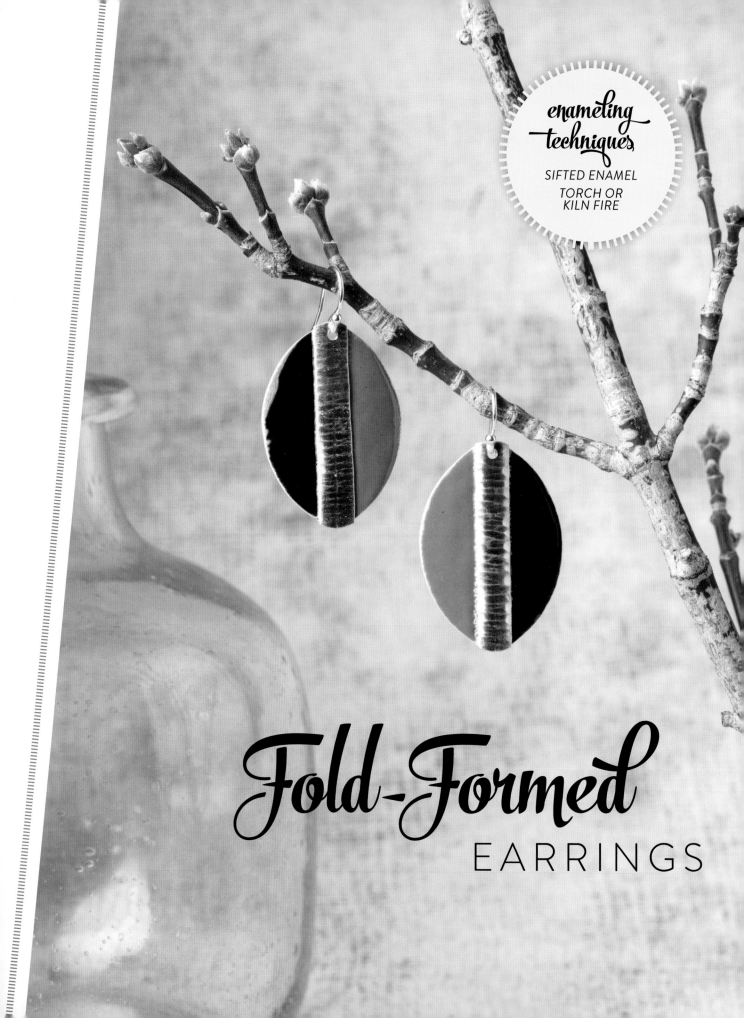

Fold-Formed
EARRINGS

Fold forming, developed by Charles Lewton-Brain, is a method of giving very thin metal sheet integrity and strength. Enamels tend to add weight to jewelry pieces. By combining the enamels with fold forming, jewelry can be enameled and remain relatively lightweight.

JEWELRY-MAKING SKILLS

Sawing

Annealing

Hammering

Drilling

MATERIALS

26-gauge fine silver sheet, 1⅞" × 1⅞" (4.75 × 4.75 cm)

Binder (Klyr-Fire/distilled water)

Thompson Opaque Enamels: #1430 (Spruce), #1995 (Black Opaque),

Thompson Transparent Enamel: #2915 (Oil Gray)

Pair of sterling silver ear wires (or see page 149 for instructions on making your own)

TOOLS

Kiln-firing tools (page 22), including 2 three-point trivets, 1½" × 1½" (3.8 × 3.8 cm) each (this project can also be torch-fired)

Fine-point black permanent marker

Plastic circle template

Jeweler's saw frame and 4/0 saw blades

400-grit sanding stick

Soldering tools (page 153) and torch (not handheld butane) for annealing

Ruler

Smooth-jawed vise

Rawhide or plastic mallet

Riveting or cross-peen hammer

Paring knife (optional)

Center punch and hammer

Drill (hand or electric), Dremel tool, or flexible-shaft machine

#52 drill bit

Brass brush and detergent

3M radial bristle disc #400 (blue)

Polishing lathe (optional)

UV filtering safety glasses

Enamel-sifting tools (page 25), including ½" (1.3 cm) sifter

Masking tape

Diamond cloth, alundum stone, or 400-grit wet/dry sandpaper

2 pairs chain-nose pliers

FINISHED SIZE

1" × 1¾" (2.5 × 4.5 cm) with ear wire

1. Set the kiln temperature at 1,450°F (788°C), turn it on, and let it warm up.

2. Using a fine-point permanent marker and a circle template, trace two 1 ⅜" (3.5 cm) circles onto a piece of 26-gauge fine silver sheet.

3. Use a jeweler's saw and a 4/0 blade to saw out the two circles. Sand the edges smooth with a 400-grit sanding stick.

4. Anneal, pickle, rinse, and dry the two circles.

5. One at a time, place the two circles back into the 1 ⅜" (3.5 cm) void in the template. Draw a line with the marker across the center lines lengthwise on the template. Measure from the center line ⅛" (3 mm) on each side and parallel to the center. Draw a straight line that distance on each side of the center line.

6. Draw a straight line that distance on each side of the center line. Now there should be three lines: one center line and one ⅛" (3 mm) away from the center on either side.

7. While supporting the piece underneath with your index fingers, place your thumbs on either side of the farthest lines and start to bend the metal down. Keep the middle line centered. Bend into a deep "U."

8. Place the "U" in a smooth-jawed vise so that the center line is up and the lines on either side are even with the vise jaws. Close the jaws and pinch tight.

9. Use a plastic or rawhide mallet to tap the top of the "U" in the vise flat **(figures 1 and 2)**.

10. With the cross-peen end of a riveting hammer, texture the flattened "U."

11. Remove the pieces from the vise and anneal them. Pickle, rinse, and dry the pieces.

12. Use your two thumbnails or a paring knife to wedge open the two flat ends. Bring the ends into the same plane as the flattened, textured "T" fold. Tap even and flat with a rawhide mallet or plastic mallet over a hard wood or steel surface.

13. With your thumb and index fingers, add a slight "S" curve to each earring.

14. Center punch, then drill a #52 hole in the top of the "T," one on each earring.

15. If any oxides (dark gray film) remain in the fold after opening, pickle, rinse, and dry again. Enamels prefer clean metal.

figure 1

figure 2

figure 3

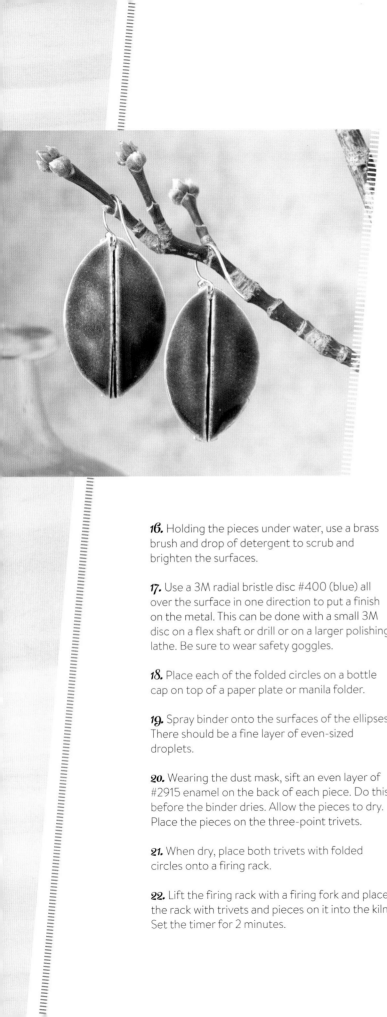

23. When the timer goes off, remove the pieces from the kiln. Set them down on a fire-safe surface to cool.

24. Cut a narrow strip of masking tape for each earring. This will cover the hammered fold while sifting on enamel. Place the tape on the hammered fold of each earring and press down firmly. It helps if the tape is longer than the fold, for easy removal (*figure 3*).

25. Wearing a dust mask, spray binder over the front of each earring, over the tape. Sift #1430 enamel on one side of each earring. Clean the sifter with paper towel, inside and out, so as not to contaminate one color with another. Sift #1995 enamel on the other side of each earring (*figure 3*). Let dry thoroughly. Carefully pull off the tape, gripping the end that extends past the fold, and pull in one direction.

26. Place the earrings on trivets. Place the trivets on a firing rack.

27. Repeat Steps 22 and 23.

28. When the earrings are cool, carefully check to make sure there are no sharp edges where the piece touched the trivet. If there are, use a diamond cloth, alundum stone, or wet/dry sandpaper under a dribble of water to smooth.

29. Attach the ear wires using chain-nose pliers.

16. Holding the pieces under water, use a brass brush and drop of detergent to scrub and brighten the surfaces.

17. Use a 3M radial bristle disc #400 (blue) all over the surface in one direction to put a finish on the metal. This can be done with a small 3M disc on a flex shaft or drill or on a larger polishing lathe. Be sure to wear safety goggles.

18. Place each of the folded circles on a bottle cap on top of a paper plate or manila folder.

19. Spray binder onto the surfaces of the ellipses. There should be a fine layer of even-sized droplets.

20. Wearing the dust mask, sift an even layer of #2915 enamel on the back of each piece. Do this before the binder dries. Allow the pieces to dry. Place the pieces on the three-point trivets.

21. When dry, place both trivets with folded circles onto a firing rack.

22. Lift the firing rack with a firing fork and place the rack with trivets and pieces on it into the kiln. Set the timer for 2 minutes.

TIP

When annealing, put a black permanent marker mark on the sheet metal. At the annealing temperature, the pigment will fade. This helps prevent overheating.

(See page 148 for more tips on annealing silver.)

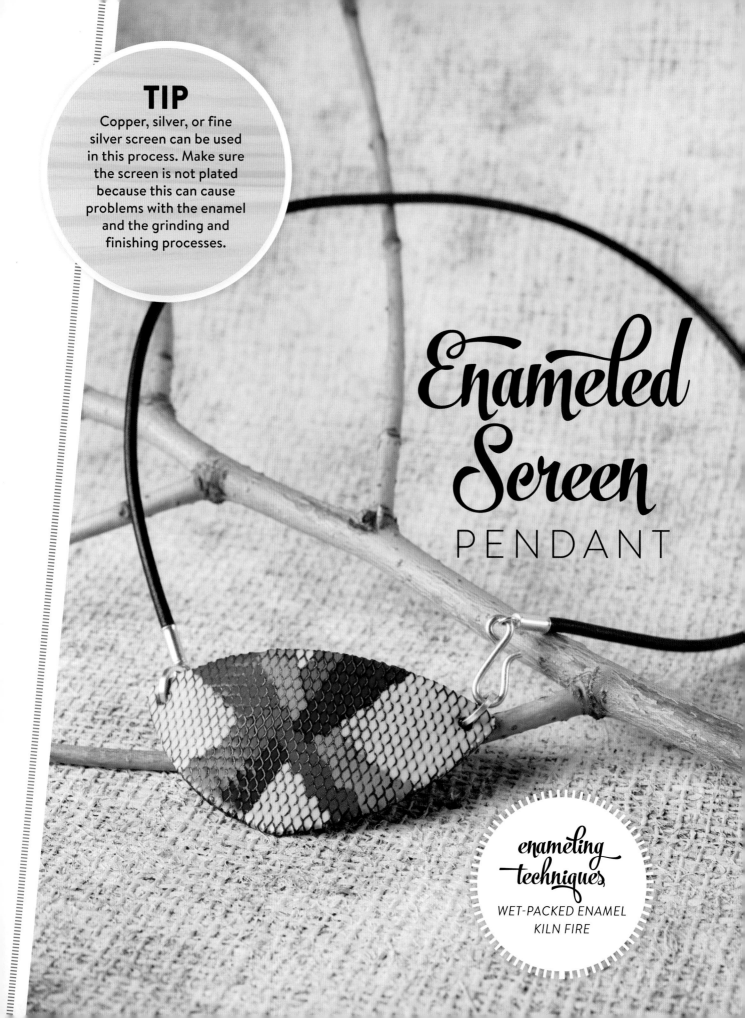

TIP
Copper, silver, or fine silver screen can be used in this process. Make sure the screen is not plated because this can cause problems with the enamel and the grinding and finishing processes.

Enameled Screen

PENDANT

enameling techniques

WET-PACKED ENAMEL
KILN FIRE

Enameling with screen is an interesting method of creating unique patterns and designs. The screen presents its own pattern, with each segment acting as a cell, which can then be filled with enamel to create even more patterns. Designs can range from abstract to almost resembling needlepoint. The screen may have a diamond-like pattern or a traditional square design. I am using a diamond-pattern screen in this project.

JEWELRY-MAKING SKILLS

Sawing

Filing

Sanding

Drilling

Basic forming

MATERIALS

16- or 18-gauge copper sheet, 3" × 1¾" (7.5 × 4.5 cm)

Binder (Klyr-Fire/distilled water)

Copper screen, 3¼" × 2" (8.5 × 5 cm)

Thompson Opaque Enamels: #1110 (Pastel), #1890 (Victoria Red), #1870 (Orient Red), #1910 (Pussywillow), #1940 (Steel), #1995 (Black), and #2030 (Medium Fusing Clear)

Two 16- or 18-gauge jump rings, ⁵⁄₁₆" (7.5 mm) each

Chain or cord with loop on one end and ½" (1.3 cm) S-hook on the other

TOOLS

Kiln-firing tools (page 22)

Pendant template (page 155)

Graph paper

Fine-point permanent marker

Scissors

Glue stick

Agate burnisher (optional)

Jeweler's saw frame and 2/0 saw blades

#2 flat hand file

#400 silicon carbide sanding stick

Ruler

Center punch and hammer

Drill (hand or electric), Dremel tool, or flexible-shaft machine

#55 and #40 drill bits

Rawhide mallet

Sandbag or bracelet/rounded mandrel

Penny Brite and Scotch-Brite pad

Enamel-sifting tools (page 25)

Torch (optional)

Pickle

Wet-packing enamel tools (page 30)

00 or 000 sable paintbrush

Alundum stone

Glass brush

Chain-nose pliers or flat-nose pliers (to open and close jump rings)

Metal shears (to cut the screen)

Spatula

FINISHED SIZE

Pendant: 3" × 1½" (7.5 × 3.8 cm)

Cord and clasp: 19" (48.5 cm) long

1. Set the kiln temperature to 1,450°F (788°C), turn it on, and let it warm up.

2. Cut out the pendant template and glue it with a glue stick to the clean copper sheet. Burnish the paper down with the back of a fingernail or an agate burnisher. Allow the glue to dry thoroughly **(figures 1 and 2)**.

3. Saw the design out with a jeweler's saw and 2/0 saw blade.

4. File and sand the edges of the shape until smooth.

5. Run warm water over the paper design on the copper. It will lift off easily.

6. Measure about ⅛" (3 mm) from each corner, top, and side, to mark where to drill the holes for hanging the pendant.

7. Center punch each mark and drill with a #55 drill bit. Re-drill the holes with a #40 drill bit to enlarge them.

8. Using a rawhide mallet and curved surface, such as a sandbag or bracelet mandrel, tap the copper shape until it has a slightly rounded form.

9. Scrub the copper shape with Penny Brite and a Scotch-Brite pad to clean it.

10. Set the copper shape on two bottle caps, back facing up. Spray with binder.

11. Fill a small sifter halfway with #1995 enamel. Sift onto the copper for the counter enamel. Set the piece on a trivet on a firing rack. Allow to dry.

12. Fire the piece in a kiln for 2 minutes at 1,450°F. Remove from the kiln and let cool.

13. Anneal the copper screen either in the kiln for 1 minute at 1,450°F or use a torch with a soft flame until the copper is dull red. Put the screen in a pickle or *gently* rub Penny Brite on it and let it sit for a couple of minutes, then rinse and dry it. The piece of screen will be *very* soft.

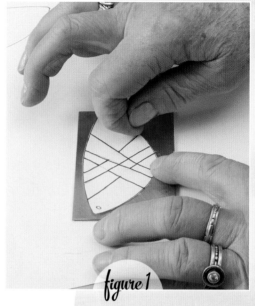

figure 1

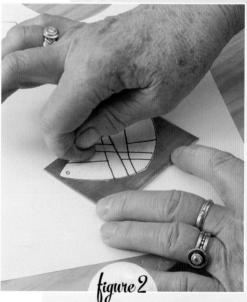

figure 2

figure 3

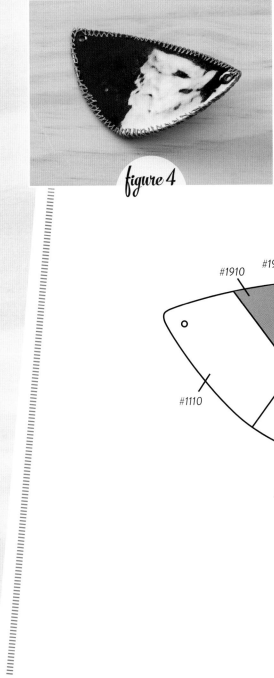

figure 4

14. Clean the front of the copper pendant shape with Penny Brite to remove oxides that will have developed from firing the counter enamel.

15. Gently press the screen onto the front of the copper piece. Trim the screen with metal shears, leaving ¼" (6 mm) of excess beyond the perimeter. Remove the copper screen and set aside.

16. Spray binder on the front of the pendant shape. Sift a thin layer of #2030 clear enamel onto the piece. Set on a trivet on a firing rack and allow to dry.

17. Fire for 2 minutes at 1,450°F. Remove from the kiln and let cool.

18. Place the screen onto the fired clear base coat. With your fingers, carefully push the excess screen down and around the edges so that it is snug and fitted to the pendant shape (*figures 3 and 4*).

19. Referring to the Enamel Placement Diagram, use a permanent marker to draw the design divisions on the screen as guides.

20. Place five plastic spoons on a paper plate. Place the pendant piece on two bottle caps to keep it stable while applying the enamel. Write the numbers of the colors of enamel on each spoon with a permanent marker.

21. Place a small amount of each enamel in the appropriate spoon. Add a few drops of distilled water to each enamel to hydrate it.

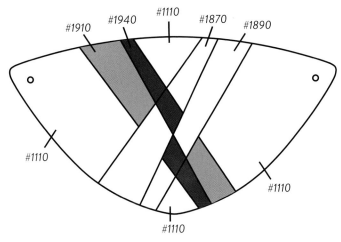

#1910 #1940 #1110 #1870 #1890

#1110

#1110

#1110

Enamel Placement Diagram

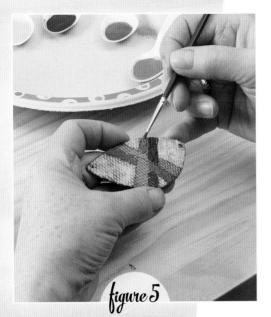
figure 5

22. Using a 00 or 000 sable paintbrush, carefully add a small amount of enamel to the spaces as planned in the design layout. Be sure to rinse the brush thoroughly before applying a different color of enamel. It is very difficult to see the design when just the screen is down. There will be four or five more additions and firings of enamel. Build slowly and carefully. The design will emerge slowly with these additions. Allow the first application to dry thoroughly *(figure 5)*.

23. Set the piece on a trivet on a firing rack and fire. It may take slightly longer than usual for the piece to fire completely. This metal is thicker than normal and larger. Try 2 minutes at 1,450°F. If that isn't enough to get a fire polish, increase the time 10 to 15 seconds at a time. Let it cool.

24. Add more enamel to each segment of the design. Allow to dry and then fire again. Don't try to fill the segments too much at any one time. Add color gradually and fire as usual. Cool the piece.

25. When the piece has been wet packed and fired repeatedly, the pattern of the screen will begin to be buried by the enamel. At this point, grind the front surface with an alundum stone until the screen is revealed again. Check for shiny spots after grinding. The shiny spots are where more enamel is needed. Carefully add small amounts to these shiny low spots. Let dry and then fire and cool again.

26. Once you have filled and fired to create a level surface, grind again with the alundum stone. Be careful not to grind the edges too aggressively. It's easy to expose the sharp edges of the copper screen. Grind the edges just until they are smooth to the touch, no more. The goal is to grind the front surface until the pattern of the screen is revealed and there are no pits or valleys.

27. Scrub with a glass brush under water. Fire the piece one more time for 10 seconds less than usual for a fire polish.

28. Attach the jump rings, one in each of the pendant holes, and close them with chain-nose pliers.

29. Attach the loop end of the chain or cord to one of the jump rings on the pendant. The S-hook will be the closure, by hooking it into the other jump ring on the pendant.

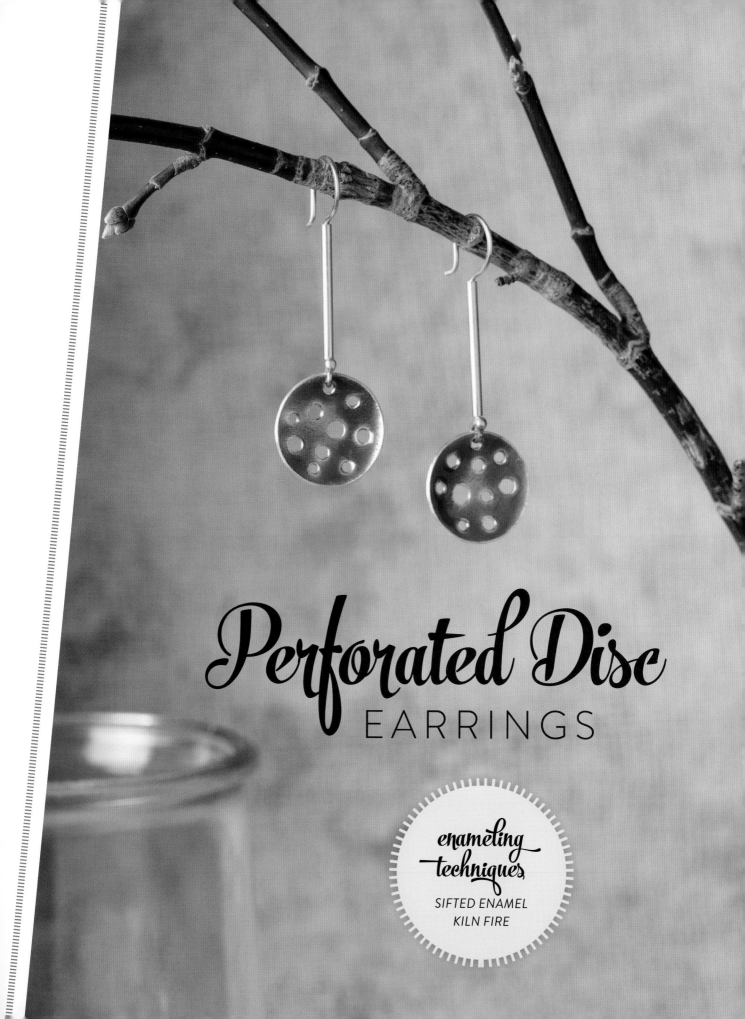

Perforated Disc
EARRINGS

enameling
techniques

SIFTED ENAMEL
KILN FIRE

These eye-catching earrings are lightweight and easy to make. For beginner jewelry makers, precut discs are readily available through many jewelry supply companies. More advanced jewelers may choose to saw the discs out of sheet or use a disc cutter. The peacock green enamel I used here is a vibrant and attractive color choice. Unlike many transparent enamels, it has good clarity and brilliance straight out of the jar without having to be washed.

JEWELRY-MAKING SKILLS

Sawing

Filing

Sanding

Drilling

Using pliers

Dapping

Forming wire

MATERIALS

Two ¾" (2 cm) 20-gauge fine silver discs or 20-gauge fine silver sheet, 1½" × ¾" (3.8 × 2 cm)

Binder (Klyr-Fire/distilled water)

Thompson Transparent Enamel: #2335 (Peacock Green)

2mm round sterling silver tubing, 2" (5 cm)

18-gauge sterling silver round wire, 6" (15 cm)

TOOLS

Kiln-firing tools (page 22)

Jeweler's saw frame and 3/0 blades

Disc cutter (optional)

Dividers or plastic circle template

#2 flat or half-round hand file (optional)

400-grit silicon carbide sanding stick

Ruler

Fine-point permanent marker

Center punch and hammer

Drill (hand or electric), Dremel tool, or flexible-shaft machine

#60 (1 mm), #50 (1.8 mm), #43 (2.3 mm), and #30 (3.25 mm) drill bits

Large (about ¼" [6 mm]) drill bit

Dapping block and punch

Rawhide or plastic mallet

Enamel-sifting tools (page 25)

Toothpick or paper clip (optional)

Wire cutters

Insulated-grip tweezers

Torch (optional)

Round-nose pliers

Flat-nose pliers

⅜" (1 cm) dowel or BIC pen

FINISHED SIZE

⅞" × 2½" (2.2 × 6.5 cm) with ear wire

1. Set the kiln temperature at 1,450°F (788° C), turn it on, and let it warm up.

2. If sawing out the discs, dividers or a circle template may be used to mark the circumference of the circles to be sawed out. Using dividers, measure ⅜" (1 cm) (half the diameter) and adjust the legs to be that far apart. Situate one leg on the silver sheet and spin the other around it, scribing the circumference of ¾" (2 cm) **(figure 1)**. Repeat for the second earring. Then saw them out.

3. If the circles have been sawed out, the edges will need to be smoothed and perfected. Use a #2 flat file to file the edges **(figure 2)**. Then sand the edges with 400-grit sandpaper wrapped around a flat piece of wood.

4. Using the ruler and permanent marker, make one small dot about ³⁄₃₂" (2.5 mm) from the edge of each disc. Center punch that dot and drill a #60 hole there. This will be the hole from which the earring will be hung.

5. Mark a series of random dots on each earring with the permanent marker. Center punch those marks, then drill holes with different-size drill bits, creating a "Swiss cheese" pattern.

6. Use the ¼" (6 mm) drill bit to remove any sharp or rough edges on the holes. (See Cleaning Drilled Holes, page 149.)

7. Place the discs one at a time in a shallow recess of a dapping block. Use a punch and mallet to form the discs into domed shapes **(figure 3)**.

8. Place each drilled, domed disc on a bottle cap. It does not matter whether the convex or concave side is facing up first. Spray each disc with binder.

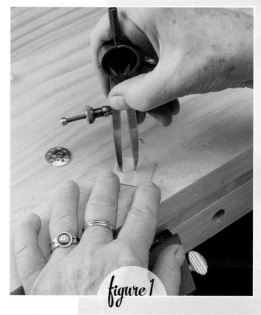

figure 1

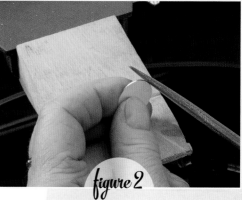

figure 2

figure 3

9. Wearing a dust mask, fill a small sifter halfway with #2335 enamel.

10. Sift a thorough layer of enamel onto each of the earring discs. If the enamel clogs the holes, use a toothpick or paper clip to ream out the enamel from the holes **(figure 4)**.

11. Place each disc on a trivet, then place the trivet on to a firing rack. Allow to dry.

12. Use a firing fork to pick up one rack and place in the kiln. Fire for about 2 minutes.

13. When fired, remove the rack from the kiln and set on a fire-safe surface. Allow to cool naturally.

Repeat the firing process with the second earring.

14. When cool, place the discs back onto bottle caps, enameled side down. Repeat Steps 8 through 13.

15. Starting with an even, smooth end on a piece of 2mm round sterling tubing, measure halfway with a pair of dividers. Carefully saw the length in half with a jeweler's saw.

16. Sand the ends of the tubing smooth, even, and flat with a 400-grit sanding stick.

17. Optional: Hold the 18-gauge wire with a pair of insulated-grip tweezers.

18. Light a torch with a small oxidizing flame (tight blue cone, slightly hissing). The tip of the tight blue cone should be about ¼" (6 mm) from one end of the wire. Hold the flame there until the end of the wire melts and forms a small ball **(figures 5 and 6)**. Repeat for the other end of the wire. You can skip balling the wire and sand the ends of the wire smooth if you prefer.

19. Cut the 6" (15 cm) wire in half.

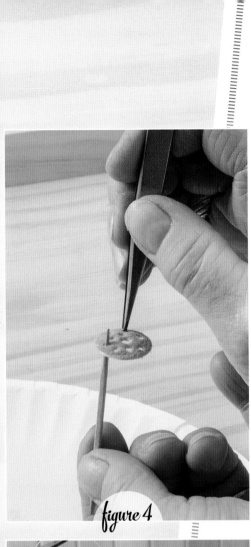

figure 4

figure 5

figure 6

20. With round- or flat-nose pliers, form a loop at the balled end of the wire. The loop should be close to ⅛" (3 mm) in diameter. At the top of the loop, grip the long side of the wire with flat-nose pliers. Bend that wire back slightly so the loop is centered on the long piece of wire.

21. Open the loop sideways with flat-nose pliers. Slip one of the discs onto the wire through the #60 hole and into the loop, so that the concave side is forward *(figure 7)*. Repeat with the second disc.

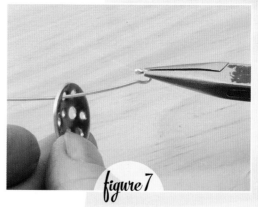

figure 7

22. Slip one of the pieces of tubing onto the wire, so that it rests against the top of the loop, above the disc. Repeat with the second earring.

23. At the end of the tubing away from the disc, use flat-nose pliers to bend the wire at a right angle to the tube, in the forward direction and centered with the disc below.

24. Hold a ⅜" (1 cm) dowel or something similar (the shank on a BIC pen works great) on the wire about two-thirds of the distance from the top of the tube. Hold the dowel firmly against the wire and roll it away from the front of the earring toward the back, creating a large loop *(figure 8)*.

Use round- or flat-nose pliers to bend the very tip of the ear wire up in a small reverse curve.

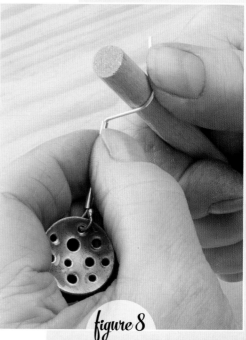

figure 8

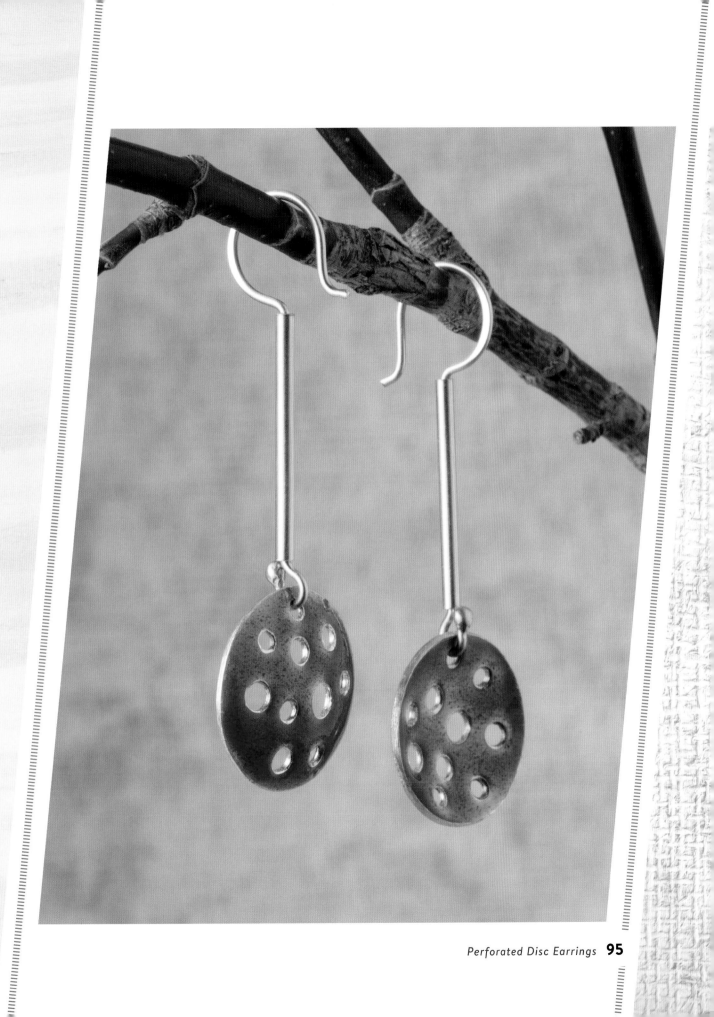

Charm
BRACELET

enameling techniques

SIFTED ENAMEL
TORCH FIRE

This charm bracelet is easy to make in a short amount of time. It suits those who have some jewelry-making experience, but those with less experience can use precut shapes and commercial jump rings. The small size of the charms eliminates the need for counter enamel and simplifies the whole project. The texture or design on the metal can be done any number of ways. If a rolling mill is not available, hammering or stamping are viable options.

JEWELRY-MAKING SKILLS

Sawing

Filing

Sanding

Roll printing or stamping

Using pliers

Forming wire

MATERIALS

20-gauge fine silver sheet, ½" × 6" (1.3 × 15 cm), or 12 precut shapes, about ½" (1.3 cm) diameter each

Binder (Klyr-Fire/distilled water)

Thompson Transparent Enamels: #2310 (Peppermint Green), #2625 (Winter Blue), #2335 (Peacock Green), #2320 (Spring Green), #2325 (Gem Green), #2410 (Copper Green), #2520 (Aqua Blue), #2530 (Water Blue), #2615 (Periwinkle Blue), #2340 (Glass Green), and #2420 (Sea Green)

18-gauge sterling silver wire, 12" (30.5 cm) or thirteen ⁵⁄₃₂" (4mm) (outside diameter) commercially made jump rings

6" (15 cm) sterling silver chain: long and short (6mm long/2mm short) or cable (3–4mm diameter links)

Sterling silver lobster clasp with jump ring, 10mm

TOOLS

Texturing tools (stamps/hammers/rolling mill)

Plastic oval template or oval disc cutter

Fine-point marker

Jeweler's saw frame and 2/0 saw blades or oval disc cutter

#2 half-round or flat hand file

400-grit wet/dry sandpaper

Center punch and hammer

Drill (electric), Dremel tool, or flexible-shaft machine

#60 drill bit

⅛" (3 mm) drill bit

Enamel-sifting tools (page 25), including two or more small sifters

Torch-firing tools (page 18)

Hand drill

3 mm rod

Wooden bench pin

2 pairs chain-nose or flat-nose pliers

FINISHED SIZE

7" (18 cm) long

1. Texture the fine silver sheet with stamps, a hammer, or a rolling mill. If using precut shapes, texture the individual pieces.

2. Using the template and a fine-tip marker, trace twelve ½" (1.3 cm) ovals onto the textured sheet. Cut out the ovals with a jeweler's saw or an oval disc cutter. If sawed out, file and sand the edges smooth.

3. Place each oval in an oval template. Mark the quarter division mark at the top of the oval onto each of the ovals with a fine-point marker. About ³⁄₃₂" (2.5 mm) from the top, mark a line crossing the division mark (*figure 1*).

figure 1

4. Center punch where the two lines cross. Drill a #60 hole where the center punch is on each oval.

5. Clean up the rough burr of metal around the drilled holes (*figure 2;* see page 149).

6. Set the ovals front side up on bottle caps. Spray each one with binder.

7. Put on the dust mask. One color at a time, put a small amount of enamel into a clean sifter. Sift a light but thorough layer of enamel onto each oval with each enamel (*figure 3*). Be sure to clean the sifters in between using each color.

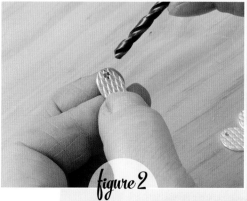

figure 2

8. Place the twelve ovals directly onto a firing rack to dry (there is no counter enamel) (*figure 4*). If you are using a smaller rack, you can fire the ovals in two or more batches.

9. Put the firing rack on a soldering tripod (*figure 5*). If using a Smith Handi-Heat torch, put a #2 tip on the torch.

10. Light the torch and heat the pieces from underneath. Watch carefully to move the heat away from each piece as soon as it reaches fire polish. These small silver pieces can melt if overheated.

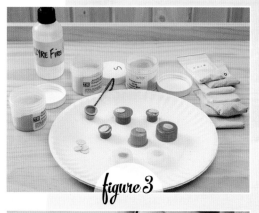

figure 3

11. When all the pieces are fire polished, turn the torch off and allow the pieces to cool completely.

12. There should be no cleanup needed on these pieces. Check all edges to make sure there are no bumps of enamel on them. If there are, sand them with #400 wet/dry sandpaper under a drizzle of tap water. Dry all the pieces.

13. Make a coil using the 18-gauge sterling silver wire and a hand drill with 3 mm rod in it. (See Making Jump Rings, page 150.)

14. Use a jeweler's saw with a 2/0 saw blade to saw through the coil to create jump rings (*figure 6*). Twelve of the rings will be the connectors for the ovals to the chain, and one will be the loop the clasp attaches to.

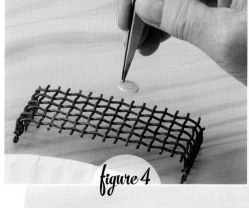

figure 4

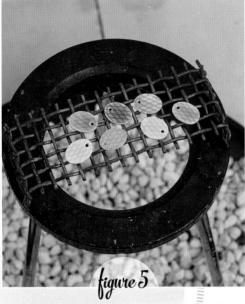

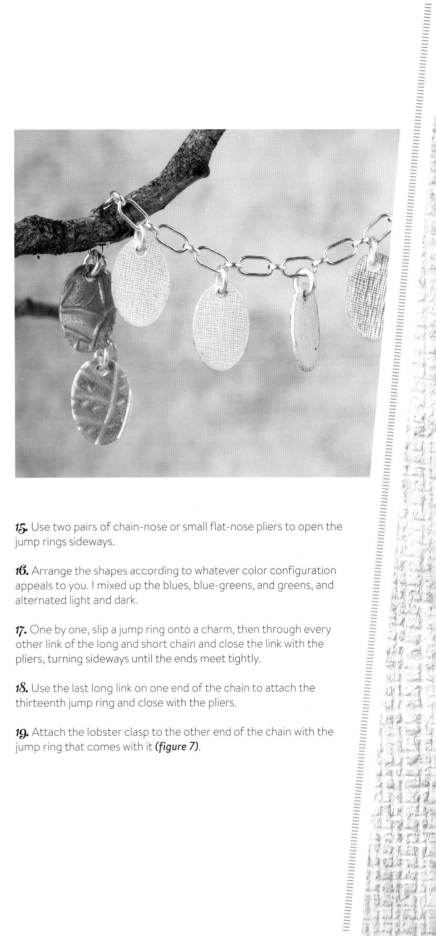

figure 5

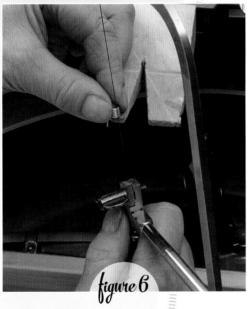

figure 6

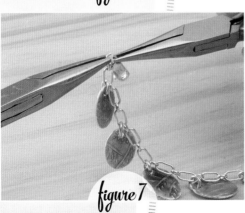

figure 7

15. Use two pairs of chain-nose or small flat-nose pliers to open the jump rings sideways.

16. Arrange the shapes according to whatever color configuration appeals to you. I mixed up the blues, blue-greens, and greens, and alternated light and dark.

17. One by one, slip a jump ring onto a charm, then through every other link of the long and short chain and close the link with the pliers, turning sideways until the ends meet tightly.

18. Use the last long link on one end of the chain to attach the thirteenth jump ring and close with the pliers.

19. Attach the lobster clasp to the other end of the chain with the jump ring that comes with it *(figure 7)*.

Three-Leaf
EARRINGS

enameling
techniques

SIFTED ENAMEL
KILN FIRE

This design uses very thin fine silver, which is fold formed to give it strength and allow it to be enameled, while still keeping it lightweight. I love the way the silver sounds as the leaves rustle against each other. These earrings could also be made out of copper, although opaque enamels would work better, as transparent enamels would look dark.

JEWELRY-MAKING SKILLS

Sawing

Filing

Sanding

Fold forming

Hammering

Drilling

Using pliers

Wire forming

MATERIALS

24-gauge fine silver sheet, two 1" × 1" (2.5 × 2.5 cm), two 1¼" × 1" (3.2 × 2.5 cm), two 1½" × 1" (3.8 × 2.5 cm)

Binder (Klyr-Fire/distilled water)

Thompson Transparent Enamels: #2420 (Sea Green), #2240 (Olive), #2335 (Peacock Green), and #2320 (Spring Green)

14-gauge sterling silver round wire, 2" (5 cm)

18-gauge sterling silver round wire, 10" (25.5 cm)

TOOLS

Kiln-firing tools (page 22)

Torch or kiln for annealing

Ruler

Fine-point permanent marker

Vise, 2" (5 cm) or larger jaws

Steel bench block

Rawhide or plastic mallet

Work gloves

Table (butter) knife

Leaf templates (page 155)

Steel scribe (optional)

Jeweler's saw frame and 4/0 saw blades

#2 or #4 flat hand file

Center punch and hammer

Drill (hand or electric), Dremel tool, or flexible-shaft machine

2 mm drill bit

400-grit sandpaper and #2 or #4 file

Enamel-sifting tools (page 25)

Alundum stone or diamond file, 400 or 800 grit

⅜" (1 cm) and ¼" (6 mm) dowels, each 3" (7.5 cm) long

Soldering tools (page 153)

Easy silver solder

Riveting hammer or cross-peen hammer

Polishing cloth or fine abrasive pad

Chain-nose pliers (for closing jump rings and attaching ear wires)

Round-nose pliers (for making ear wires)

Planishing hammer or polished ball-peen hammer

FINISHED SIZE

2½" (6.5 cm) long with ear wire

1. Set the kiln temperature at 1,450°F (788°C), turn it on, and let it warm up.

2. Anneal the six pieces of fine silver sheet.

3. With a ruler, draw a marker line lengthwise down the center on each of the six pieces (*figure 1*).

4. With your hands, fold each piece in half. The center will not be flat together. Place the fold in a vise and tighten until it is flat (*figure 2*). Anneal and cool the folded pieces. Use a table knife to wedge into the fold and wiggle it open. Tap with a mallet over a bench block to complete the opening.

5. Place each piece on a steel bench block. Strike the fold of each piece with a rawhide or plastic mallet until it is completely flattened. Anneal each of the pieces again.

6. Put on a pair of work gloves. Use a table (butter) knife to wedge into the folded pieces one at a time. Wiggle the knife back and forth until you can grip the edges of the metal and open the fold. Open as far as you can with your hands (*figure 3*).

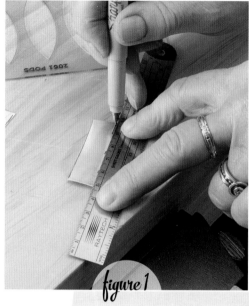

figure 1

TIP
It's a good idea to wear work gloves to protect your hands from the thin, sharp metal.

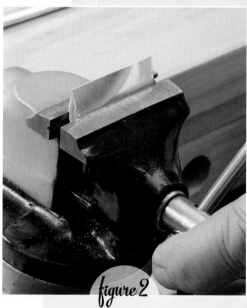

figure 2

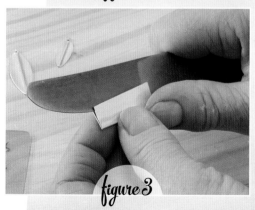

figure 3

7. Place each piece on a steel bench block fold side up and strike the crease of the fold with a planishing or ball-peen hammer to crisp up the fold and make each piece flat and even *(figure 4)*.

8. Using the templates and a fine-point marker or a steel scribe, trace two 1⅜" (3.5 cm) leaf shapes onto the two 1½" (3.8 cm) pieces of silver, two 1" (2.5 cm) leaves onto the two 1¼" (3.2 cm) pieces of silver, and two ⅞" (2.2 cm) leaves onto the smallest pieces of silver, lining up the points on the leaves with the crease of the fold *(figure 5)*.

9. Saw out the six leaf shapes with a jeweler's saw and 4/0 saw blade. File the edges of each piece until smooth.

10. Center punch each piece on one end about ⅛" (3 mm) from one of the points. Drill a 2 mm hole into each of the six center punch marks. If there is a rough burr left around the hole, lightly sand it with sandpaper or a small file.

11. Place each of the leaf shapes back facing up (I have the inside of the fold on the back) on bottle caps over a paper plate or manila folder.

12. Spray each piece with binder. Fill a small sifter halfway with #2420 enamel. Sift a thin but thorough layer of the enamel onto the back of each leaf piece. Set each leaf on a firing rack, enamel side up. Allow to dry.

13. Fire the pieces in a kiln until fire polished (2 minutes at 1,450°F). Remove and allow to cool.

14. Return the six pieces to the bottle caps, bare side up. Spray with binder. Sift #2240 onto the smallest pieces, #2320 onto the mid-sized ones, and #2335 onto the longest pieces. Allow to dry.

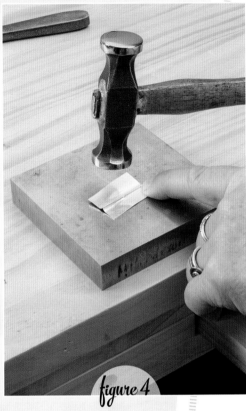

figure 4

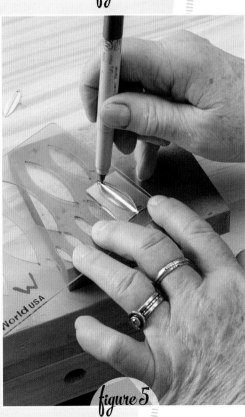

figure 5

15. There is now enamel on both sides, so the leaf pieces need to be fired on trivets on a firing rack. The long shapes of the leaves may fit better on a five-space small sawtooth trivet rather than trying to balance them on a three-point trivet. Place them on the trivets, then on a rack *(figure 6)*.

16. Fire the pieces to a fire polish. Remove from the kiln and allow to cool.

17. If there are any rough edges or sharp spots, gently grind them under water with an alundum stone or a diamond file.

18. Form two large jump rings using the 14-gauge round wire and the ⅜" dowel. Saw the ring coil where the wire crosses over after wrapping around the dowel.

19. Close the jump rings and solder the seams closed with easy silver solder. Pickle, rinse, and dry.

20. Place the rings on a steel bench block. Hammer the rings with a riveting or cross-peen hammer to give the fronts a texture.

21. Wrap the 6" (15 cm) of 18-gauge round wire around the ¼" (6 mm) dowel, making a small coil. (See Making Jump Rings, page 150.)

22. Saw through the coil, creating six ¼" (6 mm) diameter jump rings.

23. Place one jump ring on each leaf shape. Place one of each size leaf shapes onto each ⅜" (1 cm) larger jump ring, with the longest leaf shape in the middle. Close the 18-gauge jump rings and solder them shut with easy silver solder. The rings are a large enough diameter that it should not harm the enamel on the leaves.

24. Following Steps 11 through 13 on page 53, make two ear wires 2" (5 cm) long with the remainder of the 18-gauge round wire. Attach them to the large hammered jump ring with chain-nose pliers.

25. Polish the silver loops with a polishing cloth or fine abrasive pad to brighten them.

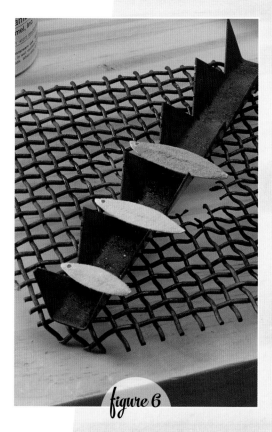

figure 6

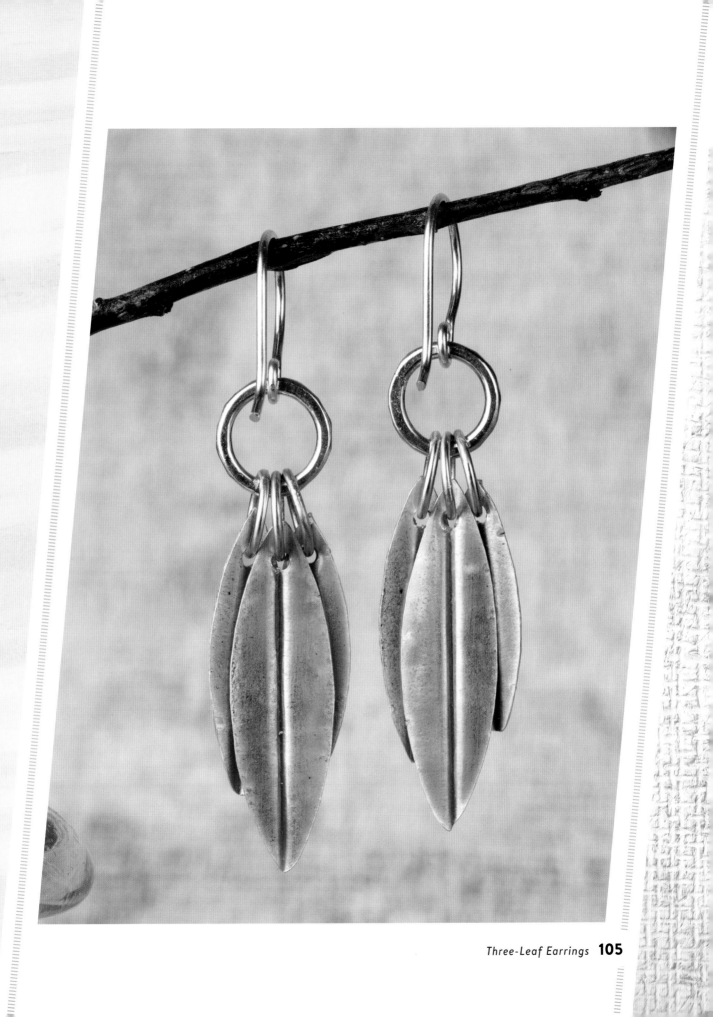

Three-Leaf
PENDANT

enameling techniques

SIFTED ENAMEL
KILN FIRE

Here's a pendant to go with the Three-Leaf Earrings (page 100). It's made with the same fold-forming technique, so it's lightweight and makes a pleasant tinkling sound when worn. I hung it from a cord to introduce even more color, but it would also look lovely on a chain.

JEWELRY-MAKING SKILLS

Sawing

Filing

Sanding

Basic fold forming

Hammering

Drilling

Using pliers

Forming wire

Silver soldering

MATERIALS

24-gauge fine silver sheet, 4¾" × 1" (12 × 2.5 cm) and 2" × 1" (5 × 2.5 cm)

Binder (Klyr-Fire/distilled water)

Thompson Transparent Enamels: #2420 (Sea Green), #2240 (Olive), #2335 (Peacock Green), and #2320 (Spring Green)

14-gauge sterling silver round wire, 2⅜" (6 cm)

18-gauge sterling silver round wire, 5" (12.5 cm)

⅛" (3 mm) satin cord, 18" (45.5 cm) or longer

Two ⅛" (3 mm) diameter sterling cord ends with loop

Sterling silver lobster clasp, 10mm

TOOLS

Kiln-firing tools (page 22)

Ruler

Fine-point permanent marker

Jeweler's saw frame and 4/0 saw blades

Torch or kiln for annealing

Vise, 2" (5 cm) or larger jaws

Steel bench block

Rawhide or plastic mallet

Work gloves

Table (butter) knife

Leaf templates (page 155)

Steel scribe (optional)

#2 or #4 flat hand file

Center punch and hammer

Drill (hand or electric), Dremel tool, or flexible-shaft machine

2 mm drill bit

Enamel-sifting tools (page 25)

Alundum stone or diamond file, 400 or 800 grit

¾" (2 cm) dowel and ⅜" (1 cm) dowel, each 3" (7.5 cm) long

Soldering tools (page 153)

Easy silver solder

Riveting hammer or cross-peen hammer

Scissors or wire snips

Glue (epoxy or craft glue for fabric/metal)

Polishing cloth or fine abrasive pad

Planishing hammer or polished ball-peen hammer

FINISHED SIZE

Pendant: 3¼" (8.5 cm) long

Cord and clasp: 26" (66 cm) long

1. Set the kiln temperature at 1,450°F (788°C), turn it on, and let it warm up.

2. Using the ruler and marker, measure and mark the 4¾" (12 cm) piece of fine silver sheet into two pieces 2½" × 2¼" (6.5 × 5.5 cm). Using the jeweler's saw and 4/0 saw blade, cut the pieces. You will now have three pieces.

3. Anneal the three pieces of silver sheet. (See Annealing, page 148.)

4. Draw a marker line down the center, lengthwise on each of the three pieces of sheet metal.

5. Place the pieces one by one in a vise, with one half in the vise and the other half above the jaws. Bend the pieces one by one at a right angle, on the center line. After removing each piece from the vise, bend them in half with your hands. The center will not be completely flat together.

6. Place each piece on a steel bench block. Strike the fold of each piece with a rawhide or plastic mallet until it is completely flattened. Anneal each of the pieces again.

7. Put on a pair of work gloves. Use a table knife (butter knife) to wedge into the folded pieces one at a time. Wiggle the knife back and forth until you can grip the edges of the metal and open the fold. Open as far as you can with your hands.

8. Place each piece fold side up on a steel bench block and strike the crease of the fold with the planishing or ball-peen hammer to crisp up the fold and make each piece flat and even *(figures 1 and 2)*.

9. Using the template with a fine-point marker or a steel scribe, trace the 2½" (6.5 cm) leaf onto the longest piece, then the 2¼" (5.5 cm) leaf onto the next to longest, and the 2" (5 cm) leaf onto the shortest, lining up the points on the leaves with the crease of the fold.

10. Saw out the three leaves with a jeweler's saw and 4/0 saw blade. File the edges of each piece until smooth.

11. Center punch each piece on one end about ³⁄₁₆" (5 mm) from one of the points. Drill a 2 mm hole into each of the three center punch marks. If there is a rough burr left around the hole, lightly sand it with sandpaper or a small file.

12. Place each of the leaf shapes back facing up (with the inside of the fold on the back) on bottle caps over a paper plate or manila folder.

13. Spray each piece with binder. Fill a small sifter halfway with #2420 enamel. Sift a thin but thorough layer of the enamel onto the back of each leaf piece. Set each leaf on a firing rack, enamel side up. Allow to dry.

14. Fire the pieces in a kiln until fire polished (2 minutes at 1,450°F). Remove and allow to cool.

15. Return the three pieces to bottle caps, bare side up. Spray with binder. Sift #2240 onto the smallest, #2320 onto the midsized one, and #2335 onto the longest leaf. Allow to dry.

16. There is now enamel on both sides, so the leaf pieces need to be fired on trivets on a firing rack. The long shapes of the leaves may fit better on a square four-point trivet than trying to balance them on a three-point trivet. Place them on the trivets, then on a rack.

17. Fire the pieces to a fire polish. Remove from the kiln and allow to cool.

18. If there are any rough edges or sharp spots, gently grind them under water with an alundum stone or a diamond file.

19. Form a large jump ring using the 14-gauge round wire and the ¾" (2 cm) dowel. Saw the ring where the wire crosses over after wrapping around the dowel.

20. Close the jump ring and solder the seam closed with easy silver solder *(figure 3)*. Pickle, rinse, and dry.

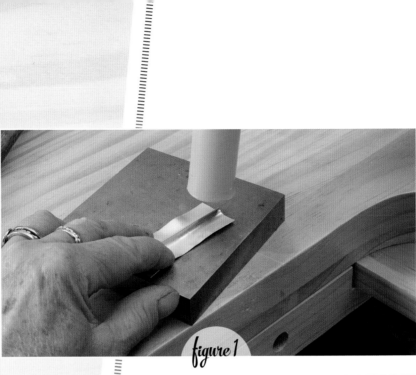

figure 1

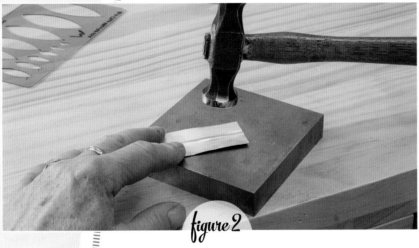

figure 2

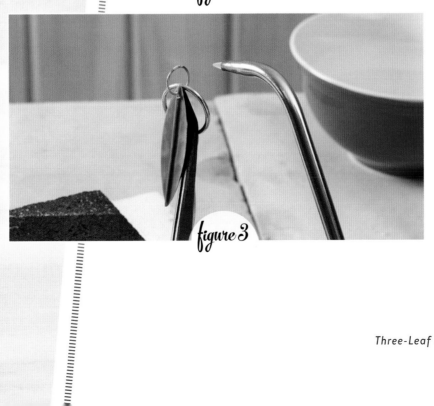

figure 3

21. Place the ring on a steel bench block. Hammer the ring with a riveting or cross-peen hammer to give the front of it a texture.

22. Wrap the 5" (12.5 cm) length of 18-gauge round wire around the ⅜" (1 cm) dowel, making a small coil. (See Making Jump Rings, page 150.)

23. Saw through the coil, creating several ⅜" (1 cm) diameter jump rings.

24. Place one jump ring on each leaf shape. Close the rings on the large (¾" [2 cm] diameter) jump ring, the longest leaf in the center with a smaller one on each side of that. Solder the jump ring closed with easy silver solder. The rings are a large enough diameter that soldering should not harm the enamel on the leaves. These can be placed in a pickle to brighten them up for a short time (3 minutes), and it will not harm the enamel.

25. Cut the desired length of satin cord with scissors or wire snips. Glue each end into one of the tubular cord ends. Allow to set.

26. Attach the lobster clasp to one loop on one of the cord ends.

27. Polish the silver loops with a polishing cloth or fine abrasive pad to brighten them.

28. Pull both ends of the cord through the large loop and bring them back through the middle of the cord to attach to the leaf pendant *(figure 4)*.

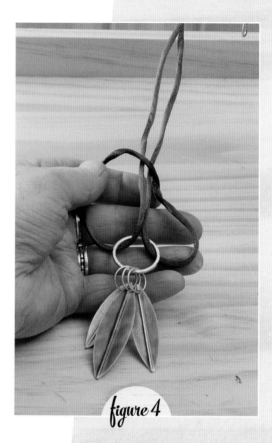

figure 4

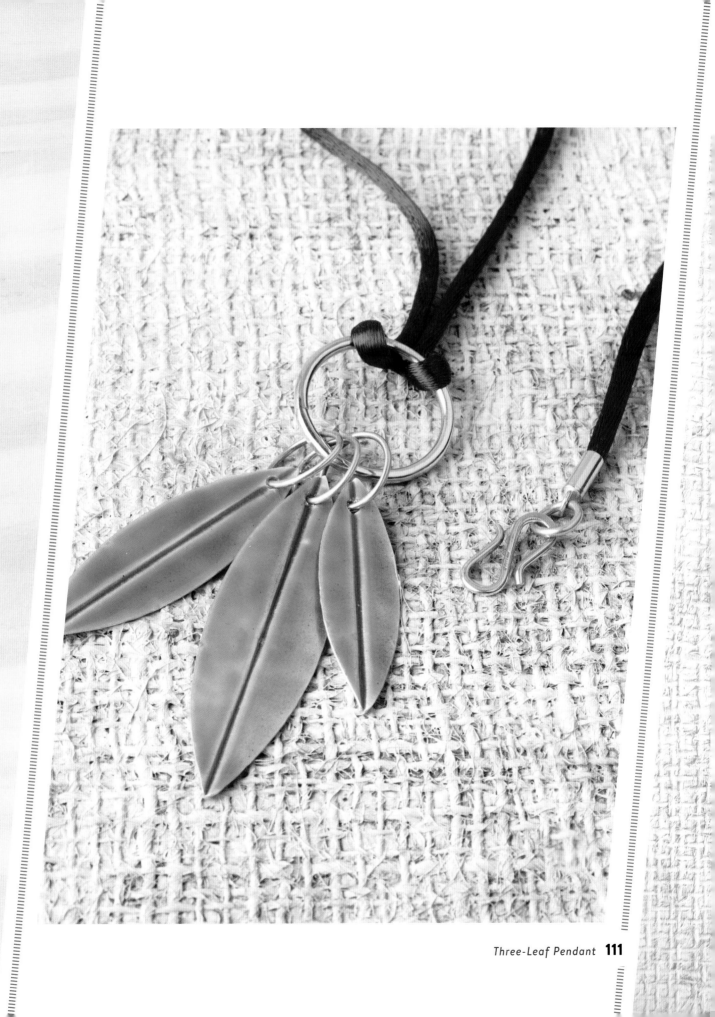

Bezel-Set Cloisonné
RING

The cloisonné in this project is the focal point of the silver ring much like a cabochon-set stone would be. Enamel or glass is about a 6 on the Moh's scale of hardness, which would equate to natural stones such as malachite, moonstone, and opal. Some care needs to be taken when setting the cloisonné piece in the bezel, but it is very doable and worth the effort.

JEWELRY-MAKING SKILLS

Sawing

Filing

Sanding

Soldering

Forming

Finishing

MATERIALS

14- or 16-gauge sterling silver sheet, 6 mm wide × length needed for desired ring size (see diagram on page 114)

20-gauge fine silver disc, ⅝" (1.5 cm) diameter, or 20-gauge fine silver sheet, 1" × 1" (2.5 × 2.5 cm)

Binder (Klyr-Fire/distilled water)

Thompson Opaque Enamels: #1995 (Black), #1830 (Marigold), and #1860 (Flame Orange)

Thompson Transparent Enamel: #2020 (Clear for Silver)

30-gauge 1.5mm fine silver cloisonné wire, 3" (7.5 cm)

Blu-Stic cloisonné adhesive

26-gauge 3mm fine silver bezel, 2" (5 cm)

16- or 18-gauge sterling silver sheet, ⅞" × ⅞" (2.2 × 2.2 cm)

TOOLS

Kiln-firing tools (page 22)

Jeweler's saw frame and 2/0 saw blades

#2 half-round hand file

Torch for annealing

Ring-bending block

Ring mandrel

Rawhide mallet

Half-round/flat pliers

Soldering tools (page 153)

Easy, medium, and hard solder

#400 silicon carbide sanding stick

Enamel-sifting tools (page 25)

Small round-nose pliers

Wet-packing enamel tools (page 30)

Glass brush

Fine-point permanent marker or scribe

Wire cutters

Round bezel mandrel

Mallet or planishing hammer

Circle template

Ruler

Flexible-shaft machine or Dremel tool

Polishing lathe

Muslin buffs for a polishing machine or flexible-shaft machine

Polishing materials: diamond file, wet/dry sandpaper, Tripoli, rouge

Tumbler with stainless-steel shot (optional)

Brass brush

Polished bezel pusher

FINISHED SIZE

Varies

1. Set the kiln temperature at 1,450°F (788°C), turn it on, and let it warm up.

2. Referring to the Ring-Sizing Diagram, measure the exact length of sterling silver sheet needed for the size of the ring desired. Cut that length with a jeweler's saw.

3. File each end of the wire even and flat with a #2 file.

4. Anneal the strip with a torch. Then pickle, rinse, and dry it.

5. Use a ring-bending block, ring mandrel, and rawhide mallet to start bending the ring (*figure 1*).

6. When the ring is three-quarters of the way to being shaped, complete the shaping using half-round/flat pliers. Be sure to keep the rounded side of the pliers on the inside of the ring to avoid making deep marks (*figure 2*).

7. Once the two ends meet completely, the seam needs to be soldered shut. The ring may not be a perfect circle in order to get the ends to meet. This is not critical at this point because the ring can be further shaped after soldering. Use hard silver solder to solder the seam together. Let the ring cool, then pickle, rinse, and dry.

8. Place the ring back onto the ring mandrel and perfect the shape by tapping it repeatedly with a rawhide mallet. Hold the ring securely on the mandrel as you do this.

9. Sand the seam smooth and even. If there are solder bumps, use a file to reduce them, then use sandpaper to remove the file marks. Sand the edges of the ring smooth (*figure 3*).

10. If desired, file the edges with a #2 file from halfway on the circumference toward the seam, on each side. Then sand smooth. This will create a tapered shank (*figures 4 and 5*).

11. Sand the exterior of the ring shank with a 400-grit sanding stick. The inside of the shank may be sanded by wrapping a strip of sandpaper around the half-round file or a dowel, placing it inside the ring, and sanding in a sweeping motion around the interior.

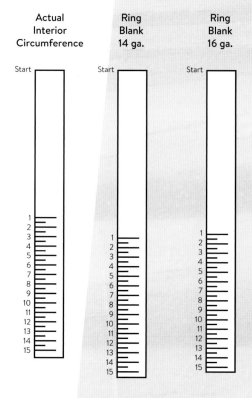

Actual Interior Circumference	Ring Blank 14 ga.	Ring Blank 16 ga.
Start	Start	Start

RING-SIZING DIAGRAM
Use this diagram to determine the length of sterling silver sheet needed for your desired ring size. Sizes 1–15 are listed for each gauge. A size 6 ring will be about 2⅛" (5.25 cm), size 7 will be about 2¼" (5.5 cm), and size 8 will be about 2⅜" (6 cm).

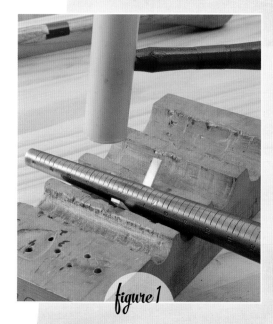

figure 1

figure 2

figure 3

figure 4

figure 5

12. Saw out a ⅝" (1.5 cm) diameter 20-gauge fine silver disc. A disc cutter or commercially stamped disc may also be used.

13. Place the disc on a bottle cap. Spray or brush binder on one side of the disc.

14. Put on the dust mask. Sift counter enamel onto one side of the disc and let it dry.

15. Place the disc on a firing rack. Set a timer to 1 minute 45 seconds. Fire the piece in the kiln. Remove the piece from the kiln when the timer goes off. Allow it to cool.

16. With the disc on a bottle cap, spray binder on the front. Sift a thin layer of #2020 Clear onto the front and let dry. Fire for 1 minute 45 seconds. Allow the piece to cool.

17. Bend the 3" (7.5 cm) of cloisonné wire into a retro-style flower, using small round-nose pliers. This takes some practice and patience. If you are not efficient at bending small wire into a desired shape, practice with 24-gauge copper wire. Sometimes it helps to draw the design on paper, then bend the wire over the drawing, little by little. The perimeter of the shape must be inside the ⅝" (1.5 cm) disc with at least ¹⁄₁₆" (2 mm) around the perimeter.

18. Hold the flower shape with tweezers and dip into the Blu-Stic. Place it on top of the fired clear enamel. Be frugal with how much Blu-Stic is on the flower. Allow the Blu-Stic to dry.

19. Fire the disc with the flower on it in the kiln for 1½ minutes. Remove from the kiln and allow to cool. The cloisonné wire will be attached to the disc with the clear enamel. If there are gaps between the wire and enamel, gently press them down with your fingers. The cloisonné wire will be very soft after being fired.

20. On a clean paper plate, place three plastic teaspoons. Write the numbers of the enamels on the handles of the appropriate spoon with a permanent marker.

21. Put a small amount of each dry enamel in the spoon marked for it. Add a drop of water and a drop of Klyr-Fire to each spoon until the dry powder has been hydrated and has a layer of the 50/50 mix over it *(figure 6)*.

22. Use a 00 or 000 sable paintbrush to scoop tiny amounts of enamel onto the disc. Black #1995 will be the background color outside the flower. The body of the flower will be Marigold #1830, and there will be a dot of Flame Orange #1860 in the center of the flower *(figure 7)*.

23. After three or four firings the level of the enamel should be close to the top of the cloisonné wire. If needed, fill any low spots and fire again.

24. Sand the top of the cloisonné medallion on a hard flat surface (sanding stick) under a drizzle of water. The surface of this piece will be flat. The easiest way to sand it will be facedown on the wet sandpaper.

25. Rinse the piece periodically to check the level of the enamel. All sanded areas will appear matte after sanding. Any low spots will be shiny. It may be necessary to add a tiny bit of enamel to the low spots and refire. Then continue sanding. If filled evenly, the entire surface will appear matte after sanding.

26. When the entire surface is filled and looks matte, scrub thoroughly with a glass brush, under water. This removes particles of the sandpaper that may remain in the enamel surface.

27. Fire the piece one last time for 15 seconds less than all the other firings (about 1 minute 25 seconds). This will give the finished piece a fire-polished finish.

28. Wrap the 26-gauge fine silver bezel wire around the edge of the cloisonné disc. Where the end crosses over the rest of the length, make a mark with a fine-point marker or a metal scribe. Saw or clip the bezel wire on that mark.

29. Make sure the ends of the bezel are straight and even and meet well before soldering them together. Place them on a soldering block. Flux the seam. Place a small piece of hard silver solder on the seam.

30. Light the torch and adjust to a soft, reducing flame. Fine silver bezel wire melts very easily. Heat slowly and evenly until the solder flows down the seam. Quench, pickle, rinse, and dry *(figure 8)*.

figure 6

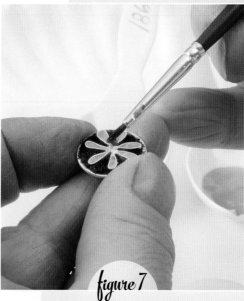

figure 7

figure 8

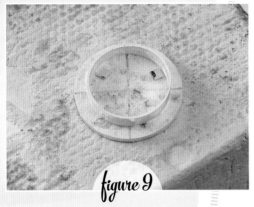

figure 9

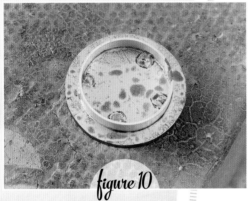

figure 10

figure 11

31. The bezel may be distorted from getting the seam together. Place it on a round bezel mandrel and tap gently until round again. Check to see that the bezel still fits around the cloisonné piece.

32. If the bezel is too tight or small, place it on the bezel mandrel and tap gently with a mallet or planishing hammer. If it is too big and sloppy, saw or clip it open and trim off a small bit. Then put it back together and re-solder as in Steps 29 and 30.

33. Carefully sand the bottom and top of the bezel to make them flat, even, and smooth.

34. Trace a ⅞" (2.2 cm) circle on the 16- or 18-gauge sterling silver sheet with a scribe to create the back plate.

35. Saw out the ⅞" (2.2 cm) circle with a jeweler's saw and 2/0 blade. File and sand the edges smooth.

36. Center the bezel on the circle back plate. Set that on a soldering block. Flux the bezel and the back plate of the sterling sheet. Cut four pieces of medium silver solder ₁⁄₁₆" (2 mm) square, and put on the back plate inside and next to the bezel *(figure 9)*.

37. Light the torch and adjust the flame to neutral (between reducing and oxidizing). Keep the tip of the dense blue cone about ½" (1.3 cm) from the sheet metal surface. Move the flame in a smooth motion, circling outside the bezel and tracing the sheet metal, until the solder flows to and around the bezel *(figure 10)*. Cool, then pickle, rinse, and dry.

38. Make a mark on the top of the ring shank opposite the seam of the ring. This should be the widest part of the shank if the shank was tapered. File a flat spot on the top of the shank, about 5 mm square. Check that the spot is level by trying to stand the ring upside down on it. When level, the ring will stand up straight when resting on it.

39. Set the bezel on the back plate bezel side down on a flat surface. Place the ⅞" (2.2 cm) of a circle template over the back plate. Make a mark at each quarter division on the template. Use a ruler and connect the marks opposite each other to find the center of the back plate. The center is where the shank will be soldered on *(figure 11)*.

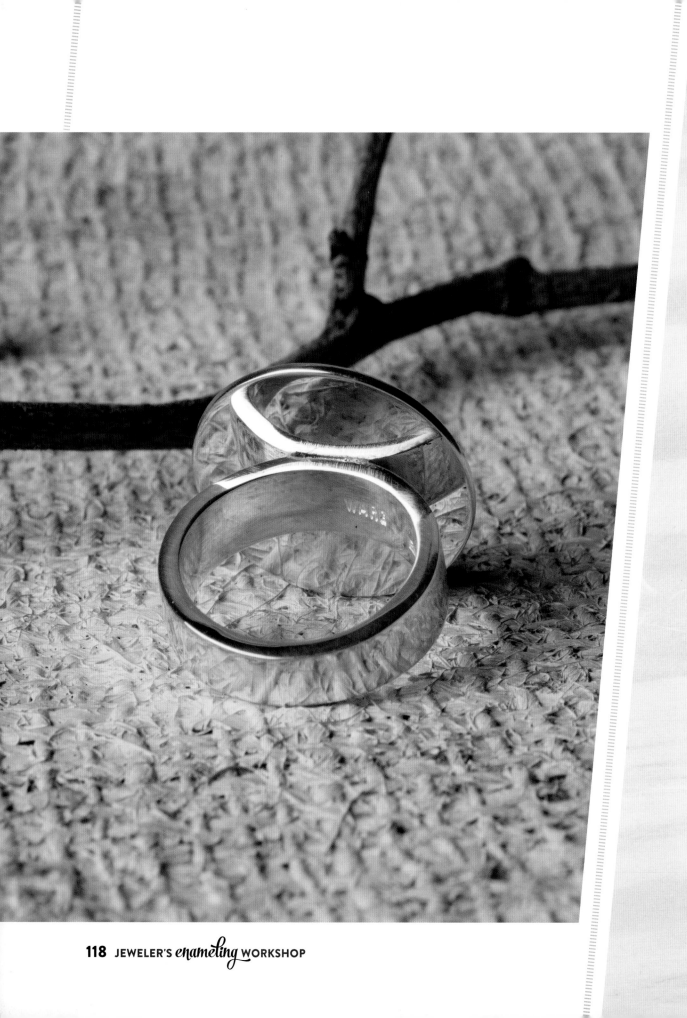

figure 12

40. Flux the bezel, back plate, and ring shank as they rest on a soldering block. Warm the flux until it dries with a small torch flame. Place the back plate bezel side down on the soldering block. Stand the ring shank on the center mark, resting on the filed flat spot.

41. Place one ¹⁄₁₆" (2 mm) square piece of easy solder sheet on each side of the shank, wedged between the shank and the back plate **(figure 12)**.

42. Light the torch and adjust to a slightly hissing, barely oxidizing flame. Point the flame down at the back plate perimeter. Move in a circular motion, tracing the edge of the back plate. Occasionally trace the shank with the flame. Heat rises, so keep most of the flame movement on the back plate. Wait for the solder to flow to the shank. Cool the piece, then pickle, rinse, and dry.

43. Sand the interior of the ring shank by wrapping a small strip of 400-grit sandpaper around a half-round needle file or by using sandpaper in a split mandrel in a flexible-shaft machine or Dremel tool.

44. If there is a buffing machine available, use a soft muslin buff and do an initial polish using Tripoli or white diamond. A tumbler with stainless-steel shot could also be used for this finishing step. Flexible shafts or Dremel tools can substitute for a larger buffing machine. The simplest way to brighten up the finish is by using a brass brush by hand and scrubbing with soap and water. This will brighten up the surface, but not remove scratches.

45. Place the enameled disc in the bezel. Use a bezel pusher to gently and gradually push the bezel down over the disc **(figure 13)**. A final rouge polish may be done around the bezel to finish the ring completely. Rouge will not hurt the enamel.

figure 13

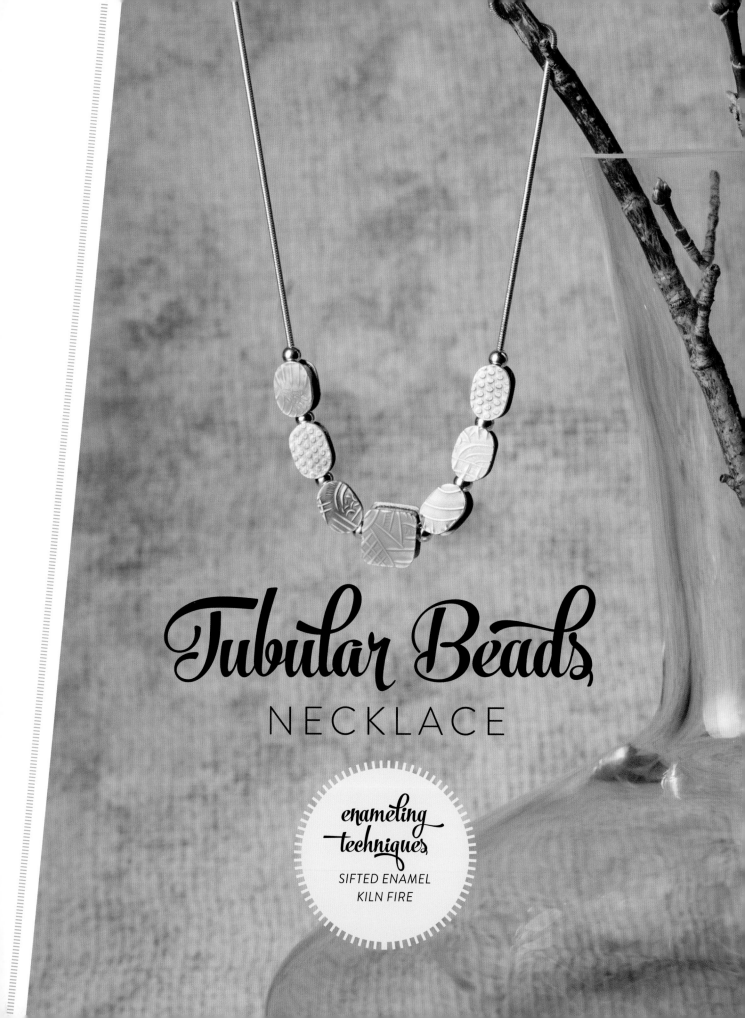

Tubular Beads
NECKLACE

enameling
techniques

SIFTED ENAMEL
KILN FIRE

All of the beads in this candy-colored necklace are sifted with transparent purple enamel on one side and varying colors on the other to create a multicolored look as they turn on the chain. The midsection of each bead is a slice of sterling silver tubing. The sides are fine silver with enamel sifted onto them after they have been soldered onto the tubing. These are rather small beads. Larger tubing and a variety of shapes can be used instead.

JEWELRY-MAKING SKILLS

Sawing

Filing

Sanding

Drilling

Silver soldering

Using pliers

MATERIALS

⅜" (1 cm) diameter sterling silver tubing, 1½" (3.8 cm)

½" (1.3 cm) diameter sterling silver tubing, ½" (1.3 cm)

20-gauge fine silver sheet, 1¼" × 4" (3.2 × 10 cm)

Binder (Klyr-Fire/distilled water)

Thompson Transparent Enamels: #2740 (Savor Purple), #2325 (Gem Green), #2230 (Lime Yellow), #2320 (Spring Green), #2420 (Sea Green), and #2222 (Flax Yellow)

8 round sterling silver seamless beads, 5mm

1.5mm sterling silver chain, 18" (45.5 cm)

Two 20-gauge jump rings, 5mm

Sterling silver lobster clasp, 8mm

TOOLS

#400 silicon carbide sandpaper

Ruler

Dividers or fine-point permanent marker

Jeweler's saw frame and 2/0 saw blades

Tube-cutting jig (optional)

Oval and square bezel mandrels

Planishing hammer

Center punch and hammer

Drill

#60 and #40 drill bits

Texturing tools

Soldering tools (page 153)

Hard or eutectic solder

#2 flat hand file

Insulated-grip tweezers or a soldering pick

Kiln-firing tools (page 22)

Enamel-sifting tools (page 25)

Scotch-Brite, 3M bristle disc, or buffing wheel

Chain-nose or flat-nose pliers

FINISHED SIZE

18" (45.5 cm) long

1. Sand the ends of each piece of tubing to make them flat and even. Hold the piece of ⅜" (1 cm) tubing against a ruler. With the dividers or fine-point permanent marker, mark five lines ¼" (6 mm) apart, starting ¼" (6 mm) from one end. Turn the tubing and mark those marks so they continue 360 degrees around the tubing (*figure 1*).

2. Supporting the tubing on a flat surface, such as a bench block, carefully start to saw on one of the lines, but do not saw through. Turn the tubing and saw partway through until the tubing is scored on that line all the way around. (Scoring the tubing all the way around before cutting it off helps keep the line straight and reduces the number of saw blades that may break.) Now continue to cut until the blade saws through the tubing wall and slices the piece off. Continue until there are six pieces of ⅜" (1 cm) tubing ¼" (6 mm) long. If you have a tube-cutting jig, adjust it to ¼", then cut six pieces of tubing ¼" long.

3. Sand the edges of the tubing flat and smooth with #400 sandpaper.

4. Place the tubing slices one at a time on an oval bezel mandrel. Gently tap with a planishing hammer until the tubing is oval, not round. You may need to sand the edges a little more if they are not flat (*figure 2*).

5. Center punch the center of the long end of each oval slice of tubing, while it is on the mandrel.

6. With the tubing off the mandrel, drill each end of each piece of tubing with a #60 drill bit.

7. Enlarge the holes on each piece by re-drilling with a #40 drill bit. (**NOTE:** It is easier to drill a larger hole in metal if you drill a smaller "pilot" hole first.)

8. Sand the ends of the ½" × ½" (1.3 × 1.3 cm) tubing.

9. Place the tubing on a square bezel mandrel. Tap until the tubing becomes square.

10. Center punch the center of two opposite sides of the square tube while it is on the mandrel.

11. Remove from the mandrel and drill a #60 hole in each center punch mark. Re-drill with a #40 drill bit. Sand the edges of the square tube again if necessary.

12. Texture the 1½" × 4" (3.8 × 10 cm) fine silver sheet if desired. It can be hammered with a texture hammer, stamped with letter or design stamps, or put through a rolling mill with a texture that is safe for the mill.

13. If the metal becomes warped from the texturing, flatten it out on a steel bench block or hard wood surface with a rawhide or plastic mallet.

14. Saw the sheet in half to create two 1½" × 2" (3.8 × 5 cm) rectangles .

15. Hold one piece of oval tubing cut edge down onto the sheet metal on the nontextured side. Make sure it is close but not even with any perimeter edge on the sheet.

16. Using a permanent marker, trace the perimeter of the tubing onto the sheet metal. Continue to do this until there are six ovals drawn on one half of the fine silver sheet. Leave a small space between each tracing. This is a guide for where each piece will be soldered. Do the same with the piece of square tubing. (**NOTE:** It's easier to solder the pieces onto a larger sheet of metal than to cut out one side at a time and solder it on.)

17. Flux the piece of fine silver sheet. Place the oval tubes and square tubes down on the sheet where marked. Place on a soldering block.

18. Place three 1.5 mm square paillons of hard or eutectic solder inside each slice of tubing, evenly spaced, flat on the sheet, next to the edge of the tube.

19. Light the torch and use a flame with a deep blue cone about ½" (1.3 cm) long and sharp (if using a Smith Handi-Heat or Silversmithing torch a number 1 or 2 tip) to heat the entire sheet evenly by tracing the perimeter of the sheet with the tip of the blue cone. Wait until you see each paillon melt and flow around the edge of each piece of tubing before removing the heat (*figure 3*).

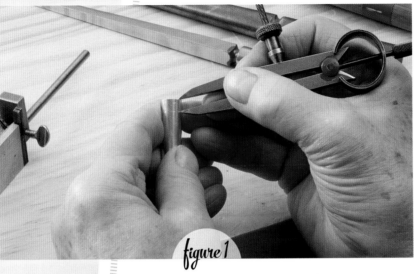

figure 1

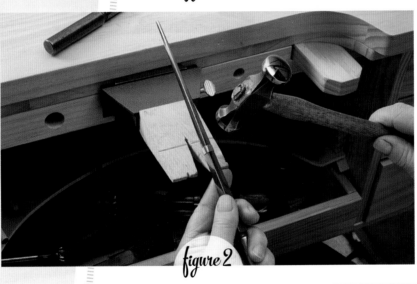

figure 2

figure 3

20. Allow to cool for 30 seconds or more. Quench in water, then pickle, rinse, and dry.

21. Retrace around each piece of tubing with a permanent marker.

22. Use a jeweler's saw to cut out each tube. If you wish to have a border on the sheet side that is larger than the tube, saw on the outside of this line. If you want the decorative side to be flush with the tube, cut on the line.

23. File the edge that was sawed out with a #2 flat hand file.

24. Trace the other edge of the tubing onto the fine silver sheet. Allow a little more room in between each piece for safe sawing after soldering.

25. Flux the piece of sheet on the smooth side.

26. Cut three pieces of hard solder for each piece of tube. Place the pieces on the traced lines for each tube. Flux the edges of each piece of tube. Rest the edge of each piece of tube on the three pieces of solder for each tube. This way, heat can get in and around the capped tubing and will flow faster, and you will see when it flows.

27. If possible, set the sheet on a tripod and heat from beneath. If not, be prepared to raise the sheet up with insulated-grip tweezers or a soldering pick to allow heat in underneath.

28. Use the same type and size of flame as in the first soldering (Step 19). Heat the entire piece of sheet evenly until all the pieces drop down as the solder flows.

29. Allow to cool briefly. Quench in water, pickle, then rinse and dry the piece of sheet metal with all the tubes soldered on. Be aware that the pickle may seep into the holes in the tubing. If you're not careful, liquid can drip out onto your other tools and corrode them. If you place the piece of sheet and tubing in hot water with baking soda in it, it will neutralize the pickle that may remain in the beads.

30. Carefully saw out the beads from the sheet. It is easy to bump into and nick a neighboring bead if you don't pay attention. Set the kiln

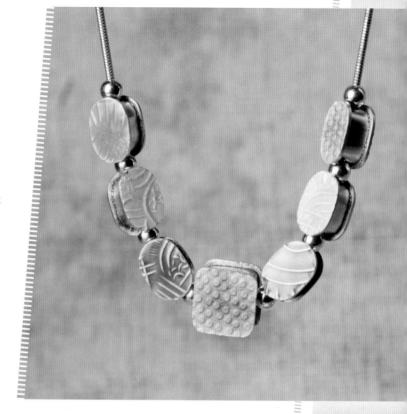

temperature to 1,450°F (788°C), turn it on, and let it warm up.

31. File and then sand the edges of the individual beads. I find it easier to sand both edges at the same time when the beads are this small.

32. Prepare to start enameling. Have all the colors ready to be used. Binder, sifters, and trivets should be on hand.

33. Set the beads with one side up on paper or a paper plate. Spray binder on that side. Since there are so many beads, it may be wise to spray half at one time so the binder does not dry.

34. Put on your dust mask. Sift one enamel at a time onto the side that has been sprayed. *Be sure to clean the sifter in between colors.* For this first firing, the beads do not have enamel on both sides, so they can be set enamel side up onto a firing rack. Allow to dry.

35. Fire the beads for 2 minutes at 1,450°F. Remember, all kilns vary, so set the timer and temperature for what you would normally use to fire small pieces.

36. Remove from the kiln and allow to cool completely.

37. If you have seven small three-point trivets, you can fire the next batch all at once. Otherwise, prepare and fire as many as you have trivets for.

38. Spray binder on the yet-to-be enameled side of each bead. Sift on the desired color for each bead. Set the beads enameled side down balanced on a three-point trivet. Allow to dry.

39. Fire again at the proper time and temperature for your kiln. Remove and allow to cool thoroughly.

40. Clean the sterling midsection of each bead with Scotch-Brite, a 3M bristle disc, or a buffing wheel.

41. Check the size of the hole in the 5mm beads. If it's too small to run the chain through smoothly, enlarge it with the #40 drill bit. Hold them one at a time carefully and spin the drill over the hole with your hand. If this does not work, try to hold them and drill. A sharp drill bit will usually shave a hole in a bead with hand pressure.

42. Attach one of the jump rings to one end of the chain with pliers and close it.

43. String the first 5mm bead onto the chain. String the first oval bead onto the chain, then another 5mm bead, then an enameled bead, placing the larger square bead in the center.

44. Place the second jump ring on the other end of the chain, add the lobster clasp, and then close the link.

TIP

I used only transparent enamels to allow the texture to show through. If you use opaque enamels, skip the texturing.

Champlevé
EARRINGS

enameling
techniques

WET-PACKED ENAMEL
TORCH OR
KILN FIRE

This design is based on a production earring design I created many years ago. I always liked the simple elegance of the piece and the art nouveau feel. I decided to re-create it as an enameled project. The sterling silver I used does not flex due to the alloy and the thickness used here, so counter enamel is not necessary.

JEWELRY-MAKING SKILLS

Sawing

Filing

Sanding

Drilling

Sweat soldering

Using pliers

Finishing

TIP

I have used a kiln here, but it's also a good project for torch firing because there is no enamel on the back for the direct contact with the flame to taint.

MATERIALS

22-gauge sterling silver sheet, 1½" × 1" (3.8 × 2.5 cm)

18-gauge sterling silver sheet, 1½" × 1" (3.8 × 2.5 cm)

Thompson Transparent Enamels: #2410 (Copper Green), #2420 (Sea Green), and #2435 (Turquoise)

Pair of sterling silver ear wires

TOOLS

Kiln-firing tools (page 22; this project can also be torch fired)

Earring templates (page 155)

Fine-point permanent marker

Scissors

Glue stick

Steel burnisher (optional)

Center punch and hammer

Hand drill, Dremel, or flexible-shaft machine

#60 and #55 drill bits

Jeweler's saw frame and 2/0 blades

#2 or #4 half-round needle file

#2 half-round hand file

400-grit silicon carbide sanding stick

Soldering tools (page 153)

Hard silver solder

Rawhide mallet

Hardwood or steel bench block

Brass brush

Bottle caps

Wet-packing enamel tools (page 30)

Alundum stone

#400 and #600 wet/dry sandpaper

Polishing equipment (buffing lathe or flexible-shaft or Dremel tool; muslin buff) (optional)

Tripoll compound, water-soluble red rouge, mild detergent (optional)

2 pairs chain-nose pliers

FINISHED SIZE

⅝" × 1½" (1.5 × 3.8 cm) with ear wire

1. Set the kiln temperature at 1,450°F (788°C), turn it on, and let it warm up.

2. Trace the templates onto paper, cut out roughly, and use a glue stick to attach them to the 22-gauge sterling. It helps if the sterling sheet is clean. Burnish the design down with the back of a fingernail or carefully use a steel burnisher. Allow the glue to dry.

3. Center punch the spaces within the design on each tracing (*figure 1*). Drill a small hole (#60) in each space. That should be six spaces in all.

4. Feed the saw blade through one drilled hole, then tighten the blade back into the frame. Saw out the space in the design. Open one end of the frame and pull the saw blade out. Repeat this process until all three spaces in each earring design are sawed out.

5. Use a half-round needle file to smooth the interior edges of the piercings. It is easier to do this before you cut out the perimeter shape, as it leaves more material to hold on to.

6. Saw out the two shapes around the perimeter of the design.

7. File and then sand the perimeter of the shapes. Lightly sand the top and bottom surfaces of the two shapes. This will reveal whether or not the shapes are flat. If the sandpaper doesn't touch the entire surface, that means there are highs and lows. Try to flatten the pieces gently.

8. Clean and sand the 18-gauge metal. Make sure it is very flat.

9. At the soldering bench, set the two pierced shapes on one soldering block and the 18-gauge sheet on another. Add a thin layer of flux to all the pieces.

10. Cut about 18 pieces of hard silver solder sheet, 1.5 × 1.5 mm each. Warm the leaf shapes with the torch. Use fine-tipped tweezers to pick up a piece of solder, dampen it with flux, then place it on the back of the shape. The wet solder will stay where placed when set onto the warm surface. Continue this process until there are nine pieces of solder on each earring shape and they are evenly distributed.

11. Warm each shape until the flux no longer bubbles (*figure 2*). Stop warming before the solder flows. Pick up each shape one at a time with tweezers and place it on the 18-gauge sheet so they both fit but are not touching.

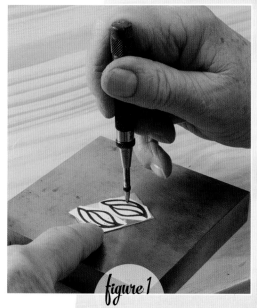

figure 1

figure 2

figure 3

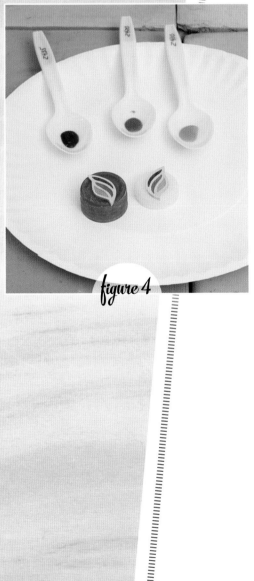

figure 4

12. Heat with the torch evenly, pointing the tip of the blue cone down about ¼" (6 mm) from the surface and trace the perimeter of the sheet with it. It may be necessary to tilt the piece with a solder pick under one edge to get the thicker 18-gauge evenly hot, then lower and heat the perimeter again until the pieces sink down onto the larger sheet. Check to make sure the solder flowed around all the edges of the pierced pieces *(figure 3)*.

13. Cool the piece, then pickle, rinse, and dry. It is important to make sure it has been thoroughly pickled. If there are visible gaps, tap the pieces down with a rawhide mallet over a hardwood block or steel bench block to close the gaps. Repeat fluxing and heating with the torch until the solder flows again. Pickle, rinse, and dry.

14. Saw out the two pieces, which now have an 18-gauge back plate soldered onto them.

15. File and sand the perimeter edges of each piece.

16. Center punch the more-pointed end on each earring and drill with a #55 drill bit.

17. Sand the back and front of each earring to make them smooth. Scrub lightly with a brass brush or toothbrush to make sure there is no dust in the crevices.

18. These two pieces need to be depletion gilded before enameling. Heat them with a torch to just below the point where the solder would flow (1,000°F [540°C]), then let cool, pickle, rinse, and dry. Repeat this process at least five times to develop a layer of fine silver on the surfaces.

19. Set up a paper plate with two bottle caps and three plastic spoons. Wash the enamels (see page 31). Place a small amount of the washed enamels #2410, #2420, and #2435 in each spoon and mark the handle with the color of the enamel. Have a cup of clean water, paper towels, and the small sable paintbrush on hand.

20. Carefully add a thin layer of #2410 to each recess on each earring with the paintbrush. Allow to dry. Place on a firing rack. Since there is no counter enamel, there is no need to suspend the pieces by their edges on a trivet.

21. Fire the pieces in a kiln for 2 minutes. Remove from the kiln with a firing fork and allow to cool.

22. When cool, return the pieces to the bottle caps. Use a paintbrush to place more #2410 in the shortest recess of each, #2420 in the middle section, and #2435 in the longest section *(figure 4)*. Allow to dry.

23. Fire the earrings again. Allow to cool and return them to the bottle caps on the paper plate.

24. Fill the sections with the same colors in the same sections as in Step 22. Allow to dry.

25. Fire one more time. Remove from the kiln and cool *(figure 5)*. The sections will have the enamel with a concave surface. As long as they are all the same depth this is an easier way to have the enamel for finishing.

26. Grind the fronts of the earrings with an alundum stone under a dribble of water or in a bowl of water. This will remove any enamel from the surface and remove any firescale produced by firing the sterling silver.

27. Sand the front and back with #400 wet/dry sandpaper under water to refine the surface after the coarser alundum stone.

28. If not using a power tool to buff with, use #600 wet/dry sandpaper in one direction over the top and back to give a satin finish to the pieces. Sand the edges also to make them look smooth and even.

29. If using power tools to buff with muslin buffs, first buff with Tripoli and then wash with warm soapy water. Follow by using a soft muslin buff and water-soluble red rouge. Wash again with warm water, fingertips, and mild detergent.

30. Attach the ear wires through the drilled holes with chain-nose pliers.

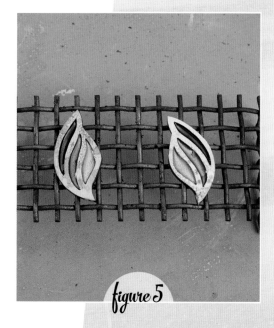

figure 5

TIP
If you'd like to make your own ear wires, see page 149.

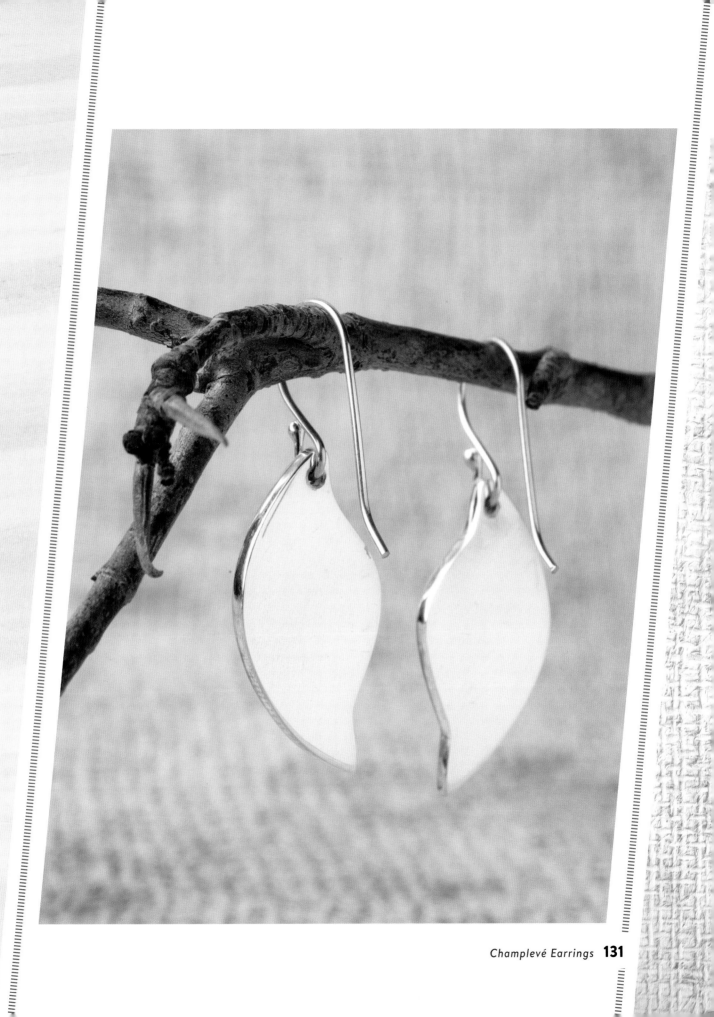

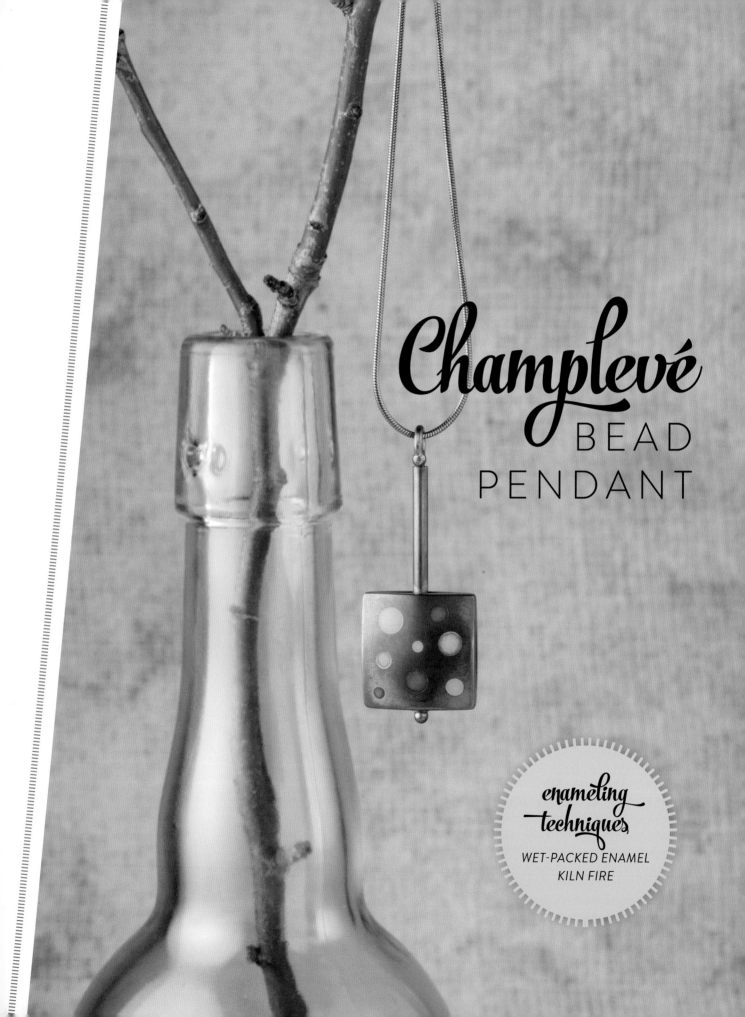

Champlevé

BEAD
PENDANT

enameling techniques
WET-PACKED ENAMEL
KILN FIRE

This bead necklace has a simple dot design, which lends itself to bright color inlays. The finish on the bead is gunmetal gray oxidation, created with liver of sulfur, which makes the vivid colors "pop." The soldering on this piece is a bit tricky, but well worth it for the sophisticated final result.

JEWELRY-MAKING SKILLS

Sawing

Filing

Sanding

Drilling

Soldering

Forming

Using pliers

Finishing

MATERIALS

22-gauge sterling silver sheet, ¾" × 1½" (2 × 3.8 cm)

18-gauge sterling silver sheet, 1" × 1¾" (2.5 × 4.5 cm)

2.5mm sterling silver round tubing, 1½" (3.8 cm)

Thompson Opaque Enamels: #1870 (Orient Red), #1319 (Bitter Green), and #1820 (Goldenrod Yellow)

16-gauge fine silver round wire, 2¼" (5.5 cm)

Finished 1mm round sterling snake chain, 18"

Liver of sulfur

TOOLS

Kiln-firing tools (page 22)

Steel ruler

Fine-point permanent marker or scribe

Jeweler's saw frame and 2/0 saw blades

#2 flat hand file

Center punch and hammer

Hand drill, Dremel, or flexible-shaft machine

#55 drill bit

Slim cone reamer

#400 sandpaper

Large (¼" [6 mm]) drill bit

Soldering tools (page 153)

Hard silver solder

Dapping block and punch

Flaring tool

Chasing hammer

Wet-packing enamel tools (page 30)

Alundum stone or diamond file

#600 wet/dry sandpaper

Steel bench block

Round-nose pliers

Soft cloth

FINISHED SIZE

Pendant: ¾" x 1¾" (2 × 4.5 cm)

Chain and clasp: 18¼" (46.5 cm) long

1. Set the kiln temperature at 1,450°F (788°C), turn it on, and let it warm up.

2. With a steel ruler, measure the center of the 22-gauge silver sheet and mark it with a fine-point marker or scribe. Carefully saw the piece in two. File the edges only if there is noticeable unevenness. The filing will be done later in the process.

3. Mark random dots on the two square pieces of 22-gauge sheet. Center punch each of the random spots.

4. Drill a hole in each of the center punches with the #55 drill bit **(figure 1)**.

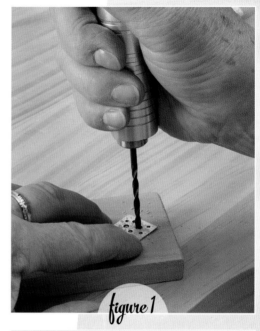

figure 1

5. With a cone reamer, expand the holes to different sizes, as long as the holes don't get so large that they break into each other. Make sure that any burrs that remain from the drilling are removed either with sandpaper or the ¼" (6 mm) drill bit spun over the edge *by hand*.

6. Set the two ¾" × ¾" (2 × 2 cm) pieces on a soldering block.

7. Flux the pieces. Cut two dozen very small pieces of hard silver solder (1 × 1 mm each).

Place the solder evenly all over the back of the two pieces around the drilled holes.

8. Place the larger piece of 18-gauge sterling sheet on the soldering block. Flux the entire surface.

figure 2

9. Warm the two smaller pieces of silver until the flux is no longer foamy **(figures 2 and 3)**. This will let the flux act as "glue" to hold the solder on when they are turned over onto the larger piece of silver.

10. Flip the two pieces over onto the larger piece of silver. Make sure that the two pieces have some space between them. They also need to be either flush with any edges or slightly inside them.

11. Pick up the piece with a pair of insulated-grip tweezers. Heat from beneath the piece, allowing the larger piece of silver to be heated first. Wait until the top pieces with the drilled holes start to drop down onto the larger piece. Slowly bring down to the soldering block without taking the flame off the piece. Continue to heat from the top until you can see the solder has flowed around all edges, including the edges of the drilled holes. Then, take the heat off.

12. Allow the sweat-soldered pieces to cool. Pickle thoroughly, then rinse and dry.

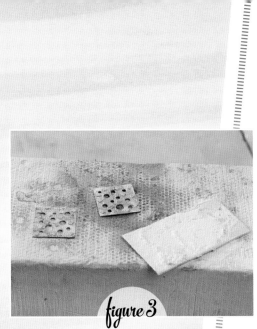

figure 3

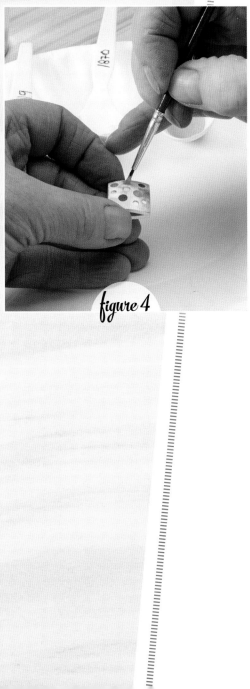

figure 4

13. Dap the two halves in a wood dapping block. The recess should be about 1⅛" (2.8 cm) to 1¼" (3.2 cm) in diameter. The dap will be slightly curved.

14. Sand the halves, one at a time, with corners down, on a flat piece of sandpaper. This will create flat spots on each corner.

15. Place one of the halves on a soldering block. Try to make sure the half is level. Flux the corners of the half. Set the other half down, warm it, and flux the four corners of that domed square.

16. Cut four pieces of hard silver solder ¹⁄₁₆" × ¹⁄₁₆" (2 × 2 mm). Dip them in flux and set on the first square's corners.

17. Carefully pick the second half up with tweezers and set corner to corner down on top of the solder.

18. Heat the pieces, pointing the flame at the base of the bottom square. Heat will rise, so do not worry about heating the top square. When the top square sinks down onto the bottom square, take the heat off. When cool, pickle, rinse, and dry.

19. File and/or sand the edges of the bead so that they are even with each other.

20. Place the tip of a flaring tool (narrow steel rod with conical pointed tip) into the middle of one of the sides. Gently tap the flat end of the tool with a chasing hammer, until the side opens up a bit. Test the opening with the 2.5mm tubing. Flare the middle of the side until the tubing can slip in tightly.

21. Repeat on the opposite side of the bead. When finished, the tube needs to fit snugly through the bead. Remove the tube before enameling.

22. Place a small amount of each of the three opaque enamels in its own spoon. Write the number of the enamel on the handle of the spoon with a permanent marker. Add a drop of binder and a drop of water to each spoon.

23. Work one side at a time with the enamels. Use a 00 or 000 sable brush to apply a small amount of the enamels into the drilled recesses *(figure 4)*. Allow to dry.

24. Rest the bead in a small trivet with the enamel side up and fire for 2 minutes. Remove and allow to cool.

25. Refill the recesses and refire. It will take about three applications to fill the recesses.

26. Turn the bead over and repeat the wet packing into the recess on this side. Leave the fired side down when firing.

27. When it appears that the enamel is nearly or completely level with the metal surface on both sides, grind the bead surfaces with an alundum stone under water.

28. If there are low spots in any of the recesses, fill them carefully with more wet enamel. Allow to dry and refire.

29. After cooling, grind again. When flush with the metal, sand under water with #600 wet/dry sandpaper. This will refine the finish on the enamel and the metal.

30. Place the 2.5mm tubing on a steel bench block with the end up. Place the flaring tool in the end of the tubing. Tap very gently until the tube end flares enough not to pass through the side of the bead that was opened with the flaring tool (**figure 5**).

31. Pass the tubing through the bead where it was widened with the flaring tool.

32. Place the bead with the tube in it on the flared end of the tube, on a bench block. Gently flare that end with the flaring tool and chasing hammer.

33. Melt a small ball on the end of the 16-gauge fine silver wire with a torch.

34. Slip the wire through the tube with the melted bead on the bottom end of the tube. Hold the bead and the tube upside down in a pair of insulated-grip tweezers. Melt a bead on that end of the wire.

35. There should be ¾" (2 cm) of tubing out of the bead on one side with about ⁵⁄₁₆" (7.5 mm) of wire with a ball on the end coming out of the tube. The other end of the bead will have a small flare of tube up against the bead with a ball of wire tight against it.

36. Use round-nose pliers to roll the long end of the 16-gauge wire into a loop (**figure 6**).

37. Thread the finished sterling chain through the loop on the wire above the tube.

38. Place the entire necklace in a warm liver of sulfur/water solution.

39. When the piece is completely oxidized, remove it from the solution. Put a lid on the solution and rinse and dry the piece.

40. Use a soft cloth to rub the piece, which will put a sheen on the oxidized surface.

figure 5

figure 6

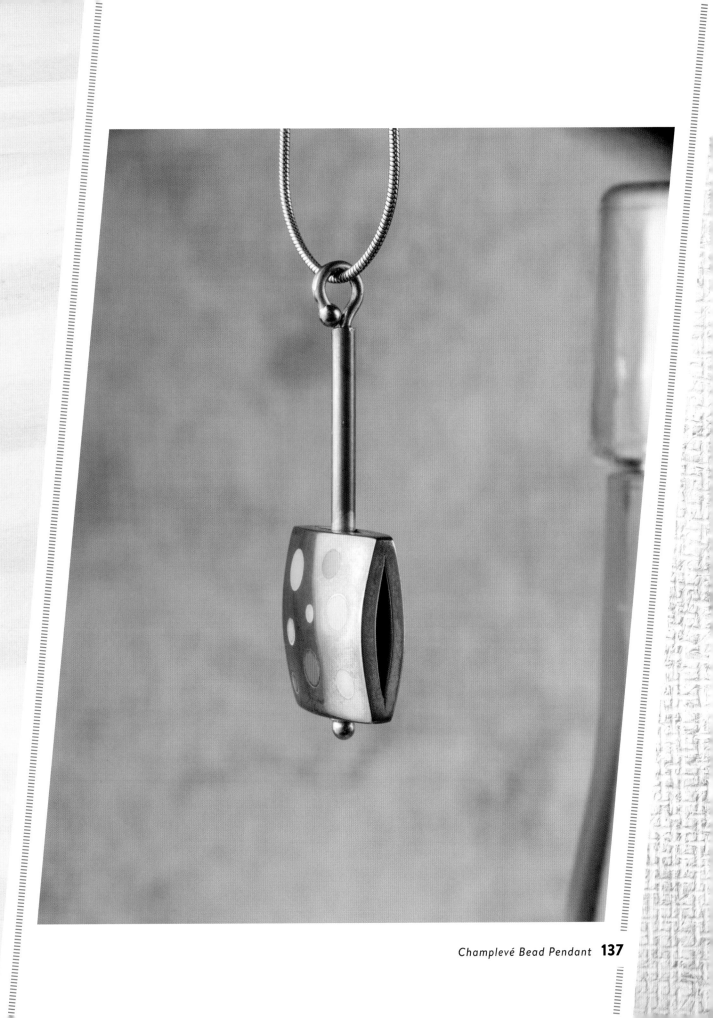

Dotted Bangle
BRACELET

enameling
techniques
WET-PACKED ENAMEL
KILN FIRE

A colorful and playful design, this bangle bracelet is a challenging project. It requires metal forming, riveting, and good silver-soldering skills. The tube rivet is one way of connecting the ends of the bangle without using solder. The tube gives a ringlike result, which ties in with the enamel-holding rings in the design, but a solid rivet could also be used. A soldered bangle would be likely to come apart during repeated firings.

JEWELRY-MAKING SKILLS

Sawing

Filing

Sanding

Forming

Soldering

Finishing

MATERIALS

1.5 × 8mm sterling silver flat stock, 8" (20.5 cm) or longer

3mm round sterling tubing (medium wall), ³⁄₁₆" (5 mm)

16-gauge round fine silver wire, 12" (30.5 cm)

Binder (Klyr-Fire/distilled water)

Thompson Opaque Enamels (three or more): #1830 (Marigold Yellow), #1840 (Sunset Orange), #1860 (Flame Orange), and #1870 (Orient Red)

TOOLS

Kiln-firing setup

#2 flat hand file

#400 silicon carbide sanding stick

Dividers

Center punch and hammer

Hand drill or flexible-shaft machine

#60 and 3 mm (⅛" [3 mm]) drill bits

#2 or #4 cut round needle file

Fine-point marker or metal scribe

Jeweler's saw frame and 2/0 blades

Flaring tool

Steel block

Chasing hammer (for use with flaring tool)

Bracelet mandrel

Plastic or rawhide mallet

Small riveting hammer (optional)

5 mm, 4 mm, and 3 mm dowels or drill-bit bases

2 pairs chain-nose pliers

Soldering tools (page 153)

Hard or eutectic solder

Sandbag, vise, or towel

Planishing or ball-peen hammer (optional)

Flexible-shaft machine and steel or diamond cylinder bur (optional)

Wet-packing enamel tools (page 30)

#600 wet/dry sandpaper

Brass brush and detergent

Fine Scotch-Brite

FINISHED SIZE

2½" (6.5 cm) diameter

1. Set the kiln temperature at 1,450°F (788°C), turn it on, and let it warm up.

2. Anneal the 1.5 × 8mm sterling flat stock. Cool, pickle, rinse, and dry.

3. File the ends of the strip with a #2 flat hand file so there are no sharp corners. Sand the ends smooth with a #400 silicon carbide sanding stick.

4. Set the legs of a pair of dividers ³⁄₁₆" (5 mm) apart. Place one of the legs centered on one end of the strip. Make a mark ³⁄₁₆" from the end with the other leg. Repeat on the other end of the strip.

5. Set one leg of the dividers on each side of one end of the strip, making two marks at ³⁄₁₆" (5 mm), crossing the mark made from the end. This will look like an "H." Center punch the middle of the cross line of the "H." Repeat on the other end (*figure 1*).

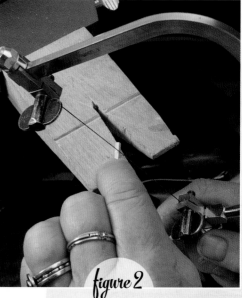
figure 1

6. Drill a 1 mm (#60) pilot hole (starter hole) in each of the center punched marks.

7. Re-drill each of the holes with a ⅛" (3 mm) drill bit.

8. The 3mm tubing needs to fit very snugly into these holes. It may be necessary to file the inside of the drilled holes with a round needle file. Stop filing as soon as the tube fits in the holes.

9. Starting with a flat, smooth end, measure ³⁄₁₆" (5 mm) in from the end and mark with a fine-point marker or metal scribe.

10. Use a jeweler's saw and a 2/0 saw blade to saw off the ³⁄₁₆" length of tubing. Sand the end smooth. **NOTE:** When sawing the tubing, make the measurement mark 360 degrees around the tube. Saw just outside the line. Make a shallow cut with the saw blade 360 degrees around the tube. Then proceed to cut through the tube one bit at a time, until the piece is cut off. The shallow score of the saw blade helps keep the blade in place for a straighter cut and fewer broken blades (*figure 2*).

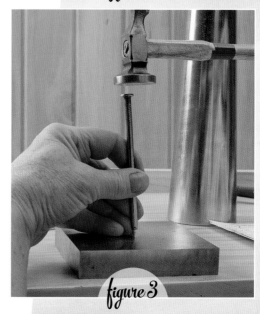
figure 2

11. Place a flaring tool (a large 20d/16d nail with the end ground into a shallow cone works great) in one end of the piece of tubing, place on a steel block, and tap the tool gently with a chasing hammer until the end of the tubing becomes slightly flared (*figure 3*).

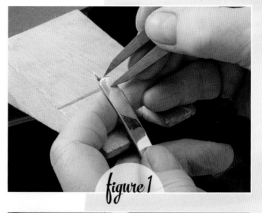
figure 3

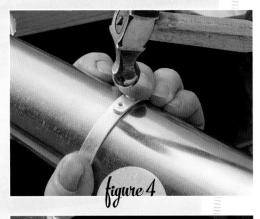

figure 4

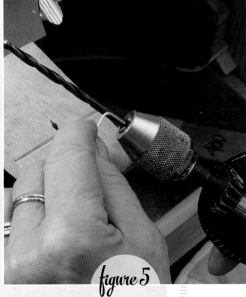

figure 5

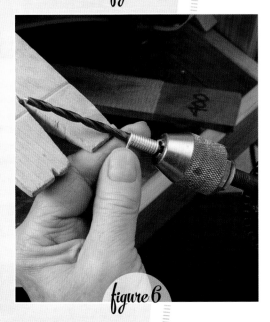

figure 6

12. Shape the 1.5 × 8mm strip on a round bracelet mandrel with a plastic or rawhide mallet. When done, the two ends should just meet.

13. With your hands, continue to shape the bangle until the two ends overlap enough for the two holes to line up, one on top of the other. This is a little-by-little maneuvering process, trying to keep the bracelet as round as possible and still have the overlap.

14. Place the flared end of the tubing from the inside of the bracelet through both holes so that the unflared end protrudes on the outside of the bracelet.

15. With the bracelet on the bracelet mandrel, flare the outer end of the tube so that it is secured in the bracelet *(figure 4)*.

16. Finish off the tube rivet by using a small riveting hammer or the round end of a chasing hammer to hammer the tube flares down onto the surface on the inside and outside of the bangle. The hammer should be able to fit into the interior at enough of an angle to achieve this. Support the bangle on a steel block and bracelet mandrel while flattening the tube inside and outside, respectively.

17. Wind the 16-gauge fine silver wire around a 5 mm dowel or rod until there are five or six jump rings in a coil. Repeat with the 4 mm and 3 mm dowel or rod. There should now be three coils in three sizes, wrapped six times. Fewer jump rings are okay if preferred. It will simplify the soldering process. *(figures 5 and 6)*. (See Making Jump Rings, page 150.)

18. Saw through the coil in one spot with a jeweler's saw and a 2/0 saw blade. This should create five or six jump rings. Repeat this process with the other two coils *(figure 7)*.

19. Close the jump rings with two pair of chain-nose pliers. Bend them sideways with one plier on each side of the seam and push gently to make the ends meet *(figures 8 and 9)*.

20. Place the rings on a clean soldering block. Flux the seam on each jump ring and place a 1 mm square paillon of eutectic solder on each seam *(figure 10)*.

21. Using a torch, solder each of the jump rings shut. Quench them in water, then pickle, rinse, and dry them.

22. Secure the round bracelet mandrel horizontally on a sandbag, in a vise, or on a bunched-up towel. Place the jump rings one at a time on the mandrel at the spot where the diameter is similar to the size of the bangle. Tap the jump ring with the flat side of a chasing hammer (ball-peen or planishing hammers will also do). This will put a slight curvature on the bottom of the ring and polish the top. The slight curvature will help the rings fit onto the bracelet while soldering. Repeat this process with all the rings.

23. Set the bracelet up in the pumice of an annealing pan or set them up with insulated-grip tweezers holding them vertically. Dip two of the jump rings in flux and place them on the bracelet.

24. Cut four pieces of hard silver solder, each ¹⁄₁₆" × ¹⁄₁₆" (2 × 2 mm). Place two on the inside of each ring.

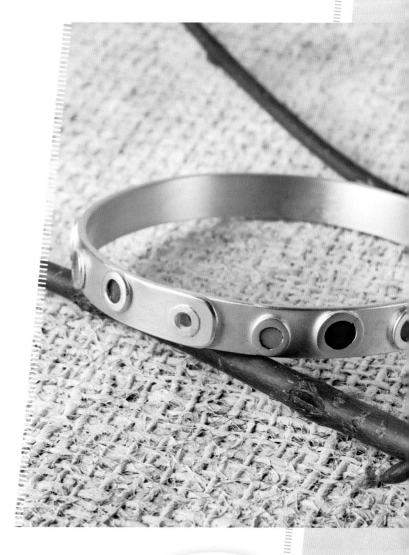

TIP

After soldering jump rings, string them onto a short length of copper wire. Twist the wire shut and pickle them in a bundle. This will prevent the need for "fishing" around the bottom of the pickle for individual rings.

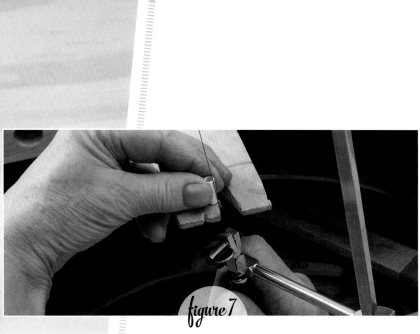

figure 7

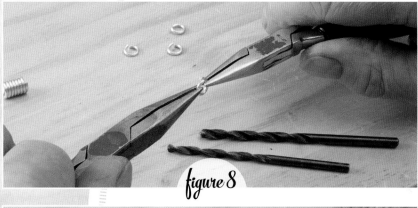

figure 8

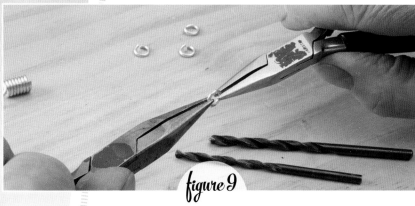

figure 9

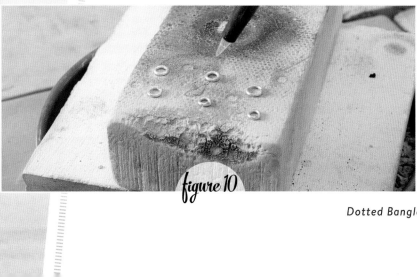

figure 10

25. Light the torch and adjust the flame to a larger, slightly hissing, oxidizing flame. Heat the entire bracelet. Then concentrate the flame under the top third of the bracelet where the rings are. Continue even heating until the solder flows to secure the rings on the bracelet.

26. Allow the bracelet to cool. Place it in the pickle. Remove from the pickle, rinse, and dry. Continue this process until all of the rings are soldered onto the bracelet *(figures 11–13)*. This is time-consuming, but if you try to solder more than two at a time there will most likely be complications with rings moving to the wrong place.

27. Some enamels will have slight color changes when fired if they are touching silver solder. If there is excess hard solder inside the rings, grind it out using a flexible-shaft machine with either a steel or diamond cylinder bur.

28. One color at a time, put about ½ teaspoon (2.5 ml) of the color in a plastic spoon set on a paper plate. Hydrate the dry enamel with equal parts water and Klyr-Fire. There should be enough moisture added to leave a layer of liquid covering the enamel.

29. Set the bracelet on a firing rack, supported by two small trivets, leaving five or so rings facing up.

30. Using a 00 or 000 sable paintbrush, apply some enamel, one color at a time, always rinsing the brush in between, to the interior of the rings that are facing up *(figure 14)*. Siphon extra moisture out of the wet-packed enamels by holding the edge of a paper towel to the enamel. Allow to dry.

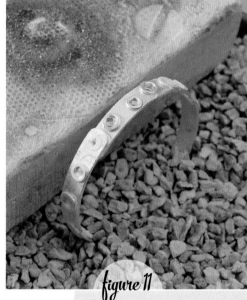

figure 11

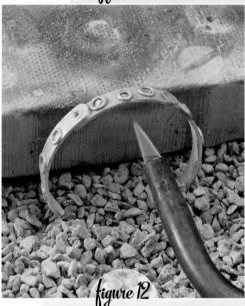

figure 12

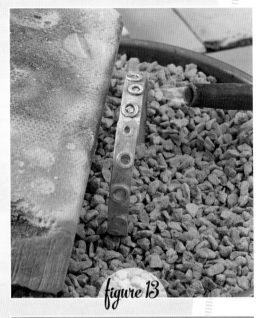

figure 13

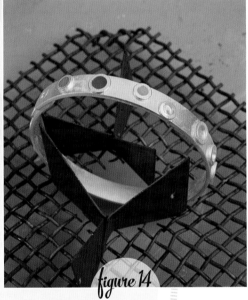

figure 14

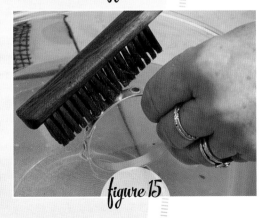

figure 15

31. Carefully move the rack into the kiln. Close the door and set the timer for 2 minutes. Remove when the timer goes off and allow to cool.

32. Repeat Steps 28 through 31 until all rings are filled with fired enamel. There may be two or three firings per group of rings. Don't try to fill the rings to the brim in one firing. This may cause cracking. A couple of thinner layers built up works better. Packing and firing are done when there is a complete layer in all rings and a slightly concave surface within each ring.

33. The seam of eutectic solder on each ring will have turned dark through repeated firings. Sand the tops of the rings with 600-grit wet/dry sandpaper, under a drizzle of water. This will brighten the tops of the rings. The concave surface of the enamels should not be affected by this.

34. By hand, use a brass bristle brush, water, and a drop of mild detergent and scrub the top of the bracelet *(figure 15)*. This will brighten and give it a satin finish.

35. Fine Scotch-Brite should be used to brighten and finish the interior of the bracelet. This may be done by hand or on a flexible-shaft machine with a Scotch-Brite attachment.

Jewelry-Making
TIPS & TRICKS

If you haven't done much jewelry making or metalsmithing, take a look at the list of jewelry-making skills at the beginning of each project and start with one that requires fewer skills. I've mentioned some good jewelry-making books in the Resources (page 156), and you might want to consider taking a class to learn more metalsmithing techniques, such as soldering. There are some tasks you'll find throughout the projects. I've given some tips here to make them a little easier.

Annealing Silver

Annealing silver can be very tricky. If sterling silver is heated to temperatures over 1,000°F (540°C), it can develop a thick layer of fire scale. This is a dark purplish oxide layer that is considered unattractive and unprofessional. Any silver heated to a red color is also at risk of melting. Annealing (oftening by heating, a redistribution of the metal's crystalline structure to make it malleable) happens when the metal is heated to a *low* red in a *dark* room. It is very subtle and nearly impossible to recognize in a well-lit room. There is no thermometer on metal when heating with a torch, so one needs visual indicators to prevent harmful side effects. Another unfortunate result of excessive heating of silver is reticulation. This is a surface melting that creates texture on the metal surface. It can be used as a texture, however, if it is developed during annealing, it may be an unwanted result.

Here are some tricks to prevent melting, firescale, and/or reticulation during annealing.

YOU WILL NEED

Torch

Black permanent marker

Flux

Quench bowl

Pickle

Prip's flux

To avoid melting or reticulation:

1. Make a mark or draw a line across the length of the metal to be annealed with a black, fresh (moist) permanent marker.

2. As you heat the metal, the pigment of the black marker will fade. This happens at just about exactly the temperature that most jewelry-making metals (silver, fine silver, copper, brass) become annealed. There may still be a shadow of the line drawn, but the black color will have faded.

3. Cool and pickle as usual.

To avoid firescale:

1. Warm the metal to be annealed and brush on a thin layer of Prip's flux to cover the piece, front and back.

2. As you heat the metal with a torch, watch for the flux to go through several phases. The flux will lose its foamy white look, become flat and somewhat pink and dirty looking, then become clear and slightly glassy.

NOTE: You can apply the flux over permanent marker to help prevent melting or reticulation as well.

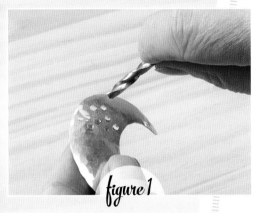

figure 1

Cleaning Drilled Holes

Almost every time you drill a hole in metal you will create a burr, or raised edge, on the edges of the hole. This can be rough and unattractive. In the enameling process, this may also be problematic, as enamel will build up in and around the drilled holes. This can be solved easily.

In your hand, hold a drill bit twice the diameter of the diameter of the hole. Place the tip of the larger drill bit on the hole and gently turn the drill while applying firm pressure (*figure 1*). As you do this, you should see that you are shaving the burr off from the perimeter of the drilled hole.

Repeat this on the back side of the drilled hole. This will also create a nice smooth bevel on the edge of the hole.

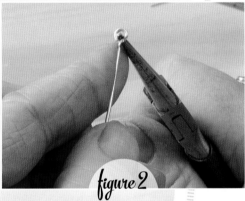

figure 2

Making Ear Wires

You can purchase commercially made ear wires or make your own.

YOU WILL NEED

18- or 20-gauge sterling silver round wire, 4–4½" (10–11.5 cm)

Wire clippers or snips

400-grit silicon carbide sanding stick or fine Scotch-Brite pad

Round-nose pliers

½" (1.3 cm) dowel

2 pairs chain-nose pliers

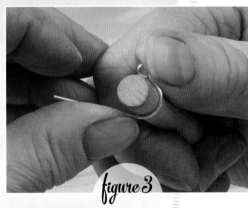

figure 3

1. Use clippers or snips to cut the wire in half. Sand the ends flat and smooth.

2. Bend a ⁵⁄₃₂" (4 mm) loop on one end of each wire with the round-nose pliers. Place the pliers with one jaw inside the ring and one outside the ring where the end of the loop touches the remaining wire. Give a little bend to center the loop on the rest of the wire (*figure 2*).

3. Form the remaining length of wire around a ½" (1.3 cm) dowel. Bend the very end of the wire in a reverse curve to create an ear wire (*figure 3*).

4. With the chain-nose pliers, open the ring of the ear wire sideways and attach to your earrings.

MAKING JUMP RINGS

It's easy to make multiple jump rings of the exact same size, with a few simple tools. I suggest using a hand drill rather than a power drill or flexible-shaft machine, as it is safer.

|||

YOU WILL NEED

Hand drill (eggbeater style)

Drill bits (with a shank diameter the same size as you want the inside diameter of your jump rings to be)

Annealed wire

Wire clippers

Jeweler's saw frame

2/0 saw blades

Jeweler's bench pin

|||

1. Choose a drill bit that has the same shank diameter you would like the inside diameter of your jump rings to be. Place the drill bit in the hand drill with as much of the plain shank extending beyond the jaws as possible with the bit held firmly.

2. Using chain-nose pliers, bend an "L" about ⅜" (1 cm) from the end of the annealed wire.

3. Place the "L" in the space between the jaws of the drill chuck, leaving the longer length of the wire extending out at a 90-degree angle from the chuck (*figure 4*).

4. Press the end of the handle of the drill firmly against your chest.

5. Pinch the wire firmly between your thumb and forefinger and against the drill bit where it meets the jaws of the drill.

6. With your other hand, slowly crank the handle of the drill. With your hand guiding the wire it will begin to wrap around the drill-bit shank forming a coil of uniform size (*figure 5*).

7. Slip the coil off the drill bit.

8. Use wire clippers to clip off any extra wire from the coil.

9. Hold the coil vertically on a wooden bench pin.

10. Use a jeweler's saw frame with a 2/0 saw blade and beginning at the top of the coil, saw through the coil one revolution of wire at a

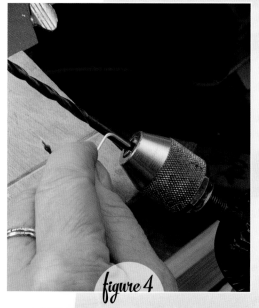

figure 4

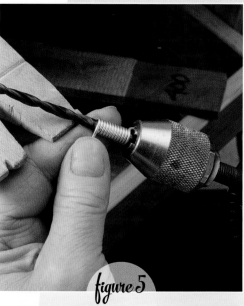

figure 5

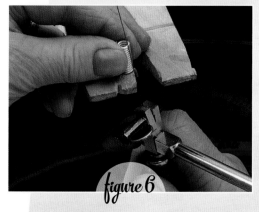

figure 6

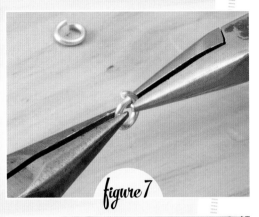

figure 7

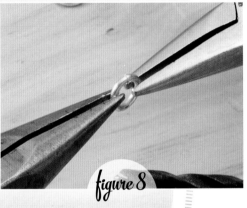

figure 8

time (**figure 6**). Keep the saw as vertical as possible and cut one or two rings off at a time. Proceed until the entire coil is cut and there are now separate jump rings.

OPENING AND CLOSING JUMP RINGS

It's very important to close jump rings snugly, without marring them or bending them out of round. This can be done very simply with the correct pliers and a little patience. This method should be used in any instance when opening or closing jump rings or other rings, such as the ring at the end of an ear wire.

YOU WILL NEED

2 pairs smooth-jawed chain-nose or flat-nose pliers

1. Hold the jump ring with one set of pliers at 3 o'clock in your right hand and the other pair of pliers in your left hand at 9 o'clock. The seam should be up, at 12 o'clock.

2. Gently bend the sides of the ring side to side with the ends moving toward each other (**figure 7**).

3. Apply enough pressure to have the ends slightly pass each other.

4. Gently pull back on the sides and move the ends into a touching position.

5. If necessary, wiggle them side to side ever so slightly, until they line up perfectly (**figure 8**).

MAKING A METAL TEMPLATE

If you plan to make several of the same pieces, you might want to create a durable, reusable metal template.

||

YOU WILL NEED

Paper

Pencil

Scissors or X-Acto knife

24-gauge brass or copper sheet (slightly larger than the template)

Scotch-Brite pad

Glue stick

Jeweler's saw frame and 4/0 blades

Center punch

Drill (hand or electric), Dremel, or flexible-shaft machine and #60 drill bit

#4 needle file or 400-grit sandpaper

||

It's worth the time to create a reusable metal template if you plan to make multiples of a piece.

1. Draw the desired design on paper.

2. Cut out the design with scissors or an X-Acto knife.

3. Clean the piece of metal sheet with the Scotch-Brite pad.

4. Apply glue stick to the back of the paper design.

5. Place the paper on the metal and burnish bubbles out with the back of a fingernail.

6. Center punch, then drill a small hole within the perimeter of the paper design.

7. Feed a jeweler's sawblade, held by one secured end in a saw frame, through the hole. Tighten the other end of the blade.

8. Saw out the design. Release the blade from the saw frame.

9. Smooth the edges of the pierced design with a needle file or sandpaper.

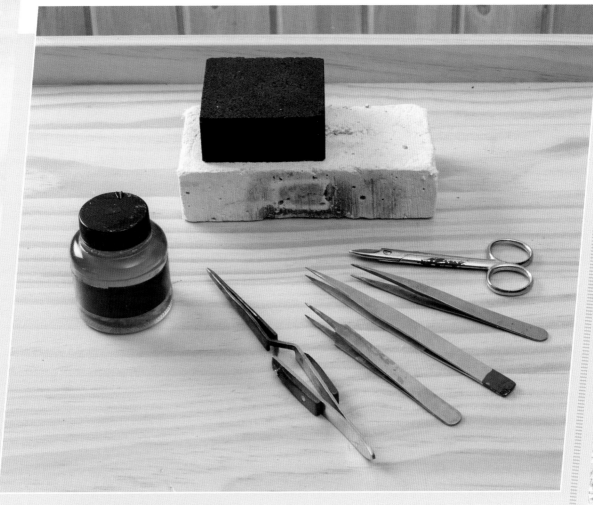

Soldering Tools

A number of projects require soldering. Here are the basic tools you should have on hand. The tools list for the project you are making will list the type of solder needed.

- Flux
- Soldering block
- Solder pick
- Scissors (for cutting solder)
- Insulated-grip tweezers
- Torch
- Friction/battery-operated striker (never matches or butane lighter)

- Copper tongs (for removing pieces from the pickle)
- Cross-locking tweezers
- Fine-tip stainless-steel solder tweezers
- Quench bowl with water
- Heated pickle
- Safety glasses

Templates

Copy the templates at 100%.

**STAMPED TRIANGLE
EARRINGS, PAGE 58**

Triangle template

U-SHAPED RING, PAGE 62

Shank template

**GLASS THREADS PENDANT,
PAGE 68**

Pendant template

**PERFORATED CRESCENT
PENDANT, PAGE 76**

Crescent template

**ENAMELED SCREEN
PENDANT, PAGE 84**

Pendant template

**THREE-LEAF PENDANT,
PAGE 106**

Leaf templates

**THREE-LEAF EARRINGS,
PAGE 100**

Leaf templates

**CHAMPLEVÉ EARRINGS,
PAGE 126**

Earring templates

Resources

Books and DVDs

Darty, Linda. *The Art of Enameling: Techniques, Projects, Inspiration.* Asheville, North Carolina: Lark, 2011.

Knuth, Bruce G.. *The Jeweler's Resource: A Reference of Gems, Metals, Formulas, and Terminology for Jewelers.* Parachute, Colorado: Jewelers Press, 2000.

Lewton-Brain, Charles. *Foldforming.* Brunswick, Maine: Brynmorgen Press, Inc., 2008.

McCreight, Tim. *The Complete Metalsmith.* Worcester, Massachusetts: Davis Publications, 1991.

Thompson Enamel Workbook. Bellevue, Kentucky: Thomspon Enamel, Inc., 1997.

Warg, Pauline. *Basic Jewelry Enameling (DVD): Torch Fired Tutorial.* Fort Collins, Colorado: Interweave, 2013.

Suppliers

COOL TOOLS
945 N. Parkway St.
Jefferson, WI 53549
(888) 478-5060
cooltools.us
Plastic design templates

HAUSER & MILLER
10950 Lin-Valle Dr.
St. Louis, MO 63123
(800) 462-7447
hauserandmiller.com
Precious metals

THOMPSON ENAMEL
PO Box 310
Newport, KY 41072
(859) 291-3800
thompsonenamel.com
Nonleaded enamels, tools for enameling, enameling books

WARG ENAMEL & TOOL CENTER
10 Oak Hill Plaza
Scarborough, ME 04074
(855) 885-9382
wargetc.com
Jewelry-making and enameling tools and supplies

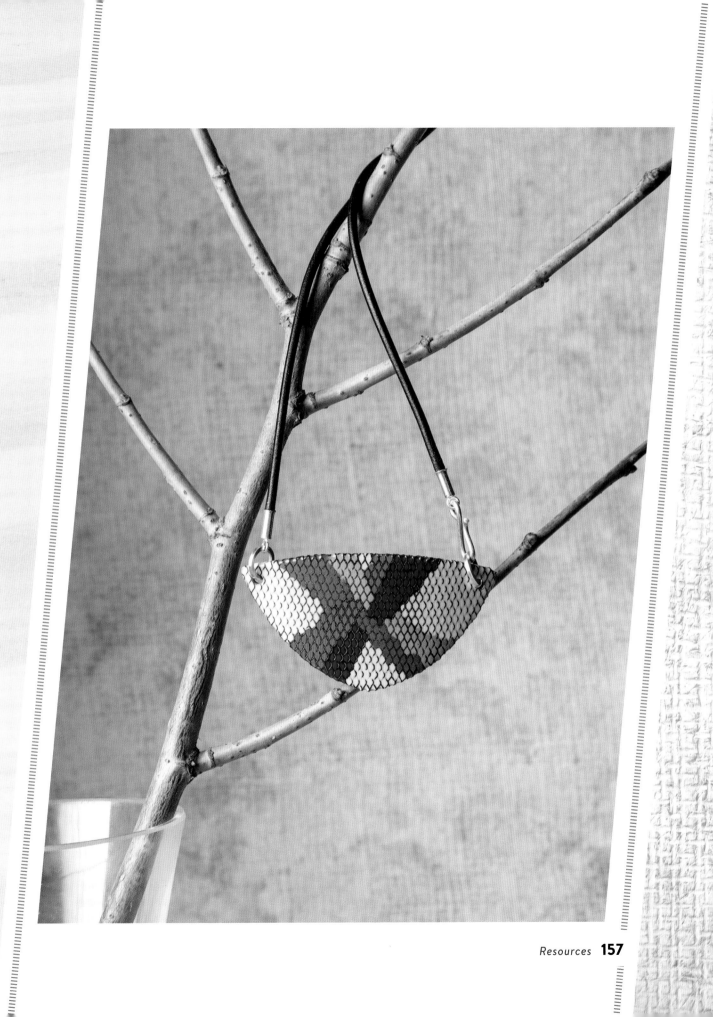

Index

EDITOR
Michelle Bredeson

TECHNICAL EDITOR
Cindy Wimmer

ART DIRECTION & DESIGN
Charlene Tiedemann

COVER DESIGN
Wendy Dunning

LAYOUT DESIGN & PRODUCTION
Bekah Thrasher

BEAUTY PHOTOGRAPHY
Matt Graves

STEP PHOTOGRAPHY
Donald Scott

PHOTO STYLIST
Ann Swanson

Distributed in Canada by Fraser Direct
100 Armstrong Avenue
Georgetown, ON, Canada L7G 5S4
Tel: (905) 877-4411

Distributed in the U.K. and Europe by
F&W MEDIA INTERNATIONAL
Brunel House, Newton Abbot, Devon, TQ12 4PU, England
Tel: (+44) 1626 323200,
Fax: (+44) 1626 323319
E-mail: enquiries@fwmedia.com

Distributed in Australia by Capricorn Link
PO Box 704, S. Windsor NSW, 2756 Australia
Tel: (02) 4560 1600, Fax: (02) 4577 5288
E-mail: books@capricornlink.com.au

SRN: 15JM06
ISBN-13: 978-1-63250-000-7

PDF SRN: EP9574
PDF ISBN-13: 978-1-63250-001-4

fw
a content + ecommerce company

www.fwcommunity.com
10 9 8 7 6 5 4 3 2 1

Learn More New Ways

TO TAKE YOUR JEWELRY TO THE NEXT LEVEL!

PATINA
300+ Coloration Effects for Jewelers & Metalsmiths

Matthew Runfola
978-1-62033-139-2
$34.99

HANDCRAFTED METAL FINDINGS
30 Creative Jewelry Components

THE JEWELRY MAKER'S FIELD GUIDE
Tools and Essential Techniques

Helen I. Driggs

LAPIDARY JOURNAL JEWELRY ARTIST

LAPIDARY JOURNA
Check out *Jewelry Artist* art of gems, jewelry ma minerals, and more. Wh an experienced artisan, *Jewelry Artist* can take y Jewelryartistmagazine.

Daily

nline com-
ting hand-
experts,
s, check out
upplies, and
.com.